GENERAL HARDWARE
MFG. CO INC.

A R T

IN GENERAL

ART IN GENERAL

1993 – 1994

Manual

This publication is sponsored
by a generous grant from
The Andy Warhol Foundation for
the Visual Arts.

Art in General's programs are
sponsored by the National
Endowment for the Arts, New York
State Council on the Arts,
Department of Cultural Affairs of
the City of New York, Con Edison,
The Foundation for Contemporary
Performance Arts, General
Tools Manufacturing Co., Inc.,
Heathcote Art Foundation, Jerome
Foundation, The Menemsha Fund,
Joyce Mertz-Gilmore Foundation,
Mid Atlantic Arts Foundation,
J. P. Morgan & Co., Inc., Abraham
and Lillian Rosenberg Foundation,
artists, and individuals. Art in
General is a member of the
National Association of Artists'
Organizations (NAAO).

Front and back cover:
Special project commissioned by
Art in General
Allan de Souza & Yong Soon Min.
Nexus. 1992–94.
From a collaborative series
of photographs funded by Light
Work Artists-in-Residence
Program, Syracuse, NY

Publications Director: Holly Block
Editor: Catherine Ruello
Publication Coordinator:
Naama Oppenheim-Kovner
Designer: Diane Bertolo

CONTENTS

ACKNOWLEDGMENTS

ART IN GENERAL'S *Manual 1993–1994* is made possible by the concerted efforts of many individuals. We are particularly grateful to all the artists, writers, and photographers we were privileged to work with, and whose work is documented here. This past exhibition season could not have occurred without them. The cover features an artists' project by Allan de Souza and Yong Soon Min, who recently relocated from New York to Los Angeles. As much as we will miss them and their artistic contributions, we are sure that our relationship, now bicoastal, will endure.

One of our most important decisions this year was to hire an editor for *Manual*, and we are indebted to the contributions of Catherine Ruello. Her efforts have made this publication possible. Special recognition goes to Naama Oppenheim-Kovner, Book Coordinator, who worked closely with Catherine to make this second volume a reality. Additional thanks go to Lawrence Chua, who wrote the introduction; to Diane Bertolo, who designed *Manual*; to Michael Goodman for his copyediting; and to Teri Slotkin, Aresh Javadi, and Myles Aronowitz, who worked closely with us and whose photographs are reprinted in this volume. The staff of Art in General has made many contributions to this publication throughout the year, and special thanks go to Joanna Spitzner, Gallery Coordinator; Sowon Kwon former Development Associate; Andrea Pedersen, our new Development Associate; Andy Fish, Gallery Assistant; Lyell Davis, Preparator; and the many interns and volunteers who contributed their skills to make Art in General an interesting place.

On a final note, special appreciation goes to our funders, particularly The Andy Warhol Foundation for the Visual Arts, whose support has made an overwhelming difference to many small arts organizations nationally and internationally. We are forever grateful to their dedication and commit-

ment to the arts, particularly in providing funds for the second year of a three-year grant toward this publication. We would especially like to express our admiration and sincere gratitude to Pamela Clapp and Emily Todd of the Warhol Foundation for the significant contributions they have made over the years. Keep up the good work.

H. B.

IT IS WITH GREAT PLEASURE that I welcome the publication of Art in General's second *Manual.*

At a time of so many funding cuts to arts institutions, it is extraordinary that we are able to publish our *Manual,* which, moreover, serves as a sampling of the range of work being presented by "grass-roots" organizations like our own. Only the generous support of The Andy Warhol Foundation

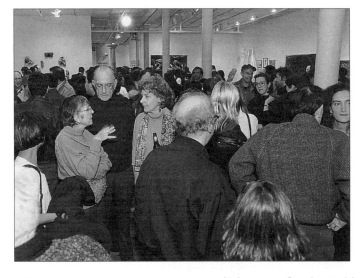

Exhibition opening of "Good and Plenty," November 20, 1993

for the Visual Arts has made this publication possible. The news media have covered the controversies currently surrounding the foundation, but I have seen little reporting about the wonderful things made possible by their support. We have benefited from their generosity, which comes to us not only in the grant form but also in the moral support and imaginativeness of the foundation's talented staff. It is a great concern to all of us that its future is being threatened.

When the great (and very wealthy) English painter J. M. W. Turner died in 1851, he designated a sizable part of his fortune for the establishment of a charitable organization devoted to the direct support of artists. During the Dickensian wrangling that ensued, the money was diverted to other ends, and Turner's wishes were never realized. The arts community can only hope that the same diversion does not occur in the case of The Andy Warhol Foundation and that the wishes of its founder will be fully realized.

MARTIN WEINSTEIN
PRESIDENT OF THE BOARD

Art in General: The Process

FROM ITS INCEPTION IN 1981, Art in General has been extremely responsive to the needs of artists. This commitment is at the basis of the rationale behind our programs and our choice of exhibiting artists. We are still, however, often asked basic questions about Art in General's process and how it works.

Art in General exhibits work in all media by New York, national and internationally based artists. Guidelines for the submission of artwork and exhibition or installation proposals are published and distributed annually. The submissions we receive form the pool from which our program is created.

No one individual determines Art in General's programming. Each year, two advisory panels are convened, made up of artists, independent curators, critics, and other interested parties who have participated in Art in General's exhibitions, or are familiar with the organization. Functioning as curatorial boards, these advisory committees review submitted materials from which they assemble group exhibitions, choose artists' projects and exhibitions organized by outside curators. One panel considers individual artists' work and proposals for guest-curated shows, always seeking projects with distinct perspectives from exhibitions organized in-house. The other panel looks at site-specific work, which includes audio, video, performance; gallery installations, the window and any other of our various nooks and crannies (like the bathroom). Finally, after recommendations are made by the panelists, studio visits are made to select specific works for in-house exhibitions, and preparations are begun to produce and/or receive shows coordinated outside. For the past ten years, there has been an annual deadline. However, due to an overwhelming number of submissions, the frequency of panel meetings was recently increased, so that artists may submit their work at any time during the year.

Much critical discussion is generated by the panelists while reviewing slides during the two day period of eight to ten hours a day. We begin the panel process with few pre-conceived ideas about exhibitions, and our discussions center around the work projected in front of us. Because of the diverse make-up of the panel, the curatorial, philosophical, and conceptual points of views expressed are as diverse as the panel itself—a fact that mirrors the ideological pluralism and diversity of the work being produced.

Art in General functions as a laboratory where emerging artists have the opportunity to experiment with their work in a wide variety of spaces, and see it in a context, that they may never have thought of before. It is a place where curators and critics can expound their latest ideas, and where the public can encounter something new or unexpected. Most importantly, perhaps, it is a place where artists, curators, and visitors can challenge each other and establish a dialogue.

HOLLY BLOCK
EXECUTIVE DIRECTOR

INTRODUCTION:

Flavor in Your Ear

Culture didn't end, for us, with the production and consumption of books,
paintings, symphonies, films and plays. It didn't even begin there. We
understood culture to be the creation of any meeting space…and culture,
for us, included all the collective symbols of identity and memory:
the testimonies of what we are, the prophesies of the imagination, the
denunciations of what prevents us from being.

—Eduardo Galeano

AS A CHILD I COULD NOT SLEEP without the pillow of noise. The hollow snap of basketball on pavement, the hiss of motors circling Grand Army Plaza, or the clatter of my mother's labor into the night were, for me, the first refrain of a sonorous lullaby. These sounds were solace, a reminder that a community's life extended beyond my own. The adult writer in these same urban spaces spends many hours waiting for the same clamor of sounds to still. The silence that follows can be a summons to think. But is it useful to speak of silence in this lugubrious and romantic way? How do we name the silences that prevent us from being?

There are many ways to muffle the din. During the 1980s, artists and arts organizations found themselves constructed into symbolic essences, an enemy within. Government funding was cut and pulled from exhibitions and artists, particularly those working in film, photography, and performance, whose work dealt with issues of sexuality and transgression. Silence was quickly named as censorship. Yet, many of these censored artists became instant stars, boosted by the notoriety of controversy. So much of the critique of censorship at this time was invested with the language of class privilege: the blasting of an uninitiated public for not "getting" the disobedient qualities of corporal imagery on display. The debates I remember

were rooted in a quaint belief in liberal individualism and freedom of expression. But what does freedom of expression mean in a freemarket economy?

It's worth noting that the artists and institutions "under siege" at the time were already funded by national agencies. Little issue was made about a more enduring and complex kind of silence. This silence is felt most directly by black artists (and I am using the term here politically to refer to African-American, Asian, Latino, and Native artists). Black artists who are silent because they have never been allowed to breathe, to be nurtured, to imagine, to enter the structures that can produce such possibilities. In an

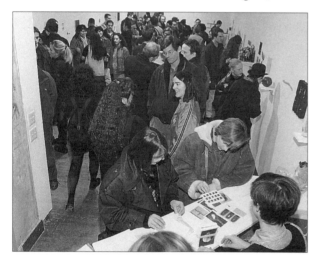

Opening of
"Little Things,"
March 12, 1994

era of job cutbacks and public education curtailment, these artists have suffered greatly. There is a name for this kind of silencing: exclusion.

What happens when we try to cross the silences between communities and cultures? We know that there was nothing abnormal about the attacks the right wing launched on the institutions who took their government funding and transgressed taboos of public taste. But did the work at the center of the tempest effectively instigate public discourse? Although the political rhetoric of *nation* favors the construction of monstrous enemies, we know the likes of Jesse Helms

are not monsters. We won't give them that glamour. They were bureaucrats simply doing their job: protecting the values that sustain their class, race, and gender privilege.

Alternative spaces like Art in General play a crucial role in building an artistic practice in opposition to that privilege. In the late 1960s, grass-roots arts groups and theater companies exploded across the country. This explosion did not take place in a vacuum. Black power movements, feminist consciousness raising, anti-imperialist struggles...all had cultural consequences. They provoked aesthetic approaches that refused the conventional separation of form and content, truth and beauty. Today, spaces like Art in General are an implicit challenge not only to artistic practice but to our understanding of the artist herself: the artist not as rebel but as servant to her community. Here I am speaking of a transgressive community rather than a static one. I am speaking of what bell hooks has called "communities of resistance."

The physical space of Art in General is poised at the confluence of several communities: Chinatown, Little Italy, Tribeca, SoHo, Loisaida. Its location demands an aesthetic language that communicates that difference.

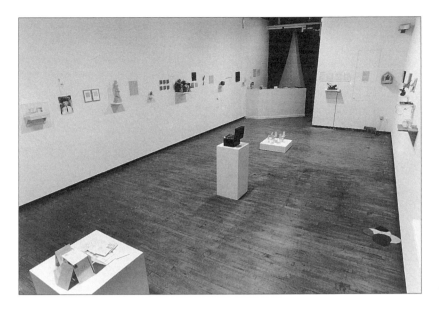

Installation view of "Little Things"

I am not just talking about speaking the right dialects in the right places or a lazy affirmation of static identity, but a real crossing of silent borders. The best work I have seen at Art in General is about communal roots as well as routes. It is as conscious of addressing as it is of transgressing. The best work involves communities for whom the gallery may not be the first place to unwind after a shift in a sweatshop, for whom the entrance into the gallery can in itself be an act of defiance or humiliation—communities whom cultural institutions have not always served. Art in General has an address, but its work reaches out beyond walls, down elevator shafts, out windows, speaks to the need to transform our territorial understanding of space as a fixed, permanent place into a diasporic comprehension of space as movement and fluidity. Over the last ten years, the exhibitions at Art in General have demanded dialogue and critical "conversating" instead of dull controversy and stupefied silence.

In the streets around Art in General, there is never a feeling of tranquility or mere quietness, never a moment of soundless calm. But these can only be restless times for anyone who believes the arts can be a site of resistance to white supremacy, patriarchy, and capitalism. These can only be restless times, knowing, as the mighty poet Linton Kwesi Johnson has said, there can be no calm when the storm is yet to come.

LAWRENCE CHUA

L. ALCOPLEY:

SEPTEMBER 10–OCTOBER 2, 1993

The Late Works 1970–1990

Sixth Floor

ART, VARIED AND DISTINGUISHABLE in different periods of human history and in different cultures, springs from human experience and is created to be valid for human beings only. Science, on the contrary, although springing also from human experience, is not valid only for human beings, and thus its applicability can be detached from human existence. Science defines phenomena in nature—many of which it detects—and attempts to explain their underlying mechanisms, irrespective of their applicability and validity for human beings.

What is common to both art and science is the creative process and the synthetic thinking in both human endeavors. Although analytical thinking built on logic is instrumental in scientific activities, synthetic thinking permits certain jumps, a creative process, without which science could not advance.

In general, philosophers assume that thinking necessarily involves the use of words and their meanings in certain contexts. In the arts, such an assumption is obvious in poetry. In other arts, such as drawing, painting, sculpture, ceramics, architecture, music or dance, thinking remains an activity without words. These arts form the unsayable, which by the use of words can be attained only in poetry. In science, thinking occurs in great part by the use of words. Thinking in science occurs likewise by the use of mathematics and not infrequently by invoking a mental image or picture.

To my way of thinking, the absolute is attainable in art. Advancement, improvement, evolution

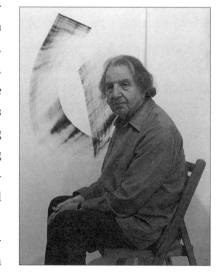

L. ALCOPLEY in his studio, New York City, 1990. "In case more than one brushstroke and more than one color are needed to complete the painting, the dialogue between me and the incomplete work continues and may last up to several weeks."

14

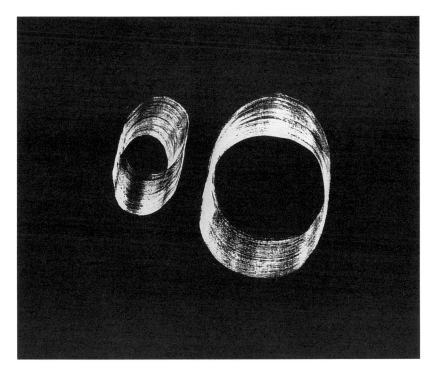

UNTITLED. 1970.
Oil on canvas,
35 x 40"

or progress are not crucial in the pursuit of art. In contrast, the absolute is not attainable in science, although certain laws can be detected in its pursuit—such as, for instance, the discovery by Copernicus that the earth revolves round the sun or Newton's enunciation of the principle of universal gravitation.

There is, of course, knowledge in art, which is not limited to the knowledge of the art historian or to that of the art connoisseur or the lover of art. It goes without saying that each artist has to be knowledgeable and aware of the materials, tools, techniques and methods to be used in producing a work of art. Yet, there is no advancement of knowledge which determines the value and/or meaning of a work of art. However, such an evaluation is not merely necessary but it is crucial with a discovery in science, which is synonymous with the advancement of knowledge.

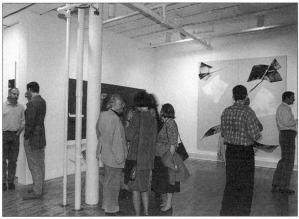

Exhibition opening

Both art and science utilize knowledge. While science is striving toward its advancement, art has no such aim. Science is geared to uncover what belongs to the physical world; art touches what is beyond the physical in the human imagination. Both are manifestations of the human mind and aspire toward human freedom.

L. Alcopley, "On Knowledge in Art and Science," reprinted from *Leonardo,* Vol. 20, No. 3, 1987, pp. 213–215.

PROJECT REACH:

Exhibition and Installation

Fourth Floor

Sharon Dong

Fabiola Abad

Cathy Maria Flores

Albert Salazar

Rothamel Alexandre

Marisol Flores

Erica Santiago

Helen Ano

Samantha Lincoln

Charmaine Francis

Mario Small

Caridad Arizmendi

Nadine McLean

Rachel Friedman

Nicholas Sumasto

Stephan Aubry

Angel Martinez

Mai-Gee Fung

Christine Tam

Jamal Brewer

Wendy Mercado

Angie Garcia

Anthony Tejada

Greg Campbell

Amber Nowling

Ronnie Garcia

Sheila Thomas

Nelson Chan

Christian O'Neill

Ronah Harris

Jeffrey Tsai

Pamela Chan

Rene Perez

Joanne Ho

Lily Tsang

Cindy Chen

Danny Ramirez

Kit Ho

Hau Wa

Jerry Chen

Felipe Rivera

Willie Holmes

Andrew Wong

Derek Chow

Nasir Rizvi

J. T. Huiett

Michael Wong

Stephany Cover

Victor Rodriguez

McKinley Jones

Assitan Zango

Carlyn DeLeon

Irena Lea Roodal

Yvonne Larrequi

Hector Rosa

Sherwin Lewis

Sam Li

16

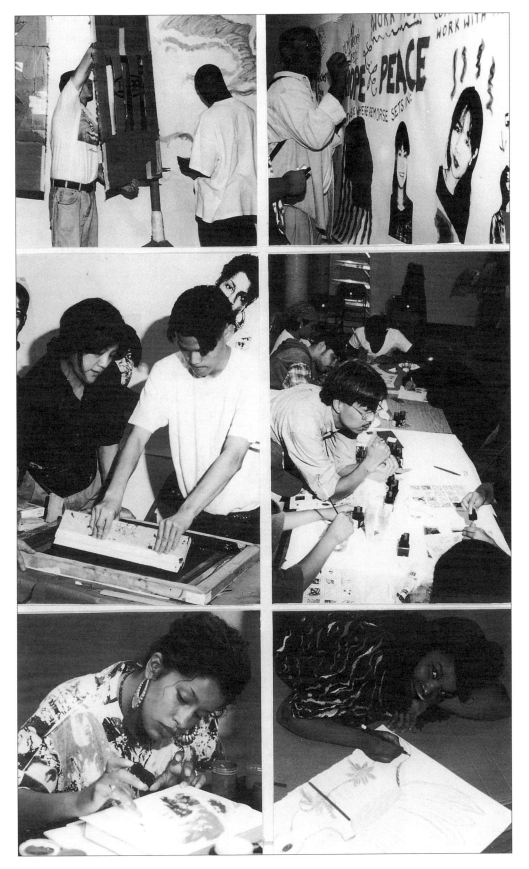

Project Reach
participants during
the workshops

AS PART OF ART IN GENERAL'S community-based education program, artists Tomie Arai, Bing Lee, and Gloria Williams led a series of art-making workshops in collaboration with Project Reach, a community-based youth crisis counseling, advocacy and organizing center.

During the sessions, which took place during the summer of 1993, the participants experimented with collage using images and words, line drawings, pastel, tempera, painting, sculpture, silkscreen, and hand-colored slide projects. The ensuing work, which dealt with issues of identity and cultural heritage, was installed by the young people in the fourth-floor gallery.

Additional workshops, including painting, writing and poetry groups, were led by Faye Chan, June Yang, and Adriana Romo as part of the project.

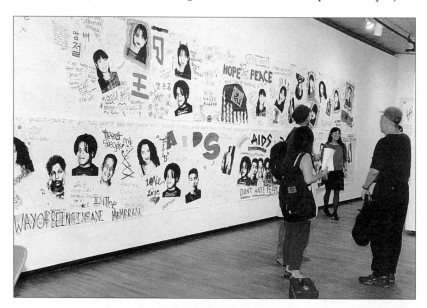

Installation view, collaborative mural

Project Reach members in front of Art in General on exhibition opening night

A Content Child

I stand 5'7"
A black Jamaican
16 years of age
A certain sound or smell
takes me back to times
when I had to walk barefoot to school
a slice of bread and bush tea for breakfast
lunch if I was fortunate enough.
I always loved dinnertime, although dinner
was served sometime around midnight
or never.
Sundays, however, was my favorite day
for on Sundays breakfast would be large,
after bath in the washing pan
it was time for boiled green bananas
with salt fish with okra and hot cocoa
with my belly full it was time for church
a mile away.
Dinner, rice and peas, freshly killed chicken,
salads and carrot juice, it was glorious
until the next morning green and white uniform
a slice of bread with bush tea and off
to school I go, hair braided, face shine, hands
with half-notebook, half-pencil. But clean.
A content child.

CHARMAINE FRANCIS, 16

How I feel about males

I don't want you to be bigger than me.
Rough hard hands
grab and pull
slapping smooth skin
blood, bruises, blacks and blues.

RONAH HARRIS, 16

You've captured me again

Once more I am your prisoner
Do you feel any sorrow or remorse?
I'm drowning in your ocean of lights.

I have nowhere to run
I have no way to save myself
The water is too high
I need you to save me

Oh, the rage I feel toward you!
How could you leave me here,
forever in this dreadful memory.

Those big blue bulbs have blinded me.
Are you satisfied with your photograph?
the harshness of your lens has captured my soul.

RONAH HARRIS, 16

Reality

Being stuck in one corner, nowhere to run
nowhere to hide, you face the reality but
the reality dont want to face you...

Others who know you, ignore you
people walk by you just give you
cold shoulders. Why? You asked why?
to yourself, but there's no answer
to be said...

You asked yourself, why? Is it because
I have AIDS? Or is it just me that they
don't want to look at because I'm gay...

Having an urge of committing suicide, but
you notice that this is not the solution
but you asked again What is the solution?

How could I get them to stop being racist?
How could I get them to like me and dont
criticize me for what I am, and not what I
do have inside of me?

Why does it have to hurt so much being in
one corner? With no one to love you...

CATHERINE GONZALES, 20

REMEMBER YUGOSLAVIA

OCTOBER 9–NOVEMBER 13, 1993

Sixth Floor

Marina Abramović

Zoran Belić Weiss

Vesna Golubović

Vlasta Volcano Mikić

Vesna Todorović Miksić

Vladimir Radojičić

Raša Todosijević

Andrev Veljković

Victoria Vesna

Maja Zrnić

The tragedy and confusion pertaining to the outrageous intensity of conflicts, devastation, manipulation and the very fact that the people, the land, villages, and cities of the entire country are being destroyed in front of our eyes, are hardly bearable. Lack of cultural identity, anxiety, pain, and distrust have become a part of our everyday lives. Therefore we, artists from the former Yugoslavia, have decided to be in a long–term art project, so that we may speak out and share our feelings with the American people.—Andrev Veljković.

"REMEMBER YUGOSLAVIA" is a complex ensemble of events organized around the gallery exhibition of the same name, and a series of video screenings, poetry readings, concerts, and performances.

Upon entering the gallery, the viewer first encounters the collaborative work *Remember Yugoslavia/Dedication Piece* in which, in an evocation of the iconic gold of Byzantine culture, the names of renowned Yugoslavs—from Macedonian revolutionary Goce Delčev to tennis champion Monica Seleš—are simply written with black acrylic on a faux-antique gold surface painted on the gallery wall. This memorializing of the dead and the living, united not by time or endeavor but only by the circumstance of an eroding nation, symbolizes the artists' mourning for the disintegration of their former homeland. This work, and the goal of the exhibition as a whole, was to explode the polemics of internal and national politics, and to focus on recognition of the losses the war has imposed on all its citizens.

In his essay, "A Thousand Words for Peace" (distributed during the exhibition), Raša Todosijević writes, "The general confusion is compounded by the fact that those killing one another are people who have a common origin, who speak the same or similar language, and consider themselves part of the same Southern Slav group of peoples." The ten

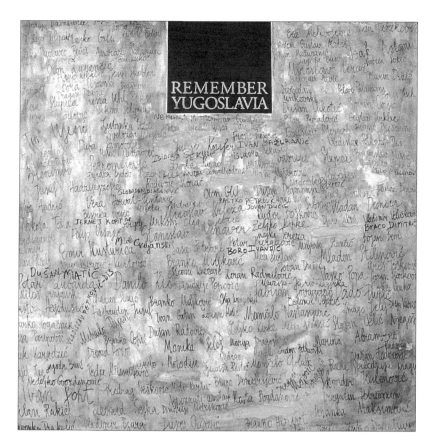

Collaborative work. **REMEMBER YUGOSLAVIA/ DEDICATION PIECE**. 1993. Black and gold acrylic, china markers, charcoal, and chalk on gallery wall, 96 x 96"

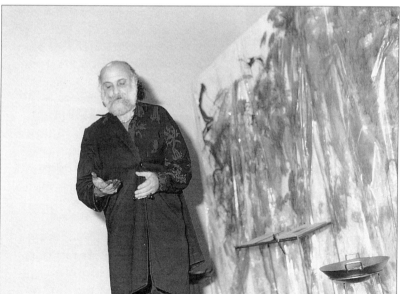

Ira Cohen, during a reading of his poetry at Art in General, enacts a ritual suggested by the installation **REMEMBER BROTHERS AND SISTERS IN ARMS/ REMEMBER YUGOSLAVIA**, by Weiss, Radojičić, and Veljković (shown at right), in which Cohen, rinsing his hands in bowls of dripping "blood," smears his hair with it, while asking through his poem, "Why not kill last year's wedding guests?"

Yugoslav artists of "Remember Yugoslavia," in transforming the gallery into a memorial, intended to transcend the simple ethnic and religious distinctions usually presented on the media to the American people, and to communicate the complexity of their emotional responses to the disintegration of a nation.

drought. Epidemic. The astronauts photographed a huge storm, Cyclone Litanne, in the Indian Ocean yesterday...

VLADIMIR RADOJIČIĆ Searching for an excellent and intelligent gentleman from a fine home, who will, in these revolutionary times, die under my name. Money is no object. Will pay cash. Inquire every night 12PM–1AM Tel. (212) 995 0884.

RAŠA TODOSIJEVIĆ Adam Béláne, brother of Shirley Béláne, starting on a long, uncertain journey, asked his good friend to take care of his crocodile. After several years of trials and self-denial, a crocodile in the house became unbearable. One night, during their usual walk, Béláne's friend threw the animal down the drain. Moral: never trust an art critic!

ANDREV VELJKOVIĆ In art, my obsession lies within a genuine reaction to everyday life, events, experiences, and with a big concern for concept, form, and fact-of-the-matter materials. Challenging the authority, and political, social and cultural hypocrisy is now my nightmare.

VICTORIA VESNA I was trained as a painter, and still view the world as one, but I am now using electronic tools to explore the vast unexplored territory of cyberspace. I believe in collaborative worldwide networking of creative energy between artists.

MAJA ZRNIĆ We must love. Not only people from the same ethnic or social background as us—this is essentially loving ourselves—but we must learn to love people from the other side, who are different from ourselves. Only then do we really love. This is the message of Christ.

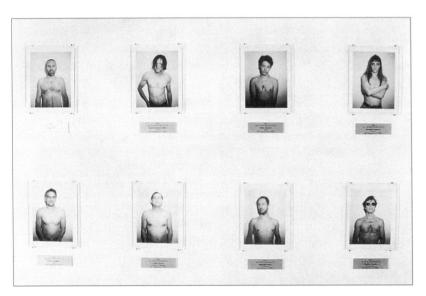

Above: Vladimir Radojičić. **THE ALIENS** (detail). 1992–94. Black-and-white Polaroid portraits of Yugoslav expatriates, labeled with ID number, name, occupation, and departure date. The subjects, men and women from all walks of life, are shirtless, gaunt, and unsmiling. While they suggest a prisoners' line up, they also raise the awareness of a once stable identity, now opened to flux in the midst of political passion

MARINA ABRAMOVIĆ More and more of less and less.

ZORAN BELIĆ WEISS ...And that is how they became part of the history of being on the margin which is (so appropriately) blank, disorganized, something that surrounds and enters the main text via lines of absence and nonsense...and enables secret, non-published messages to appear in someone's mind...through effigies...from within.

VESNA GOLUBOVIĆ My work is an attempt to show the invisible in its abstract, visible form.

VLASTA VOLCANO MIKIĆ Only unity saves the Serb.

VESNA TODOROVIĆ MIKSIĆ The artist is a chronicler: ongoing war in our country that no longer exists, conflicts among our families in North America and elsewhere. Spiritual famine. Financial

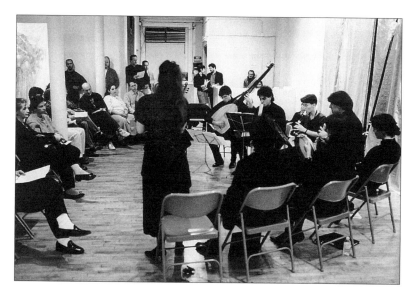

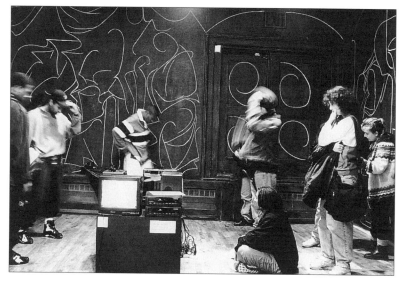

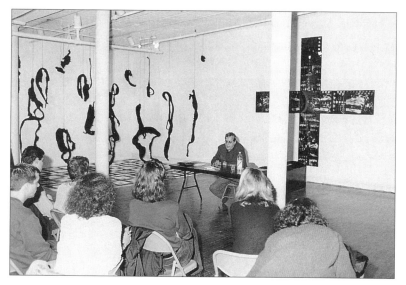

Top: North and South American musicians joined with their Yugoslav counterparts to play Balkan music of the Renaissance

Center: Marina Abramović's video installation, **ART MEETS SCIENCE AND SPIRITUALITY**, a videotape structured around a 1990 panel discussion of the same name explores ideas emerging from the continued shift towards a global culture. Abramović urges viewers to look at themselves as embedded within a system transcending individual persons and nations. On walls: Vesna Golubović's acrylic and chalk mural **PRAYER**

Bottom: American-Yugoslav Pulitzer Prize Winner, Charles Simic, reading his poetry at Art in General, October 20, 1993. On the left, Vlasta Volcano Mikić's **SIGNS ALONG THE ROAD**, scorched rubber tires dangled over a charcoal-engraved floor of Orthodox crucifixes. On the right, Victoria Vesna's **IN ORDER TO SHINE YOU'VE GOT TO BURN**. Installation with a monitor inlaid in a child's coffin in front of a cruciform collage

CASBAH PAINTINGS

Charles Yuen

Fourth Floor

IN THE PAINTINGS OF CHARLES YUEN rising smoke becomes a sac of fluid, protrusions are orifices, and the concept of an invaginated space is made real in reversal: what looks like an object is in fact a container, a vessel for secrets.

What kind of secrets? My own curiosity leads me to ask about the identity of the figures in the paintings. Who, or perhaps, what are they? Man or woman? I wonder about the maker of these works as the paintings ooze with a nascent sexual identity that clearly is not clear. There is also a vaguely innocent Orientalist feel—Matisse in Morocco maybe—that suggests a secret desire to be complicit with, rather than critical of, that practice. The depth of the paintings is flattened. Coupled with the paintings' lush coloration, the flattened depth reveals a decorative impulse that is on the verge, almost, of taking over the paintings.

The figure appears in many guises, similar yet slightly different in each incarnation. A small shaven head hovers disembodied or upon sleek smooth shoulders under a body without bodily definition. Appendages are elongated. Arms are without elbows. Legs without knees end in delicate points that remind us of the bound feet of women in nineteenth-century photographs of Chinese brothels. Sometimes the hands take on the forms of a contortionist, or adopt the mudhralike positions of Buddhist iconography. In one painting the figure, under an

YOU WERE SAYING. 1992. Oil on canvas, 42 x 108½". Collection the artist

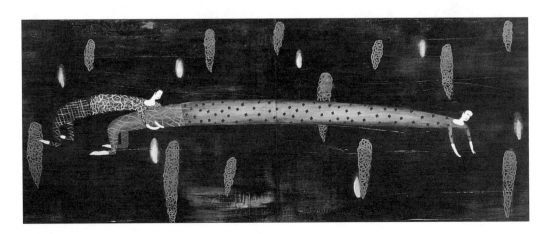

umbrella, sits upon a patterned Oriental rug covered with smoking lamps and golden slippers. A pasha? A young Arabian prince? In other paintings, vessels have intricate carvings and painted decoration. The garments take on the deep hues of woven silk with the layering of different cloths.

The figures in these paintings have the passivity of one that is acted upon, as if they are themselves vessels of another being. There is a serenity and acceptance in their essence that suggests an entity given over, entirely, to the forces that direct it.

It has been suggested that to be a male of Asian descent in a Western world is to be emasculated. Asian men are portrayed as meek, impotent, childlike, and quiet in contrast to the Western-defined prototypes emphasizing stand-up machismo and hunky heroes. It has also been said that for males of Asian descent, carving out a sexual identity in the model of Western masculinity merely reinforces Asian, and hence their own, invisibility.

ALI BABA. 1991. Oil on canvas, 70 x 54". Collection the artist

Charles Yuen's paintings are filled with lush details and suggestive locales that remind us of the Western conceptions of the Orient as a rich and otherworldly source of the exotic. In constructing an identity for the maker and the viewer, his paintings begin to do something different and something taboo. The paintings take pleasure in the aspects of the Orient that the Westernized construction serves to emasculate. By reinterpreting the exoticism of the East in a way that is not merely a pastiche or wholesale absorption of it, Yuen creates a highly seductive space that defies the rigid binaries of masculine/feminine, protrusion/orifice, or East/West. His works embody a critique of Orientalist impulses, ultimately, by re-creating them.

KARIN HIGA

CHARLES YUEN Although my materials use a minimum of petrol fuels, they produce invisible pollutants. The process becomes one of damage control.

GOOD AND PLENTY

NOVEMBER 20–DECEMBER 18, 1993

Sixth Floor

Anthony Arnold

Sarah Barnum

Sidney Berger

Valery Daniels

Susanna Dent

Karni Dorell

Elizabeth Ernst

a.k.a. Futai

Matthew B. Geller

Elizabeth Gemperlein

Kenneth Sean Golden

Dennison W. Griffith

Baiyou Han

Eric Heist

Amy Hill

Marta Jaremko

Leslie Kippen

Taylor Lee

George Littlechild

Margaret McCann

Ellen Mac Donald

Norma Markley

Denise Mumm

Heather Nicol

Sang-Kyoon Noh

Thor Rinden

Barbara Sandler

Stashu Smaka

Allan de Souza

Jeremy Spear

Masako Takahashi

Mary Ting

Suzanne Williamson

Tina Yagjian

"GOOD AND PLENTY" is Art in General's second salon exhibition. The Salon, founded in the seventeenth century, was the name given to the exhibitions of members of the French Royal Academy of Painting and Sculpture. Its creation coincided with the birth of the academies and other organs of the newly emergent power of the centralized state. The Salon was the archetype of officially sanctioned art, validating certain artists and styles with the authority of the state. Its jurors believed they were creating a national culture: a singular set of styles and codes that would unite the various parts of the nation by means of expression that could be considered uniquely French. The Salon is most famous today for the works that were not selected for exhibition, notably in the 1863 Salon, when paintings by Edouard Manet, Paul Cézanne, and Camille Pissarro were all rejected. This led to the creation of the Salon des Refusés, organized around works not included in the official Salons. Subsequently, the Salons des Refusés were organized specifically in opposition to the official style—starting the long historical process of art resisting state authority—and a direct cause of the emergence of a coherent notion of an avant-garde. "The public, no longer dominated by the *salon*, gradually came to realize that there existed a small group of people thinking and living and creating beyond the pale of ordinary behavior." [1]

Art in General's Salon is organized to be the exact opposite of its French antecedent. Rather than attempting to define an official style, "Good and Plenty" is determinedly unthematic. Selected by a committee, each of whose members suggested a number of artists, the exhibition attempts to be a reflection of the art community as it is being experienced by the disparate artists who compose it. The works come in all media (though primarily painting and sculpture), and range from conceptual to object-based, from work that is attempting to engage the latest in critical discourse to work that is consciously rejecting the fashionable in contemporary art. The catchwords of this show are diversity and inclusionism, in terms of race, gender, age, background, style, and media.

Of the painters in the exhibition, a number use photographs as the starting point for their paintings. However, in contrast to Photorealism and other movements that dominated the 1970s and 1980s, these painters,

Opposite:
Installation view

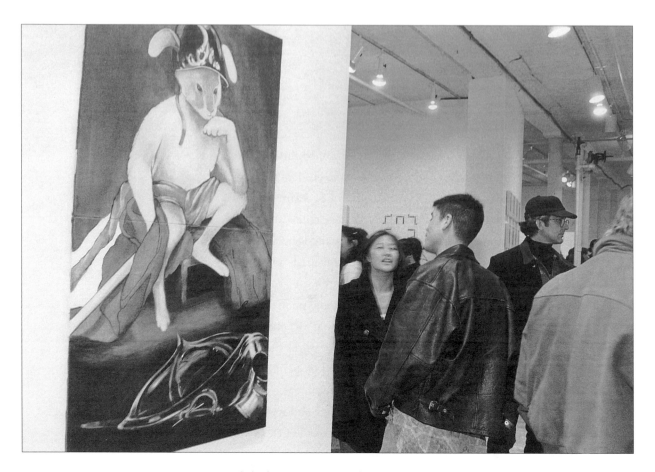

Exhibition opening.
Left: Anthony
Arnold. **MARS.**
1992. Acrylic on
canvas, 64 x 32".
Collection the artist

while deriving imagery from photographs, produce finished work that is far more painterly than Photorealist, the photographs contributing mostly to a sense of frozen time. Other painters in the show break with tradition not by their unconventional starting point but through the use of material not normally associated with painting. Still others work in a determinedly traditional style to investigate a range of modern problems, from child abuse, to the battering of women, to the feeling of insignificance of the individual in a world that has become divorced from human considerations.

The sculptors are equally diverse, with a number whose work is consistent with the second generation of feminist critique. While the feminist artists of the 1970s and early 1980s such as Hannah Wilke and Carolee Schneemann used their own bodies, either through photography or performance, to disrupt the representation of an idealized body, these artists perform a similar function, not by representing the body but instead by representing its absence. Several artists have created hybrid constructions, which are the formal descendants of Robert Rauschenberg's constructions of the 1950s and 1960s. These works continue to blur the distinct formal categories of modernism, for an era more concerned with the travails of everyday life than the heroism of aesthetic perfection.

ANTHONY ARNOLD My recent work: loss, change, hubris, transformation/metamorphosis— a visual theater of the imagination, and a response to our fragmented culture and the discontinuity and paradox of contemporary life.

SARAH BARNUM Have you ever been seining? You and a friend walk a wide fishing net, strung between two poles, out from the beach till the water is waist deep, then you turn the seine, head back for the shore, and see what you've caught. My recent paintings are a merging of daydreams and night dreams.

SIDNEY BERGER I have always found it helpful to keep in mind that all is interwoven and connected in ways that are not always apparent, and that illusions keep us interested.

VALERY DANIELS My art making is a continuous peripatetic activity, the essence of which is a desire to make personal order from cultural chaos.

SUSANNA DENT To put together parts where I felt like I could exist just for a moment, I feel on fragile ground, lost and tenderly found.

KARNI DORELL Having been raised between places, culturally and nationally, I am trying to keep my head above water in the rising tide of marginality. Apparently, I am succeeding in it.

A.K.A. FUTAI I'm investigating the way water travels: Rain flows into the river, the river flows through the fish. You eat the fish and it flows through you. You pee and it flows into the ocean, which evaporates into the sky. Rain flows into the river, which flows behind my house and out of New York faucets.

MATTHEW B. GELLER Doubtless, here a context-sensitive declaration would be a story without a plot and without a central crisis. Moreover, it would be almost devoid of bilinear methodology. It could contain metaphors.

ELIZABETH GEMPERLEIN My recent paintings deal with the paradoxical role of the symbols of religion and images of the feminine.

KENNETH SEAN GOLDEN My recent work explores the metaphor of body as home, and addresses the physical in a dialogue with something other than physical. Fingerprints reference the body as unique identifiers. They are a personal mark as well as a universal reading.

DENNISON W. GRIFFITH I make paintings and small encaustic-covered wall sculptures. The nexus of photography, cinema, and portraiture are the subjects of my paintings.

BAIYOU HAN My main objective of historic fictionism is to search for the abstract in true events. This sphere of interest is very close to that of naturalism.

ERIC HEIST My work addresses issues of individual connectedness/alienation from the viewpoint of a male critical of myths about freedom and escape. I play with the idea of ego disappearance while acting as a medium for others to speak through.

AMY HILL Now that photographers have total control over their medium, our level of skepticism has been raised to the n*th* degree. We have to fine-tune our vision or miss out on everything.

MARTA JAREMKO My work deals with the ambivalence of motherhood. At the same time, I am also indirectly commenting on the prevalence of child abuse cases in the media, and their indictment of our affluent but indifferent-to-children society.

TAYLOR LEE When I paint it is like going on a journey. I paint from memory and imagination, creating a world that is both familiar and strange.

GEORGE LITTLECHILD "The 7th generation awakens."

MARGARET McCANN My images are somewhat ironic meditations on the futile struggle of the self to assume the size of its possibilities against the limitations of time and space.

ELLEN MAC DONALD
My work is autobiographical and political. I have recently been questioning the role of the artist as victim and/or perpetrator in society and in art history.

NORMA MARKLEY My large paintings are abstractions of a physical dimension—TIME; my small paintings/sculptures are abstractions of a feeling—PAIN; my drawings are abstractions of the line of a WORD + the line of an IMAGE.

DENISE MUMM My fiberglass sculptures are mythic abstractions derived from female symbols of power and divinity. The colors, texture, and construction methods are drawn from my background in the textile arts.

HEATHER NICOL
Dresses... concealing and revealing/presentation/desire to be chosen/the belle of the ball/fear of falling from grace/being the last one picked/seduction/peeking up skirts/calling attention/shop windows/fabric of dresses/fabric of proms/weddings/rituals.

SANG-KYOON NOH The time consumed and patience required by the process of gluing sequins on canvas must be one of my utmost artistic struggles in order to overcome this inevitable solitude and sadness of human life.

THOR RINDEN
Slabism Manifesto
O, slab, O resistant prism,
you are my palette and my "ism,"
you and gesso and paint expresso,
upon your face my manifesto.

BARBARA SANDLER
I currently work on small portraits of men in a curious state of being: they look as though they have been stripped bare of their self-protective outer layer, revealing the skeletal underpinnings of odd anatomical, futuristic animals.

STASHU SMAKA
Consciousness is like space
Everything is mental
Everything is transient.

ALLAN DE SOUZA White word on black ground. "...now we have the Bible and they have the land." My work explores the clash and repercussions of the two.

JEREMY SPEAR Lower Manhattan has provided me with printed fabric, Plexiglas, electrical supplies, and other industrial products to incorporate into my paintings. The application of these materials bridges a formal gap from daily life to the meditative and optical construct of painting.

MASAKO TAKAHASHI
My recent still lifes deal with the dynamics of merit versus grace, free will versus fate....Dolls, games of chance, or games of skill, and folk toys from all over seem to embody these ideas.

MARY TING I create organic forms that are contorted, wrapped up, or hunched over to convey feelings of isolation, internalized emotions, and silent cries of anguish. My work is fueled by my family's cultural conflicts, internal struggles, and isolation.

SUZANNE WILLIAMSON My mixed-media pieces of animals on the farm explore their use as symbols of our nostalgia for the "natural" world. I also apply photographic images, paint, and stains onto old clothes to connect the animal images with the domestic roles of women.

TINA YAGJIAN I manipulate film stills or film photographs to alter their appearances. Fragments of image and narrative appear and recede unevenly in a strange and elusive context, like memory that is continually re-formed in time and can't be completely recalled or understood.

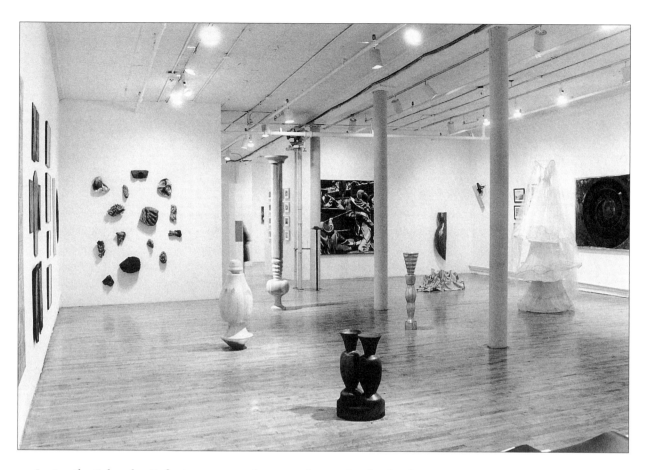

Installation view

Just as the Salon des Refusés was created to meet the needs of artists in nineteenth century France, Art in General's salons are a response to the realities of the art world of the 1990s. In the late 1980s, art funding in New York State was cut by over 50 percent, at the same time the National Endowment for the Arts was sustaining sharp cuts. These funding cuts have caused many spaces to close or to curtail their programming. Other spaces have decided to focus on the work of better-known artists in the hope of securing foundation support. For these reasons, the opportunities for emerging or under-recognized artists to show their work, especially in New York, have decreased dramatically. Unthematic salons such as "Good and Plenty" allow a large number of artists to showcase their work to a new audience.

ANDREW PERCHUCK

1. Roger Shattuck, *The Banquet Years*, New York: Random House, 1955, p. 25.

POTATOES, TEDDY BEARS, LIPSTICKS, AND MAO

NOVEMBER 20–DECEMBER 18, 1993 Fourth Floor

Michelle Charles

Gail Goldsmith

Stacy Greene

Zhang Hongtu

THIS FOUR-PERSON EXHIBITION features bodies of work in which a singular, iconic image or motif is invoked again and again. Rather than locate content within one object in isolation, these artists rely on the interplay between like forms and the dynamic of repetition. Unlike Minimalist or Pop tendencies, however, which embraced the mass-produced and the technologistic, these photographs, sculptures, and mixed-media constructions retain the haptic, are modest in scale, privilege the personal, and highlight subtle disruptions and variations to the organizing rubric.

Michelle Charles's *Potato Books* is made up of twenty-one accordion-style books, unfolded and hung vertically in a rectangular, gridlike configuration, with each book mounted from the top and hanging freely in strips. On each "page" of each book is a charcoal drawing of a potato, soberly rendered with an attention to naturalistic detail. Upon closer inspection, one notices that each potato is slightly different in size, in location, and in finish. Charles invites metaphorical associations between, for example, painterly processes and organic phenomena, between the surface and texture of the picture plane and peels and skin. In fact, the colors of the paper and subtleties of the glaze mimic the actual colors of potatoes. Stepping back again, one is taken in by the simultaneity in presentation and the intimacy of scale and sequential experience suggested by the book form, which gives way to a larger narrative of accumulation and preservation but not necessarily to taxonomic structures. In this work, the humble vegetable (and perhaps as an extension, the

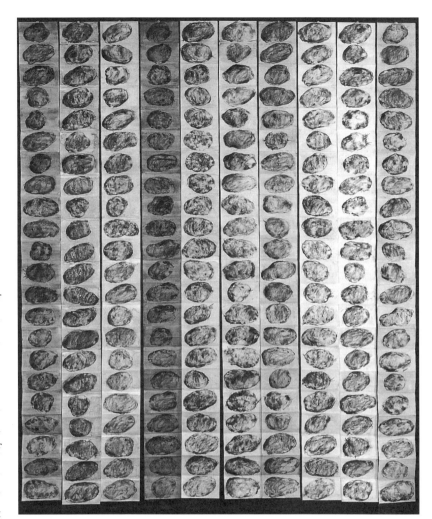

familiar and mundane aspects of the natural world) is unexpectedly accorded a place of honor, and preserved without hierarchy, fanfare, or sentimentality.

Gail Goldsmith's dirt-brown clay teddy bears are posed upon white pedestals in varying states of recline and neglect, but do not, however, recall the fun and mischief of childhood. Under bright lights, these creatures seem awkward, decontextualized, forlorn little ruins. Molded faithfully from life, the bears reference well-worn toys from the artist's own life. The surfaces are combed and scratched, suggesting traces of the hand, and the cuteness (the bears are often detailed with ribbons and bows) is offset by a heaviness that is both literal and figurative. In this work, Goldsmith self-consciously locates art making as a therapeutic endeavor, and anachronistically "revives" these objects of sentimental value to her. But what were once cheerful and comforting presences are now emblematic of loss and nostalgia. Perhaps they are also symptomatic of a longing for impossible reconciliations.

Stacy Greene's Cibachromes of used lipsticks command an imposing presence within the gallery space. Against a cold gray background, each phallicized lipstick is magnified to a disconcerting scale that enables us to see more of these artifacts of feminine ritual than what we might at first be comfortable with. Greene is interested in the toll taken by the lipsticks as they become personalized. She privileges the smeared, the twisted, and

Michelle Charles. **POTATO BOOKS.** 1992–93. Charcoal with glaze on foldout books, 22 books, each 83 x 6", overall 83 x 60". Collection the artist

Opposite: Gail Goldsmith. **LITTLE SISTER BEAR.** 1990. Clay, 16 x 16 1/2 x 14". Collection the artist

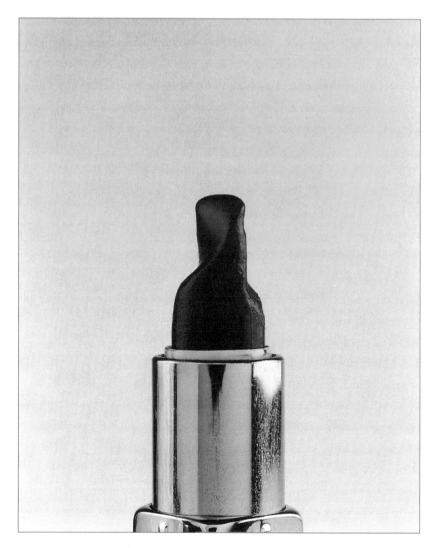

MICHELLE CHARLES
I have recently added milk to my subject matter: bottles being siphoned from one to the other. I am interested in the connection and flow that exist between things, the idea of full and empty, and the nourishing quality of this liquid.

GAIL GOLDSMITH How to be an artist: Play around, start with child's play. Get serious! Start being serious. Lighten up! Pick up whatever comes to hand, the old or the discards. Throw that junk away—clay is beautiful.

STACY GREENE My first concern with *Lipsticks* was the abstraction and mystery of the object. I saw everyday "ready-made" turned into a surreal, biomorphic, subconscious image— a sculpture evolving from a private daily ritual. In *Lipsticks* personal object/process reveals through color and shapes a relationship of imprint at the periphery of the body.

ZHANG HONGTU If you stare at a red shape for a long time, when you turn away, you will see a green image of the same shape. In the same way, when I lived in China, I saw a positive image of Mao so many times that now my mind holds a negative image of Mao. In my art I am transferring this psychological feeling to a physical object.

otherwise sullied traces of use. The harsh lighting and the matter-of-fact, even clinical, presentation works in pointed contrast to the slick advertising page, where cosmetics and the models who wear them are airbrushed to perfection. A pristine tube of lipstick that might appear moist and inviting on the fashion spread looks messy, greasy, perhaps even threatening here. In these portraits of her women friends, Greene conspicuously avoids objectifying representations of women—the female body itself is only alluded to as indexical traces of lips. But neither does she vilify the beauty industry. Greene points more to ambivalences, through an examination of how gendered materials are actually used, and what that might reveal about constructions of the feminine.

There is potentially no end to Zhang Hongtu's *Material Mao* series. Within a variety of different materials serving as a ground (burlap, stone, animal hide, corn…), the hollowed-out silhouette of Mao Zedong is a constant presence/absence. These works were constructed in direct response

to the visual (and ideological) conditioning Zhang experienced as someone who came of age during the Cultural Revolution in China, where the smiling, paternal images of Mao were ubiquitous. At turns banal, humorous, fanciful, and obsessive, these assemblages recall the afterimage, the optical phenomenon, where, after staring at something for a prolonged time, its ghost image appears everywhere else one looks. In another portion of the installation, an uncanny incarnation of Mao as a Quaker suggests that the deployment of images to serve consumerist values and certain political ideologies at the expense of others is not only endemic to China. In contrast to Warholian celebrations and veneration of mass-mediated icons, Zhang encourages a healthy distrust of the authority of icons, through a backhanded acknowledgment and insight into how we succumb to their power.

In repeating a singular motif, these artists do not seem to be motivated by a corrective impulse (i.e., "keep doing it until you get it right"). Rather, they share an interest in the use of images that can function intertextually. It is through this play of the serial and the unique that their divergent sensibilities and themes are articulated.

SOWON KWON

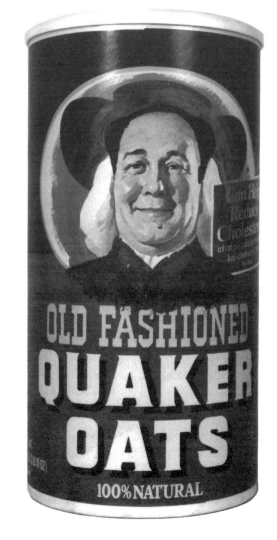

Opposite: Stacy Greene. **ELLEN.** 1993. Color photograph, 20 x 24". Collection the artist

Right: Zhang Hongtu. **LONG LIVE CHAIRMAN MAO** (detail). 1990. Acrylic on Quaker Oats box, thirty boxes, each 9 3/4 x 5 1/4". Collection the artist

GATHERING MEDICINE

JANUARY 15–MARCH 5, 1994

Sixth Floor

IF GIVEN THIS TOPIC, *gathering medicine,* I would present a piece that would allude to the syncretism of the three cultures that most inform my life. I was raised in a family where we were loathe to take an aspirin if a tea made of a bay leaf, manzanilla, or limoncillo would do the trick. We would not reach out for a tube of Ben-Gay or "over-the-counter" liniment if a soak in a tubful of water laced with yerba buena and menta would soothe our aches. That does not mean that we would forego our regular visits to the "family physician" for shots or treatments or serious childhood diseases, but for most discomforts the remedy was one that could be prepared at home with the use of herbs. There were times, however, when neither the natural herbal treatment nor the allopathic method of treating disease provided relief. In those cases a spiritual imbalance was suspected, and the solution would be to turn to *santeria*. It never occurred to me that this was not the way everyone else handled their maladies. All of these methods were valid to me. They were an integral part of my existence, and, most importantly, they all worked. For years I have exhorted myself to sit down with my mother and find out what

Left to right: Donna Thompson, Carole Byard, Maria Elena González, Beverly R. Singer, Regina Araujo Corritore, and Rejin Leys at the exhibition opening. "Some of the work is angry and unforgiving; some of it is conciliatory and bighearted. All of it is meant to heal: ourselves, each other, our nation, the world."
—The organizers

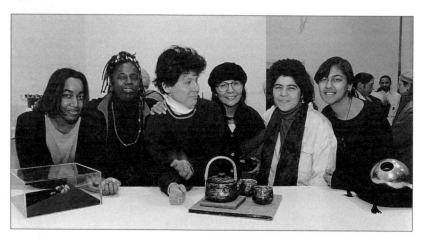

Nadema Agard

Karen Lee Akamine

Manuela Aponte

Tomie Arai

Mildred Beltré

Kabuya Patricia Bowens

Brenda Branch

Angela-Nailah E. Brathwaite

Joy Dai Buell

Dina Bursztyn

Carole Byard

Yvonne Pickering Carter

Vladimir-Cybil Charlier

Martha Chavez

Polly Chu and Diane Suzuki

Regina Araujo Corritore

Esperanza Cortés

Erika Cosby

Joan Criswell

Adriene Cruz

Pura Cruz

Maricela Cuadros

Maria M. Dominguez

Sheila Eliazer

Teresita Fernández

Ana Ferrer

Maria Teresa Giancoli

Maria Elena González

Wilda Gonzalez

Karen Elise Goulet

Teresa Harris

Miriam Hernández

Linda Hiwot

Robin Holder

Anita Miranda Holguin

Safiya Henderson Holmes

Arianne King-Comer

Kumi Korf

Anna Kuo

Lanie Lee

Dori Lemeh

Charlotte Lewis

Rejin Leys

Soraya Marcano

Malpina Mark-Chan

Gloria Maya

Iris Maynard

Valerie Maynard

Liliana Mejia

Raquelín Mendieta

Rosalyn Mesquita

Damali Miller

Maryln Mori

Annie Nash

Selime Okuyan

Gloria Patton

Selena Whitefeather Pérsico

Emma Piñeiro

Lillian Pitt

Liliana Porter

Helen Evans Ramsaran

Sophie Rivera

Janice Sakai

Cheryl Ann Shackelton-Hawkins

Yolanda R. Sharpe

Beverly R. Singer

Deborah Singletary

Clarissa Sligh

Yumiko Ito Smith

Gilda Snowden

Elaine Soto

HollyAnna Spino

Masako Takahashi

Barbara Takenaga

Donna Thompson

Mary Ting

Mimi Chen Ting

Ana Tiscornia

Charzette Torrence

Gail Tremblay

Gladys Triana

Linda Vallejo

Gelsy Verna

Betty Phoenix Wan

Carolyn Warfield

Bisa Washington

Gina T. A. Washington

Shirley Woodson

Mónica Yoguel

NADEMA AGARD My work is inspired by images and cosmologies from Native American traditions. The devotional pieces are made in reverence to the Earth Mother, Father Sky, Grandmother Moon, Corn Mother, and all creative and regenerative forces of the universe.

KAREN LEE AKAMINE I create objects, environments, words, and images to remind myself and others who we really are.

MANUELA APONTE In my work I try to bring into the present ancient forces of the universe sometimes known as gods, or as a healing form of therapy for humanity. Being a tropical Caribbean, those are the forces I represent.

TOMIE ARAI I explore the relationship between art and history, and the role played by memory in the retelling of a collective past. I use autobiographical and historical material to create works on paper—pages of living history that help me to establish a personal sense of place and community.

MILDRED BELTRÉ Quick thought, long thought Mixtures and in betweens.

works. I am still amazed that a few slices of potato placed on a windowsill and allowed to be kissed by moonlight suddenly hold a new energy and power to heal. I have always looked for some pragmatic, scientific solution to my questions. Yet, over the years I have found that the answers are not always found in measurable scientific ways.

Today traditional medicine, wherever it is practiced, is often associated by the governing power with ignorance. Current economic structures have created an environment of dependence on nonindigenous products. It is a shame that this has happened, since it continues to devalue the validity of our elders' wisdom. Also it has taken away the communal importance and, in some cases, the economic viability of women, since they were the ones who gathered and still gather the products used as medicine. Women are the ones who have the knowledge of healing. Furthermore, the skepticism of many has taken us farther from our connection with our natural surroundings, making us less sensitive to the damage that can be visited upon the world around us. This distancing is dangerous for all of us.

The bringing together of works by women who are addressing the many wounds in our society that need to be healed is an empowering act. I am impressed by the variety of material, both natural and machine-made, used to create works that have personal, social, and political connotations. A number of the pieces are quite abstract—some striving for a semblance of unity and perfection. Others by their fierce appearance seem to have the power to exorcise the various "demons" that the individual artist has focused upon. In the representational pieces, the specific concerns of the artist are clearly and unmistakably visible and understandable.

Excerpt from **SONIA L. LOPEZ** *'s essay for "Gathering Medicine"*

CREATION. NATION. VIOLATION. Five hundred years of lands etched with strangers' names and nightmares filled with barbed wire. To be a people without country, without even memory.

To look into a mirror is to see the shards of another woman's face, her darker skin, her peaceful eyes, and to imagine the Franciscan priest, the American soldier, Columbus, the horny tourist who took her peace from her. Or the white college girl with a backpack who buys her birthstone for a buck. To see her reflected in our mirrors in the first place is a revolution. We come from a lineage without memory. Since time immemorial, our families have eulogized the Spanish (from Spain, mind you)— English/French/White blood in our veins, touting photographs and made-

ANGELA-NAILAH E. BRATHWAITE In order to heal the body one must first heal the spirit. A piece of jewelry is a thing of beauty and can be a healing object bringing both pleasure and balance.

JOY DAI BUELL An archeologist of the present, I scan the abandoned wealth of our/their society in constant amazement. Objects strewn from a passing car, detritus found on walks—all find their way into my work to be refound, refined, reborn in time.

CAROLE BYARD At this moment, this very moment, I am trying to be my very best. Trying to stay in the glow. To create something close to me, old/new, here/there, Poem/NO WORDS.

SUZANA CABAÑAS Plug into the sun, get high on the moon, meditate upon the star. Open the eye of the inner eye of the inner mind of the heart. Learn to see, learn to see, learn to see.

YVONNE PICKERING CARTER My work: Three media, three moments, three messages—trinity, trial, treatment. Three movements, three mourners, three muses—transgression, tranquility, treasure.

VLADIMIR-CYBIL CHARLIER My work deals with metaphors and reinscription of myths in our postmodern saga. It is the sing-song of an archaic poem we should feel and not quite understand.

MARTHA CHAVEZ I am a folk-art artist using whimsy as my creative method of expression. I am very pleased to paraphrase what I have heard many times about my work: The eyes of her paintings beg returns and questions.

POLLY CHU AND DIANE SUZUKI ...so she began telling me tales every night. And every night I was so charmed by her tales that I didn't want them to end....

ELVIRA COLORADO When will we have access to the resources that those who study our history have? When will they stop substituting their myths for our stories? Isn't this another form of colonization? It is time to begin the healing of ourselves, our families, communities, and our Mother Earth.

HORTENSIA COLORADO *Communidad yo India salvaje* shame dirty pagan salvation *mestiza* shame Mexican American hot tamale Hispanic Latina labels *secretos* shame *silencio* denial shame *DENIAL NO SOY* dig dig dig retrieve acknowledge HEAL.

REGINA ARAUJO CORRITORE I relate New Mexico to my art in the respect for the landscape, the beauty and economy of the desert, the racial tension in the area, the issues of borders that separate people, and what real gains can be made of the free-trade open borders.

ERIKA COSBY I paint images borrowed from television, film, advertising, and food labels in my pursuit of blatant (and subtle) stereotypes of African Americans' behavior, image, and character. By satirizing these stereotypes, I hope to dispel the implied realism of those images, and eventually diffuse their power to endure.

JOAN CRISWELL I hope, through exploring ice-age paintings and sculptures, to make an artistic connection with prehistoric artists. Inspired by their haunting and rhythmic images, my works are an homage to their endurance with, and respect for, a hostile environment.

Installation view

up anecdotes attesting to our difference, to our unplain nativeness. When I was in the Philippines several years ago, the most popular brand of soap was a bleaching bar. *Get Rid of Your Dirty Skin! Be Crystal White! With Wonder Soap!* And I thought we became a free nation forty years ago. It is about a five-hundred-year-old leash made of concertina wire ending at the steps of Capitol Hill and at our bathroom mirrors. To heal a wound from the skin to the moon takes as much time.

"Gathering Medicine" is a testament to re-memory: past, future, today. It is about sculpting, molding, etching our skins into recollections of our pasts and visions of our futures. It is about survival. It is about carving holes in our souls for space to breathe. It is about creating and re-creating a narrative that says I exist, I am here, I am somebody. It is both beautiful and painful. It is also tiring. Very tiring. We are tired. Of being at war. Of burned-down villages and burned-out projects. Of being underpaid and

unpaid. Of being ignored. Of losing sons, brothers, fathers, lovers to some-
one else's battle. Of sterilization. Of the rolls. Of being alone. Of being
pregnant and ignored on a crowded train. Fuck family values. LISTEN UP.
To heal is not necessarily to make peace. It is not by definition bloodless....
It's about taking our anger and clearing out the mess. What had no right to
be there in the first place. Sweep out the scum. Search and Destroy.

Excerpt from **VEENA CABREROS-SUD**'s essay for "Gathering Medicine"

speak to me so that i may speak to you, by your
voices we recognize each other in the darkness...[1]

THIS IS A STORY ABOUT THE POWER and the possibility and the vision of
the story in the African and, subsequently, the African-American cosmolo-
gy. This is a story—sung, danced, sculpted, painted on our hands and our
canvas or braided in our hair—that gathers us in the arms of our universe.
This is a story that we write and perform and wear. This is a story about cul-
ture. This is a story that goes around and comes around, that remembers us
to ourselves and, in that remembrance shared/communal/call and
response, creates the liminal place where, in our culture, we have "gathered
medicine." This is a story about the place we make and about how, in that
place, we have remembered and found, created and re-created, the force to
make ourselves. This is a story about how, in the continually shifting place
called history, we have survived whole. How we have gathered head and
heart and hand and history and, as the Vodun practitioners would say, we
"make the god." This is a story about the journey of a story and the story of
a journey toward a self, fuck the odds, held whole.

chickama chickama craney crow
went to the well to wash his toe
when he got there
his chicken was gone
what time old witch [2]

In 1692 in Salem, Massachusetts, a black woman, Tituba, was tried and
convicted of the crime of witchcraft. The evidence: her skill with the uses of
healing herbs, her ability with animal husbandry, her way with growing
things in rocky ground and, particularly, her "power" to weave a web of sto-
ries so engaging, so transporting, so transforming that her young white

ADRIENE CRUZ I want to
share the creative spirit that moves
me to feel the magical healing
power of colors, beauty, and
love...through art.

PURA CRUZ I worked for a
dentist who attached himself to the
"sweet air" equipment for hours.
Similarly, a character in *The
Lawnmower Man* is driven to virtu-
al states of mind. Fast forward: a
series on gene altering points to
the new Past, Present, Future.

MARICELA CUADROS In
my work, I balance elements of my
cultural tradition as a Mexican-
American artist. I have also been
challenged to integrate the univer-
salism becoming more evident in
today's world: the beauty of one-
ness, yet its immense diversity.

MARIA M. DOMINGUEZ
Texture is born on my nappy, tight,
curly hair. It layers itself on my
surfaces...too slowly. Excitement is
born on the last layer. This is my
pinnacle of joy!

ANA FERRER A particular
medium or style does not interest
me. I'm more concerned with using
whatever resources are needed to
convey my emotions and ideas.
That's what is important—art as a
personal diary.

MARIA TERESA GIANCOLI I am compelled by the wide open spaces of the wilderness and the ocean. I photograph water, fire (as sunlight), and air in intimate spaces. I record/ recall desire for contemplation in areas of silence punctuated by the mind.

MARIA ELENA GONZÁLEZ I sometimes execute an idea that has been in the back of my mind, other times it is just spontaneous. But however spontaneous there is always a precedence. The important aspect of creating is the realization, the release, and the actualization/ materialization of the idea.

WILDA GONZALEZ Indian (Native American Taino, Carib, etc.) is prevalent in all of our existing cultures. Nature and earth are the blooming flowers that heal and illuminate our dreams.

KAREN ELISE GOULET The delicate place that exists along the edge of human experi-ence is what I seek to articulate. It is the place where the personal transforms into universal. A nod of the head or gesture of the hand saying "I know what you mean" is what completes a work of art for me.

Puritan listeners claim to have been "hexed" by them. Tituba was enslaved. She had been brought to that cold gray Puritan city by a priest who pur-chased her from her native Barbados. She had brought with her the legacy of her African mothers. She brought health and light and nutrition to the dark house of her "masters," and at night, in her dreams, she wove a web of thought to "carry her back" to her homeland. She transported herself through her dreams. She "crafted" the art of gathering herself. That ability kept her alive in this absolutely cold place. When she shared this ability in her "household arts" and in her stories, she was accused of witchcraft and sentenced to be hung.

Excerpt from **GALE JACKSON** *'s essay for "Gathering Medicine"*

1. Bascom, *Ifa Divination,* Bloomington: Indiana University Press, 1969, pp. 14–16.
2. An African-American play song performed as a hiding/counting game recorded as far back as the late nineteenth century. See: Altona Trent-Johns, *Play Songs of the Deep South,* Washington D. C.: The Associated Press, 1994.

KIMIKO HAHN Even before my mother's sudden death, my theme of loss was deepening to include personal and collective symbiosis.

TERESA HARRIS Some may regard my work as empathic, others as a betrayal of ethnic consciousness, but many will experience a thought-provoking emotional response. My subject matter examines the restrictive social and institutional rules placed on individuals in multiracial cultures.

MIRIAM HERNÁNDEZ The courage, indeed, to go on with my work comes from the support I give to and get from other women.

LINDA HIWOT I make love when I paint, always reaching. I have not completely reached yet, but I do know where heaven is. My brush is the vehicle that takes me there.

ROBIN HOLDER My work is motivated by a need to create a wholesome visual statement of integrity, which reflects a life experience of layered realities striving for balance and harmony in a conflicted world.

ANITA MIRANDA HOLGUIN I like discovery, innovation, and change, which is why I work in many media. Through an exploration of ideas in art I find I'm able to expand my self-knowledge, my culture, my heritage, and how this relates to the universality of all mankind.

SAFIYA HENDERSON HOLMES My interest in visual art has always been with me, but the literary arts took over. The encouragement and spirit of artists like Carole Byard and Valerie Maynard have helped me shape my literature visually, to lift the stories/poems from the page.

JIN HI KIM As a composer and komungo (Korean fretted zither) performer, I integrate concepts and aspects of Korean traditional and Western contemporary music. Most of my compositions are multicultural, mixing instruments from around the world. I have created the world's only electric komungo.

ARIANNE KING-COMER My art is my source of meditation. Exploring and manipulating textiles through multimedia is a metamorphosis—forever changing my point of view. I am a butterfly in the universe.

KUMI KORF I have come to realize that I want to regard my unique being in this world through making my art. Autobiographical nature is unavoidable at many levels. I make artist's books, two-dimensional, sometimes sculptural works, using artist-made paper, prints, and found objects.

ANNA KUO To paint is to write Gods.

LANIE LEE I document personal experiences. I create mixed-media boxes and journals that use a central image to set up a narrative. I usually work in series to give different perspectives on the story.

DORI LEMEH My responsibility as an artist is to keep demystifying preconceived ideas and myths about African Americans and women. Though my artwork addresses racism and sexism, it simultaneously serves as positive forms of ethnocultural empowerment and self-affirmation.

CHARLOTTE LEWIS I have sought strength through the awareness of a human spirit, with a legacy that has caused me consciously to reach back and pluck from ancestral origins, expressing balance with nature and the cosmos. I seek righteousness, truth, justice, and harmony. Africa lives!

FORMAT: A HEALING OBJECT; MEDIA: ANY, EXCEPT FOR TOXIC
OR HAZARDOUS MATERIALS; SIZE: NOT TO EXCEED 12 INCHES IN
ANY DIRECTION; WEIGHT: NOT TO EXCEED THREE POUNDS

REJIN LEYS As a cultural activist, I use my image-and-object-making skills to share information in a way that I hope sharpens awareness and promotes action around issues of social justice.

SORAYA MARCANO Through the body, I explore the instinctive nature of contemporary human beings. I have explored themes such as renunciation, atheism, passion, and the infinite theme of sexuality. In my work, woman has been totem, whore, organic form, and a symbol of all humanity.

GLORIA MAYA I walk upon this ancient ground in search of *chamisa*. Perhaps, truth shall approach me. I gather this fragrant, native, ceremonial, healing plant, which my ancestors know with respect, perhaps truth, and whose fiber formulates the pages of my work.

IRIS MAYNARD We all draw symbols every day of our lives to express ideas, computations, history, feelings, etc. Drawing has been part of the human experience from the beginning.

VALERIE MAYNARD Ever since I titled a sculpture *We Are Tied to the Very Beginning,* this has been my path. It has provided my work a connectedness with all that I hold dear.

LILIANA MEJIA My work reflects my life experience and deals with multiculturalism. I use acrylic, oil, pencil, the female figure, and abstractions. I include symbols that represent perfection, life, struggle, etc.

RAQUELÍN MENDIETA My work is a personal healing ritual that addresses individual and universal issues. Although formal concerns are present, it is the process and the experience that involve all of me. I hope this involvement reaches out to the viewer and touches her/his own experience.

ROSALYN MESQUITA A fascination with personages of my family and tracing past and present events are what motivate my art making. Images that bombard my everyday life are also introduced.

DAMALI MILLER I am able to breathe because of this desire to touch through my work this amazing continuous cosmic creation—earth—that inhales and exhales life.

MARYLN MORI I paint vegetables and fruits because I am overwhelmed by their intrinsic beauty in all stages. This solitary process affords me the time to be introspective with self-growth and awareness.

ANNIE NASH Symbols, phrases, lists, poems, and words are layered into my artworks to help viewers understand how I feel about being Indian and having grown up outside tribal society. I also hope my work opens new windows through which the viewer can look at her own life.

SELIME OKUYAN My recent multimedia installations are a representation of the effects of cultural and psychological invasion. I use imagery, symbols, and objects to convey the political, economic, and cultural upheaval in the former Soviet Central Asian region.

GLORIA PATTON The blood that runs through my veins connects me to all in my line that has come before, and all that will follow. If there is such a thing as blood memory, my art is its physical manifestation.

Opposite, from left to right: Helen Evans Ramsaran. **HOUSE OF THE HEALING SPIRIT**. 1993. Bronze, 15 x 12 x 4"; Polly Chu and Diane Suzuki. **TANGIBLE**. 1992. Mixed media book, 10 x 8 x 2 1/2"; Mary Ting. **SHE CARRIED HER WOUNDS IN A BAG**. 1993. Tarlatan, wax, paint, rope, and glue, 9 x 4 x 1"; Emma Piñeiro. **n o NO**. 1993. Mixed media; Ana Ferrer. **UN REMEDIO (BABALU-AYE/ SAN LAZARO)**. 1993. Wood, nails, acrylic, and Xerox, 12 x 12 x 5"; Anita Miranda Holguin. **LOYAL TO MOM**. 1993. Mixed media, 14 x 8 1/2 x 7"; Shirley Woodson. **THE HEALER**. 1993. Canvas, wood, fiber, and metal, 15 x 9 x 3 1/2"; Manuela Aponte. **OBATALA**. 1991. Color photograph, 12 x 12"; Barbara Takenaga. **BLUE BRANCO AND QUEUE**. 1993. Plastic horse, hair, acrylic, and plaster, 12" H; Maria Elena González. **UNTITLED**. 1992. Wood, rawhide, joint compound, graphite, lacquer, and velvet, 9 1/2 x 12 x 16 1/2"; Gilda Snowden. **ALBUM: FETISH FOR NADINE**. 1993. Assemblage with gold leaf, copper, fabric, and encaustic, 11 x 10 x 4"; Liliana Porter. **THE WAY**. 1993. Acrylic and assemblage, 9 x 7"

SELENA WHITEFEATHER PÉRSICO Enthralled by simple interactions, such as the meeting of a grapevine and a branch, I see twigs gesture, tendrils entangled in loving or sometimes strangling embrace, tinted polluted air, encaustic, earth, graphite, a xerographic record, pure pigment.

EMMA PIÑEIRO My works want to capture the search for a better understanding of the human race in a century so complex and so far from inner spiritual growth.

LILLIAN PITT It is a privilege to be in partnership with clay. Together we create images of my Native American cultural history, my people, my friends, and family.

LILIANA PORTER The object, its image, the word that names it, the memory, and the distortion of the memory are all approximations to the concept of things. Reality appears ambiguous, fragmented, and ultimately ungraspable.

LIDIA RAMIREZ As a performer and writer, I use my work to explore and celebrate my roots as a Hispanic woman. I incorporate songs, poems, and monologues. Food, however, is a central image in my work and a metaphor for the Hispanic-Caribbean experience.

HELEN EVANS RAMSARAN I have studied prehistoric and ancient cultures in Mexico, Japan, Europe, and Africa. My recent works deal with spirituality as expressed in ritual, ceremony, and early stages of architecture among peoples of these cultures.

SOPHIE RIVERA I capture images on film or in a line/Seeing life objectively instead of by design/"Art," she says, is not to judge but simply to define.

JANICE SAKAI Making art has come late in my life, unconsciously as part of a personal healing process. But when I think back, I often made gifts that were art (collage boxes, cards, bags) for people I loved. If that was outreaching, my work is now inner soul reaching.

CHERYL ANN SHACKELTON-HAWKINS My art is a heady mixture of collage, assemblage, and mixed media. As a former photographer and a current book artist, my work is always evolving. Next stop: video and books you can interact with.

YOLANDA R. SHARPE Adding to the art-critical discourse on beauty, I deconstruct representations of angels. I develop abstractions of angels to portray transcendence and sublimity. My angels are seductive, luminous, pure, and complex. They fulfill my strategy of displacement, that of dislodging preconceptions and traditions.

BEVERLY R. SINGER My recent video is a collection of stories about American Indians who are living sober. It's not easy to face the truth about yourself. It hurts. What a gift it was to make a video about alcohol abuse-prevention. For in the process of creating, I got sober.

DEBORAH SINGLETARY I am a visual storyteller. My paintings evolve out of the instinctive psyche and divine wisdom of the wild woman archetype. They are "contemporary Tarot cards," oracular visions carrying multilevel meanings.

CLARISSA SLIGH My work is an attempt to connect the ever-present past to our continuing presence. I construct the unsayable, the unspeakable, and the unrepresentable through a reframing process. History has taught me that every mark I make is connected to every gesture humankind has made.

YUMIKO ITO SMITH "Simply peace always beside us." As I look into spiritual, soulful essence, my works have become smaller and wearable as jewelry or good-luck charms. Quietly but steadily tapping the heart...

GILDA SNOWDEN Autobiography: to document, to make, to preserve one's self, to carry on, to deliver a message. The tornado is my symbol for self, inner power, and personal strength.

HOLLYANNA SPINO My traditional values and beliefs are constantly affected by my ever-changing environment. I often think about my ancestors' efficient use of resources and try to make myself see with those resourceful eyes...how can I use what is within my reach to survive, contribute, communicate.

BARBARA TAKENAGA I am interested in the associative play of reading the images and objects used in my work. For me, it is as much about how meaning is constructed as it is about how multiple readings reside together under one "skin."

DONNA THOMPSON As a photographer/mixed-media artist, I focus on recycling negative experiences polluting life space. The images I produce reconcile the conscious and subconscious. A healing process occurs between what we accept as knowledge and our true nature.

MIMI CHEN TING A virgin ground intrigues me, I peel back the bareness to explore the world inside. Along the way, I discover unlikely wonders as well as people and places I recognize. The pictures I make translate these encounters.

ANA TISCORNIA My work develops within a conceptual space between an "objective" reality and many subjective ones. This objectification of the process of subjectivity attempts to challenge the institutionalized as well as to affirm the right to personalize history and culture.

CHARZETTE TORRENCE My work transforms the essence of time and space placed upon the real world to create an emotional visual illusion that has a quantum impact on all its inhabitants.

GAIL TREMBLAY I work in mixed media because I like the way various textures and materials work together. I try to create objects that talk about the magic in the world and speak against the obliteration of an indigenous way of seeing.

GLADYS TRIANA In the last decade my work has been committed to the recollection of past experiences as a means to reaffirm my identity and self-concept. From childhood memories, I use symbols representing fragments of hidden emotions to exemplify my present life.

LINDA VALLEJO My artwork revolves around my experience as a twentieth-century woman and a Chicana studying the ancient indigenous traditions of Mexico and the Americas. I have worked to discover woman in her modern and ancient places as a source of strength, love, and integrity.

GELSY VERNA I am interested in shapes, in their power to activate images, and in that area between illusion and abstraction. What I seek is a balance between the elements I organize in the picture and the message I find in them.

BETTY PHOENIX WAN Dreams, precious, intimate, memories, spirit, emotion, soul, mystery, and intrigue. Myth, stories, truth, representation, beauty, meaning, concept, and context. Visual creations, installations, channeled through my Asian-American mind and yellow-skinned body.

CAROLYN WARFIELD Using assemblage, collage, performance, and textile surface design, I challenge man's emotional side of "being," his "identity and place," to stimulate expanded vision and transformation.

GINA T. A. WASHINGTON I create to show beauty, evoke emotions, raise questions, and to heal. All of these things I do for myself first and foremost, with hopes that the viewer will be moved, too.

SHIRLEY WOODSON My paintings are my prose, the collages my poetry, and the drawings my dialogue. My art seeks to clarify, glorify, translate, and transform.

MARLIES YEARBY I created the Movin' Spirit Dance Theater Company in 1989 to explore my creative process. I use voices to create sound scapes of melody, audible breath, and percussion through the spoken words.

MÓNICA YOGUEL I've become obsessed with the ghostly appearance of human presence and with the repetition of day-to-day life. I explore human gestures and try to isolate them from the "person," as meaningful traces in themselves.

SPEAKING SITES—DIALOGUE: INGRID AND PLATO

JANUARY 15–MARCH 5, 1994

Ingrid Bachmann

Fourth Floor

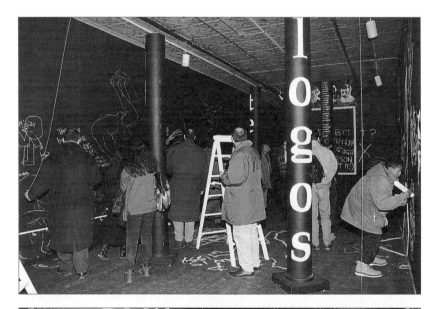

Above: viewers responding to drawings, stories, and quotations on the floor and walls of the gallery, during the first week of Ingrid Bachmann's participatory installation. Below: installation view several weeks later

To know an age's physical freaks is to know its points of standardization.

—Susan Stewart

THIS PROJECT, with the somewhat tongue-in-cheek title "Dialogue: Ingrid and Plato," began as a rethinking of the gallery space: to propose the gallery as a forum for ideas, as a site to create and initiate dialogue, and as an opportunity to work directly in and on the gallery architecture, both literally and metaphorically. The aim was also to question and critique in a somewhat theatrical and potentially humorous way, certain assumptions of Western thought. Plato's Socratic dialogues with their emphasis on "ideal theories" were used as a model.

In this case, the dialogue is a multidirectional exchange between the Western tradition, the architecture of the gallery, myself (as a female and a feminist in the late twentieth century), the friends and volunteers who work on the exhibition, and you, the visitor.

For most people in the West, the chalkboard has associations to authority and socially sanctioned or conditioned knowledge. But interestingly, it also provides a surface that can continually be written, erased, and rewritten, much in the same manner as our public histories and our personal histories are continually being reinvented. If authority, as Susan Stewart suggests, is invested in domains such as the university, the school, the gallery, the marketplace, and the state, it is necessary that exaggeration, fantasy, and fictions be socially placed within the domains of nonauthority: the feminine, the childlike, the mad, and the senile. The aspect of closure and who wields the power to erase and to write is key.

The primary position of the body in installation is an important aspect of this work. The circus and the carnival, rather than the spectacle, are the model for this piece.

The "opening" of this project marks its beginning rather than its conclusion. You are invited and encouraged to participate and respond to this dialogue by writing, drawing, and erasing with the chalk and chalk brushes provided.

INGRID BACHMANN

INGRID BACHMANN
Current discussions around new technologies posit artworks that are interactive, immersive, and that engage the complete sensorium. I am interested in exploring these ideas through basic processes, such as drawing, and in grounding the technological experience within a rich material and physical environment.

CHANGING THE SUBJECT:
PAINTINGS AND PRINTS 1992 – 1994

MARCH 12–APRIL 30, 1994

Emma Amos

Sixth Floor

Aesthetic Intervention

Always engaged with the issue of representation as a means by which the self is constructed and made visible, in her new work Emma Amos makes the canvas and the blank sheet of paper cultural sites for critical exploration of art practices. Amos disrupts the essentialist assumption that a pure imagination shapes artistic work, both by interrogating the way in which aesthetic sensibility is shaped by the particularity of artistic vision and by showing how that vision is constrained by a concrete politics of representation that maintains and perpetuates the status quo. Showing us that all art is situated in history and that the individual choice of subject matter reflects that situatedness, in her new work she articulates a vision of universality that coexists in a dialectical relationship to the particular.

Starting from the standpoint that the politics of racism and sexism create a cultural context wherein white male artists necessarily work within an art world that is predisposed to extend them recognition and visibility, Amos begins by calling attention to the constraints that limit and confine all those "others" who are not in the privileged category. Within white supremacist capitalist patriarchy, images of power and freedom are symbolically personified by the white male "subject," in relation to whom all other beings are constructed as unfree "objects." At the outer limits of otherness, then, one finds the image of black femaleness personifying, within the existing culture of domination, the following: powerlessness, a lack of agency, and an incapacity for transcendent vision. These remain the properties of the powerful. Any black female who dares to embody them is out of place, transgressing boundaries, a menace to society.

By placing her own image in paintings and prints that depict a world where she could never "belong," Amos resists objectification and subordination. She subversively announces her subjectivity via the imaginative appropriation of the space of power occupied by white males, and then emerges from the shadows to call atten-

tion to subjugated knowledge. In the painting *The Overseer,* she links repressive white supremacy to attempts to control and define images of whiteness and blackness. Exposing in her work the way racism depicts black folks as objects rather than subjects of representation, Amos problematizes whiteness. Both in *Lucas's Dream* and in *Mrs. Gaugin's Shirt*, she calls attention to the racialized sexism of white male painters like Gauguin, Samaras, and many others who were never troubled by their rendering of the dark body in ways that reinforced white cultural imperialism. While Amos interrogates the sexism and racism that has shaped the artistic vision of many white artists, determining the ways they represent images of difference, her intent is not to censure but to illuminate through exposure. Presenting us with representations of white supremacy through her many images of the Ku Klux Klan in works like *Ghosts* and *Captured*, she articulates the link between that whiteness which seeks to eliminate and erase all memory of darkness and that whiteness which

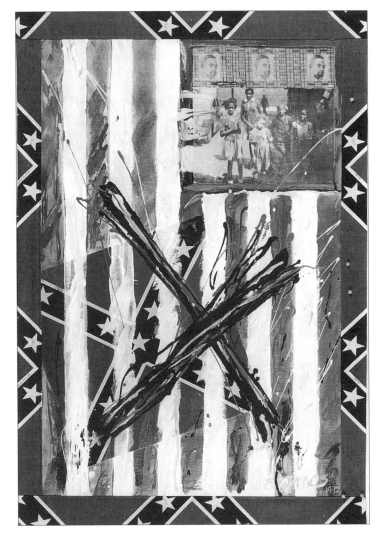

X FLAG. 1993. Acrylic on linen, laser transfer photograph, and Confederate flag, 58 x 40". Collection Alice Zimmerman

claims the black body in representation, only to hold it captive. To resist that claiming, Amos challenges the use of blackness as the space where whiteness can be redefined. To make that challenge, she must focus on the white body.

By laying claim to the white body through a process of objectification, visually represented in the painting *Work Suit* and the print *Work Suit Try-On*, she imaginatively appropriates the naked white male figure to gain artistic visibility. Subverting the paradigm to seize power, rather than to deify white male power, she pokes fun at it. Her white male body suit is not impressive: it looks ridiculous. A satiric comment on the stupidity of categories, this playful mockery does not deny the reality of domination. In *Way To Go, Carl, Baby,* and *A. R. Pink Discovers Black*, we are asked to reexamine race and gender in relation to who has control over the image. By reclaiming an inclusive site of image-making, using it to critique and signify, Amos imaginatively dismantles the structures of race and gender privilege. This is the art of insurrection.

Reworking the narrative of democracy and freedom evoked by the flag that

appears and reappears in this new work, she identifies it only as a curtain, a veil that must be lifted if we are to see clearly the politics of our cultural reality. Linking her artistic practice with the militant resistance to white supremacy, traditionally personified by the revolutionary leader Malcolm X, in *X Flag* and *Malcolm X, Morley, Matisse and Me*, she calls for a politics of the visual that can account for an art wherein white male artists can be acclaimed when they use black figures in their work, while African-American artists receive a message from the established art world that their use of white images will not be embraced. Black artists learn that even in the world of artistic practice no one will accept and condone black artists toying with, controlling, or shaping images of whiteness.

In this new work, Emma Amos articulates a pedagogy of resistance wherein she calls for the linking of memory with power. Margaret Randall reminds us in *Gathering Rage* that "authentic power comes from a fully developed sense of self, possible only when both individual and collective memory is retrieved."[1] Linking her art making to those of her peers in the works *X Ray Showing Norman Lewis and Women at the Club, Never: For Vivian (Browne)*, and *Fragments: For Mel*, she lays claim to a legacy of participation in avant-garde art practices where black presence is most often denied and erased. Again, the issue is visibility, recognition.

That recognition comes via acts of transgression and resistance, border cross-ings, participation in the cultural revolution evoked by the *X* symbol. In this work, *X* appears as the chosen space of marginality where the oppressed and exploited exit from a history that denies them subjectivity, refusing to be objects, rejecting association. This refusal is highlighted in the print *Standing Out*, where the black male thinker is set apart, watching the silhouetted white male and female appro-priate the space. It is this chosen position of "outsider" that liberates. Released from the established dominating order, with a freedom gained by dislocation, dis-

EMMA AMOS It's not words I need to make a powerful image (books do it better), it's the impact of some quirky visual relating to experience, intuition, passion, and fear that comes from paint, form, movement, and color.

STANDING OUT. 1994. Silk collagraph and laser transfer photograph, edition of 9, no. 1, 22 x 20". Collection the artist

association, and the dynamics of struggle, black artists are empowered to be self-defining, critically reflective, able to challenge, revise, and rework history. Art is revolutionized in the process; freedom of expression is made more inclusive.

In these prints and paintings, the rejection of domination as the only possible point of contact between those who are different does not lead to a reversal where-in black power substitutes itself for white power; instead, it allows for radically dif-

ferent liberatory visions to emerge. In this free world, identities are not static but always changing; intermixing, and crossbreeding become mutual practices; and the power to explore and journey is extended to all. Writing about the need for an insurrection that does not simply mirror the dominant culture in *When the Moon Waxes Red,* Trinh T. Minh-ha reminds us that

Emma Amos (right) during the installation of "Changing the Subject"

> to disrupt the existing systems of dominant values and to challenge the very foundation of a social and cultural order is not merely to destroy a few prejudices or to reverse power relations within the terms of an economy of the same. Aware that oppression can be located both in the story told and in the telling of the story, an art critical of social reality neither relies on mere consensus nor does it ask permission from ideology. [2]

Defiantly, Amos places her image among the repressive fascist forces of white supremacy in *Blindfolds* and *The Overseer* to counter a cultural politics of exclusion and denial that would separate making art from concrete struggles for liberation. One struggle makes the other possible not just for African-American artists but for any artist. The convergence of possibility that is hinted at in the painting *Malcolm X, Morley, Matisse, and Me* rejects a binary approach to the politics of difference that would have everyone's identity be fixed, static, and always separate, replacing it with a paradigm where mixing is celebrated, where the cultural interchanges that disrupt patterns of domination are dismantled so that an ethic of reciprocity and mutual engagement forms the aesthetic ground on which the subject can be constantly changing.

bell hooks

reprinted from the catalog of the exhibition, ©Art in General, 1994

1. Margaret Randall, *Gathering Rage,* New York: Monthly Press Review, 1992, p. 171.
2. Trinh T. Minh-ha, *When the Moon Waxes Red,* New York: Routledge, 1991, p. 6.

Traveling exhibition organized by Laura J. Hoptman (New York City), Holly Block (New York City), Ava Molna (Budapest, Hungary), Mary Murphy and Hamza Walker (Chicago), and Allen Frame (Memphis). Each curator selected fifteen artists, and a total of seventy artworks were exhibitied at Art in General

LITTLE THINGS

MARCH 12–APRIL 30, 1994

Fourth floor

Zoltán Ádám

Emily Feinstein

Hüseyin Alptekin and Michael Morris

Rick Franklin

Beöthy Balázs

Jessica Gandolf

Tamás Banovich

Elizabeth Giordano

Laurie Bartholomew

Sara Good

Monica Bock

Jacob el Hanani

András Böröcz

Chris Hanson & Hendrika Sonnenberg

Imre Bukta

Skowmon Hastanan

Erin Butler

Janet Henry

Gary Cannone

Joel Holub

Jno Cook

Michael Hopkins

Linda Cummings

Jo Hormuth

Verne Dawson

Julia Jacquette

Carol DeForest

Terri Jones

Tom Denlinger

Gyula Juliús

Luke Dohner

Sermin Kardestuncer

Gail Duggan

Byron Kim

Martha Ehrlich

Jay Etkin

Diana Kingsley

Mary Lum

Joni Sternbach

Bill Lynch

János Sugár

Adelheid Merz

Péter Szarka

Liz Meyer

István Szili

Greely Myatt

Tony Tasset

Aron Namenwirth

James "Son" Thomas

Victor Ochoa

Rirkrit Tiravanija

Gabriel Orozco

Daniel Tisdale

Rolland Pereszlényi

Péter Ujházi

Elizabeth Peyton

Gyula Várnai

András Ravasz

Marlene Vine

László László Révész

Michael Volonakis

Gábor Roskó

Thomas Weaver

Bill Rowe

Barbara Wiesen

John Salvest

Stephen Williams

Tairah Shah

THE X-GIRLFRIENDS

Robert Shatzer

Charles Yates

Greg Shelnutt

Julie Zemel

Lisa Sigal

Allison Smith

Less Is More

CREATED IN RESPONSE to a request for an exhibition of American art created for Eastern European audiences, "Little Things" has become an experiment in multinational collaboration between disparate cultures, and a living example of the possibilities of a truly international dialogue between like-minded artists, curators, and art professionals. The premise of the exhibition was simple: working with particular conceptual parameters, specific enough to be meaningful, and flexible enough to be inclusive, it was possible to organize an exhibition in which the work of emerging artists from any number of countries, selected by indigenous curators, could hang together in a single, ever-expending show and make a coherent statement. The theme that was chosen for investigation was the term *small* with all its formal, conceptual, and ideological implications. Curators were encouraged to give free rein to their interpretations of the theme, but a certain number of ground rules were established at the outset. Each organizer would choose works from no more than fifteen participating artists, and, regardless of medium, none of the works could exceed twelve inches in any dimension. The size limit was imposed not only to ease transportation, which it did, but to demonstrate a growing trend among artists to work on a radically smaller scale, both in terms of size and subject.

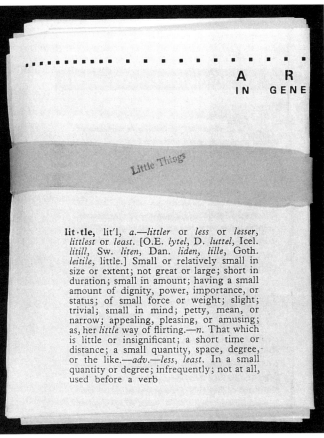

Front cover of "Little Things" catalog

Why many American artists today choose to make work on a smaller scale is open to question, but a turn to a more modest kind of expression after many decades is indicative of both an ever-shrinking art market, and of a general reconsideration of the position of our country on the international cultural spectrum. Over the past few years, American society, like many others around the world, has been undergoing a kind of collective identity crisis. Social and economic instability at home,

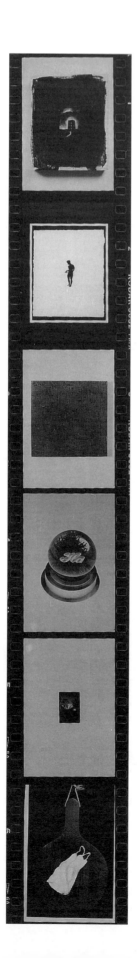

and political realignments internationally, have made us, as a nation, question those very carefully constructed definitions of who we are and what we represent. For American artists, particularly those living and working in New York City, this inability to grasp our own place in the world has shattered many illusions that we have labored under since the Second World War; among them, our roles as self-appointed spokespeople of an international culture. Today, many artists prefer to share personal observations rather than issue sweeping decrees, finding that speaking for themselves in a whisper is much more appropriate for the times than attempting to speak for the world, in a roar.

Over the past few years, the concept that dominates the discourse among young artists has been that of *limits*. The reduction of size is a natural limit, which indicates a desire to know something, but perhaps not everything. Those artists who work small often chose to concentrate on what can be known—what can be seen with the eyes, or felt or held in the hand. Their field of action is consciously restricted, as are their materials, most of which can be found at arm's length....

It should not come as a surprise that these little objects, little pictures, little piles of stuff from New York City, can hang in symphony with, rather than in contrast to, the work of other artists from other regions in the United States and from other countries. As humble as these "small things" may be, they wrestle with vital questions concerning the role of the individual in a society whose boundaries are rapidly being erased. The goal of this exhibition then, as it travels from city to city, from country to country, is to present these very different voices in a kind of chorus, which in its common and very human concerns cannot help but be harmonious.

LAURA J. HOPTMAN

excerpt reprinted from the catalog of the exhibition

HÜSEYIN ALPTEKIN AND MICHAEL MORRIS We thought about this conversation we had while driving on the Autobahn, of the blind spot one experiences from the mirrors of an automobile (the side one and the other, on the inside of the windshield). The blind spot has a potency, a presence, and point of view. It has become a metaphor for our work.

ERIN BUTLER Painting is the play between working with the physical juicy stuff of the paint itself, and that which is glimpsed, dreamlike, exasperating, fluid, and intense. Even when the form it takes is ugly, it's an act of love.

LINDA CUMMINGS Re-dressing the image and imagination of "The Feminine" inspires my work. I search for new forms to embody the spirit, passion, and power of the hidden voices and overshadowed visions of women in art, language, and culture.

EMILY FEINSTEIN Recently, I have been reconstructing fictitious locations with reference to the working-class suburbs in which I grew up. Through repetition, placement, and scale, a landscape develops—one that attempts to evoke experience and memory as well.

JACOB EL HANANI My working small comes in part from my Middle Eastern childhood, where time had a more palpable character, and where there was so much attention to visual detail. It is also a reaction against the bigness I encountered when I came to the USA.

JANET HENRY I use toys, dolls, tchotchkes, beads, and other miscellany to construct what I call lariats. They are sewn up in clear vinyl and hang from binder rings, chains, or phone wires. I call them lariats because they are so malleable that they take on a new shape every time they are handled.

JULIA JACQUETTE My work addresses my urgent need to discuss feelings of longing and desire. I use visual metaphors related to desserts and jewelry. My obsessive, repetitive rendering of these objects is as much part of the work as the imagery is.

MARY LUM My work has to do with an obsession for reading and collecting. It is about the relationship of language to experience, and about how, when we read, we are always thinking of other things—no matter how subliminal or transparent.

ARON NAMENWIRTH I consider my work a quiet prayer for humanity. My concern is for creating a moment of clarity in a confused world. I find painting a form of revelation and the written word a form of resistance, like any force, something that is balanced and moves.

JONI STERNBACH My recent photographs are naked females in silhouette, grouped by morphology and gesture rather than age. From a distance, it is a Rorschach-like effect of black shapes resolving into specific figures only at closer range. This is meant to underscore the hypothetical value of this work as documentary.

Opposite: Contact sheet with works from the fifteen artists selected by Art in General. From top: Thomas Weaver. **ASYLUM**. 1993. Acrylic and oil on wood, 6 x 5"; Joni Sternbach. **UNTITLED SILHOUETTE #26**. 1991–92. Platinum and palladium print, 12 x 12"; Marlene Vine. **HOMAGE TO E.H.** 1992. Mixed media on paper on Baltic plywood, 11 x 11 x 1"; Julie Zemel. **HAPPY**. 1993. Plastic figure, pine tree, glass globe, artificial snow, and mixed media, 4 1/2 x 3 1/2 x 3 1/2"; Michael Volonakis. **THE FALCONER**. 1994. Silver gelatin print, 10 x 12"; Linda Cummings. **DOMESTIC ICON** (from The Fall series). 1994. Oil on wooden breadboard, 11 1/2 x 8"

MARLENE VINE My paintings are concerned with the grid and ripped edge, to me, perfect abstract metaphors for the constructed contemporary world. The idiosyncratic treatment of the fissure signifies, among other things, the rupture between modern and postmodern.

MICHAEL VOLONAKIS I grow to understand how everything is connected to everything else.

THOMAS WEAVER My themes are in an American vein: isolation, fractured identity, contradictions, the desire for transcendence, and its failure.

JULIE ZEMEL I get ideas from mass-marketed products and techniques used to make people want and need them. This interests me more than most art because of art's invisibility when compared to popular culture. I want my work to be accessible, and have relevance to people inside and outside the art world.

As scale increases, so does the importance of the gesture—Frank Stella

YEAH FRANK, BUT BIGGER IS BETTER until it bursts. Then suddenly, as if by default, small becomes a reaction. But how big is big and how small is small? Not only are these terms relative, but they seem to have been altogether misplaced in the larger set of extremes, objects/nonobjects. And given that art objects of any scale have been subsumed by the specter of the commodity, big and small have been further obscured, if not collapsed. This ready collapse of the two terms, however, signals that there was never any real difference.

Small has always been cursed with commodity status. Commodity status, however, is not transcended when scale is increased. If anything, an increase in scale means an increase in commodity status. Big art requires big business. Examples of the sheer big badassness of it all: Kiefers rollin' out of the studio at a million a pop; or Van Goghs at fifty-three million a pop; or what about Caro's archisculpitechture thingamabobs, God only knows what they cost. In each case there is greater rather than less signification of the world of crass commercial exchange. In the eye of this form of exchange, love or size have nothing to do with it. What this equation proves is that most big art is still small. It is no longer a question of big or small but the difference between the means of economy and the economy of means.

Clarity demands that the essence or heart of a particular matter always be visible. But the ability to comprehend this essence or center from the margin is actually to forsake the center. The marginal, casual elements become as revealing as those given central importance. Whether it's the anecdote in favor of the full story or the footnotes in favor of the chapter, the symbiotic relationship in this scenario is one in which the smaller partner packs the wallop. The casual, marginal, or small gesture of economical means functions as the more potent and concise signifier. Although the grand gesture has the ability to elaborate on a point perhaps less important than the gesture, small can cut to the quick and map a thematic territory far outweighing its actual size. Why use a bomb when a bullet will do?

But the more radical consequence of decentralization brought on by focusing on the marginal or small elements is that it suggests that there is

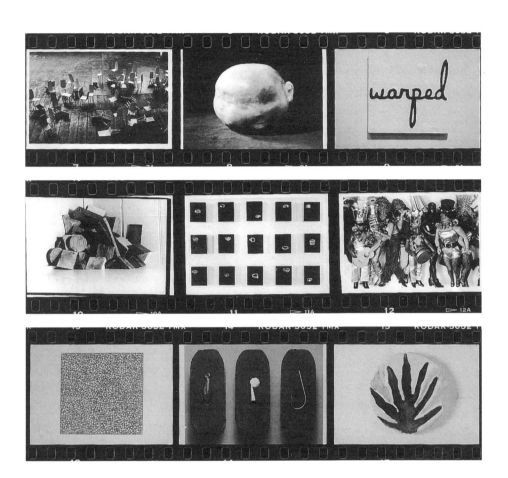

Contact sheet with works from the fifteen artists selected by Art in General. From left to right: Emily Feinstein. **MEETING**. 1993. Painted wood, 8 1/2 x 12 x 12"; Gail Duggan. **TWIN**. 1993. Beeswax, 4 1/2 x 6"; Aron Namenwirth. **WARPED**. 1992–94. Oil on canvas, 12 x 12"; Mary Lum. **THE PERIODIC TABLE**. 1994. Painted wood, 6 pieces, overall 12 x 12 x 12"; Julia Jacquette. **RINGS** (detail). 1992. Oil on panel; Janet Henry. **ANTHROPOLOGY 101**. 1982–94. Mixed media and dolls, 7 x 12"; Jacob el Hanani. **UNTITLED**. 1993. Pen and ink on paper, 5 x 7"; Hüseyin Alptekin and Michael Morris. **BLIND POTENT SPOT/MAGNETO-RADIATOR**. 1992. Coal, nails, and mixed media; Erin Butler. **FERN MEDITATION**. 1993. Oil on canvas on chipboard, diameter 5"

no single site for the production of important or great art. The means of producing masterpieces is in your own backyard. New York is no longer a carrot dangled in front of my face. The center may well be Memphis or Chicago, or even Budapest. With multiple centers, which means no real center, the dialogue shifts from one of domination/imitation to one of equal reciprocity. Perhaps better than any single work in the show is the dialogue between the works. In the end, I cannot help but compare the exhibition to a Jim Jarmusch film, which leads me to believe that maybe paradise would be as strange a mix as these four places.

HAMZA WALKER

reprinted from the catalog of the exhibition

ANIMATED

Micheal Carroll

Gregg Deering

Louise Diedrich

Jane Fine

Felipe Galindo

Diego Gutiérrez

Larry Mantello

Melissa Marks

Nurit Newman

David Schafer

Norman Steck

Mark Dean Veca

Hell's Bells

THE INTERCOURSE BETWEEN THE FINE ARTS—such as painting and sculpture—and popular forms of expression—such as advertising, the comics, and illustrations—is a two-way street that serves to enrich both parties. For many citizens, Leonardo's *Last Supper* is either a hanging carpet or a jigsaw puzzle, Surrealism the weird juxtapositions one sees on MTV, and Bauhaus the kind of furniture they sell at IKEA. On the other hand, where would Marcel Duchamp be without the Vermot Almanac? [1] Or Philip Guston without the comic strip "Krazy Kat"?

The twelve artists in "Animated" are visual scavengers drawn to the cartoon's narrative-driven, reductive visual language. When it relies on caricature, the cartoon form is a modern-day hieroglyphic reveling in exaggeration and distortion, and in its capacity for social commentary it is often a theater of the absurd of the printed page that can counter even the most appalling disaster with knowing laughter.

The cartoon's intrinsic irreverence finds its expression in Melissa Marks' series of colored pencil drawings chronicling the adventures of *Volitia the Abstract Vagina* as it intertwines with *The Snake, The Flame,* and *The Pyramid.* Using bright acid colors such as mauve, viridian, turquoise, pthalo blue, and crimson, Marks invents improbable comic shapes to illustrate the fantastic encounters of her unusual heroine. By means of her manipulations, *The Snake,* i.e., the penis, is sometimes seen as an asparagus, and the vagina becomes intestines, string cheese, or a bushel of seaweed. In transforming a sexual body part into a character, Marks builds upon the cartoon tradition of anthropomorphizing just about anything. One can think of talking animals, speeding trains leaning forward, or smiling vegetables of a nutritional ad campaign.

Issues of sexual politics are also alluded to in *Pubina Comics,* Micheal Carroll's small watercolor. The multiple windows of the comic layout are appropriated by the artist to introduce us to *Lady Labia!, Femme Fetal, Menstra!,* and *Machisma* ("FUCK OFF!" sneers Machisma as she flexed her muscles). In one frame, a lesbian couple in leather straps and engaged in foreplay is being observed by a male in profile. In another, a Mickey Mouse look-alike wearing work boots and ersatz ears, stands hammer in hand inside a long pink corridor. From the open doorway facing him comes a red ejaculation of unknown origin. The usual obviousness of the comics is here subverted by an unexplained phenomenon.

The grotesque tradition of juggling body parts and ribald punning are the stock-in-trade of Jane Fine's paintings. Ambiguous chunks of colored flesh are lifted from the anatomy of Warner Brothers' Looney Tunes characters, to be freely reconstituted into lumpy, amorphous masses dripping and oozing across their own borders, a breach of the established cartoon etiquette of maintaining clear graphic boundaries. Scatological suggestions abound, adding an earthy note to the bright proceedings.

The cartoon tendency to flip-flop the high-low totem is apparent in Mark Dean Veca's series of small paintings. Four banal icons—Popeye's muscular forearm, Pluto's snarling teeth, a toothpick-impaled Olive, and a hamburger with lettuce—are perfunctorily depicted floating in space as celestial bod[ies]. The reverse side of irreverence is the elevation of what is deemed vulgar or insignificant. It is the natural response to the wearisomeness and austerity of hierarchy, and the cartoon, being a colloquial language, welcomes this leveling tendency.

A different kind of leveling occurs when one encounters the fresh paradigm of an unfamiliar culture. Felipe Galindo, a Mexican living in New York, infuses new life into the slight practice of street caricature. Ephemera—from a Nathan's Famous deli napkin, to a Saks Fifth Avenue shopping bag, or a Chinese takeout food container—are collected and converted into drawing sur-

Installation view

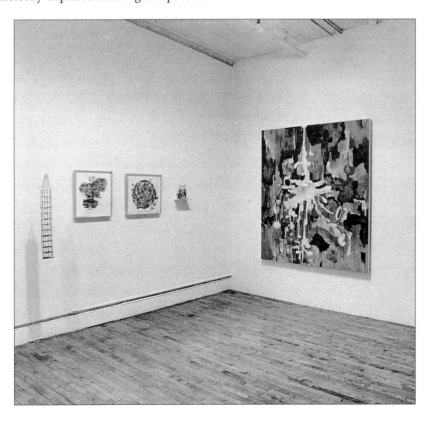

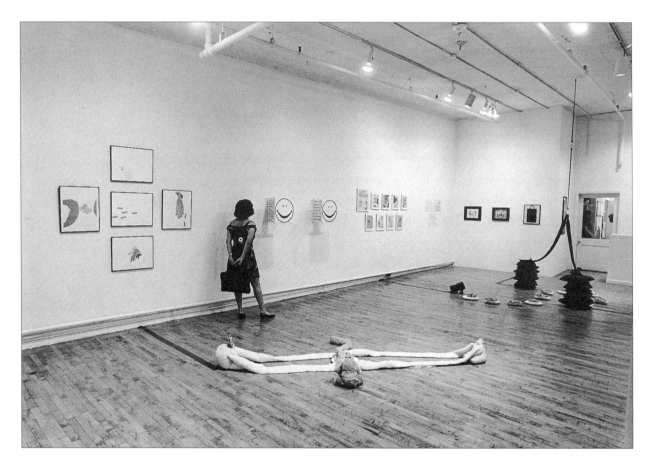

Installation view

face or collage material. Typically, Galindo superimposes and synthesizes his drawn vignettes with the existing graphics of the found surface. Thus, in a coffee shop scene, vulgarized depictions of the Acropolis and Zeus are printed on a flattened coffee cup that doubles as a counter for the drawn characters. Icons of Greek culture now function as design motifs framing the phrase: "WE ARE PLEASED TO SERVE YOU." Although akin to the tourist's snapshot, Galindo's images are made intimate through the intercession of the artist's hand, since to draw from life is to domesticate, and is the means by which the artist can map out his new surroundings.

Louise Diedrich's images owe something to the over-the-top graphic style of Marvel Comics' well-known inventory of steroid muscles, heroic poses, and ass-kicking mayhem. She is also influenced by the illustrations in *Heavy Metal* magazine and its fascination with Satanic pageantry. Her

earnest shading technique, straight from high school art class, is another instance of a contemporary artist borrowing from the amateurs. This deadened technique is used in a graphite and Bic pen drawing, *Born of Normal Parents panel #10* to offset the fantastic vista of a three-tiered fountain, with its baroque display of bound, gagged, eviscerated, and decapitated figures. Architectural excess is here combined with the convoluted bowels of the violated bodies in a grotesque marriage between ornament and crime. The transubstantiation from water into blood completes the spectacle.

Norman Steck employs a similarly innocuous technique to wryly deal with the disturbances of personal psychology. Some of his imagery is copped from the cutesy illustrations common to children's books and greeting cards, although recast to convey adult dramas. In *Pussies & Pansies,* a bevy of soft hairy creatures garlanded by flowers is arrayed in various postures of contemplation and repose. In *Muse,* Steck's pencil is let loose to depict a tornado's swirling air currents, a farmhouse and a tree turned upside down, a tractor, and a nude female standing, incongruously, in the midst of agitated nature.

The round-faced dorks found on greeting cards and the cheery inane verbal expressions usually accompanying them ("...Helluva Thought, Ain't It?"; "...But You *Used* To!!") make up Larry Mantello's La-La Land. In *Lucky Dog Jamboree,* the central image is a pizza-shaped cacophony of greeting card fragments, plastic eyes from stuffed dolls, and stick-on decals of butterflies; *Jam Buoy* is a multitiered hanging construction made from more greeting cards, beads, bells, metal pins, and Xerox transparencies of dumb sentences. The infantile atmosphere of the amusement park, where fun is a prerequisite, is recreated by Mantello from the gimcracks and doodads of five-and-dime stores, in an ambivalent evocation of banality and innocence.

Another round-faced dork, his index and middle fingers forming a V beneath his nose—a Mexican gesture for "screw you, mother"—turns up in a Diego Gutiérrez collage. Gutiérrez has gone berserk pasting Band-Aids every which way in *Curitas,* a collage series. They are converted into little cars for drawn cartoon figures in one image, bifurcate a pink pig in another, and gather menacingly behind a stick-on decal, *The Thing,* in a third. Like Mantello, Gutiérrez balances his playful banter with a formal sensibility, resulting in works that are reckless yet inevitable.

The ubiquitous smiley face, the universal cheerfulness sign, is emblazoned by David Schafer on the exterior sides of a pair of steel structures protruding from a wall. Hidden behind them are inspirational passages culled from self-help books. "I am a vital, radiating expression of life. I overflow with liveliness, energy, and joy. I shine forth optimism and enthusi-

MICHEAL CARROLL No chasm is wider than that which separates art from therapy. Narcissus is the primary muse of the artist, but we tend to forget that it is fatal for him to see the reflection of his face, and not that of his creation, which is his true self.

GREGG DEERING I am working with the meaning we put into messages. Weighing external content read into contextualized images (such as political art or Hollywood product), and the personal content associated with the conventions of painting.

LOUISE DIEDRICH My work is about masochism, I mean money—both.

JANE FINE The humor and beauty in these paintings is something of a cover-up. Creatures sprout and bloom while struggling against the heavy drip and ooze of material. The paintings are optimistic yet deal with the absurdity of an upbeat posture.

FELIPE GALINDO As an immigrant artist, my first impression of the U.S. was that of a consumer society with a great amount of waste and many disposable products. I integrate these materials in my pieces as social commentary, creating compositions of the detritus of urban civilization.

DIEGO GUTIÉRREZ I'm interested in addressing fragility: the fragility of the body as it confronts the world, of its limits and the limit itself, of the fragility of memory, of that which is eternal but is also just here and there, of the frontiers in themselves and to what they conform.

LARRY MANTELLO My work is indulgent in an irresistible, thoughtful celebration of time. It persistently insists on entertaining itself in tradition and charitably acknowledging the present. On occasion, I have accidentally arranged an affectionate sharing of common and innocent affections.

MELISSA MARKS *Volitia the Abstract Vagina* is a genius both intellectually and emotionally. Her muscular flesh embraces all passion and difficulties, her X-ray vision explores the interior life of all form, her power and ability are immense. Stay tuned.

asm in all that I do," reads one quotation. The zombie prose subverts its own "positive" content, paralleling the lifeless symbol on the cold steel. Schafer's piece points out the curious phenomenon that, as with greeting cards, where big occasions are marked by small words, what is enough to assist a man in getting through the day may be a few sentences of optimistic babbling.

Hollywood lobby cards, records and advertising from the 1940s and 1950s, political cartoons, and other found images are used by Gregg Deering as foundations for his theatrical tableaux. Pressed between sheets of Plexiglas, their meanings are altered by Deering's addition of found objects and painted symbols. In *Slightly Tempted,* two suited men are

crowned, respectively, with a sack of money and a globe, while the wrist of a third character is adorned with a fluttering tag saying, "TIME." In *Dixie Dugan,* a dog leash is attached to a guy in a fedora talking to a woman whose head has been replaced by, again, a painted globe. In these pieces, the semantics of the political cartoon have been co-opted by the artist to convey a private, absurdist drama.

The cartoon tradition of drawing analogies between humans and animals is used by Nurit Newman to address stereotypes of the Jewish body. In *Nose Job,* two rubber elephants are sprawled on separate stacks of red pillows, their ridiculously elongated trunks tied into a knot and suspended from the ceiling. They are encircled by bowls of dried-up matzo balls, while the artist is seen rolling matzos on a small TV screen. She tosses them into a bowl, places them over her eyes, and stuffs them into her panties.

According to the artist, the elephant is not only chosen because of its long nose but also because of its bad feet and poor digestion. "I can't believe I ate all that food," moans a Jewish-looking man in an Alka Seltzer commercial. Although executed with a sense of humor, the disturbing subtext of Newman's playful arrangement is that, for those on the margin, one's natural attributes can be perverted by the dominant visual culture into personal obscenities.

By adopting, then altering, the mechanics of various idioms from the vast inventory of popular culture, the artists in "Animated" are aggressive participants in a new colloquialism, which dredges up into view that part of our heritage not emanating from the museum or the textbook, but from the mass media and the shopping mall. While the attitude with which each artist approaches his or her source may range from delight to ridicule, together they provide us with a fuller index to the current psychology.

LINH DINH

NURIT NEWMAN The actions individuals take to preserve the self in the face of marginalization are attempts to convince the marginalizers that one is not the "other" they perceive one to be. The back-and-forth awkward attempts to reconcile the self can lead to a maladjustment or deformity.

DAVID SCHAFER The formal strangeness of pseudoreligious and patriotic texts can be seen as a symptom of lack. The language or signs of spirituality, intended to satisfy a desire for equilibrium and utopia, does not deal with feelings, but is a manipulation of emotions rooted in the subconscious. I am interested in language that embodies a state of inadequacy.

NORMAN STECK My work is at times personal; at other times it takes the form of social critique. Using simple imagery, pathos, and humor, I seek to reflect on some of the contradictions, hopes, and desires of the American scene.

MARK DEAN VECA Saturday-morning cartoons were my catechism.

1. Founded in the 1880s, this French popular almanac was famous for its puns, riddles, spoonerisms, and risqué jokes.

W H A T I S A R T ?

MAY 13–JUNE 25, 1994

Sixth floor rear

Michael Bramwell

Esperanza Cortés

Renée Cox

Lisa Corinne Davis

Ernesto Pujol

Elaine Soto

Ricardo Zulueta

"WHAT IS ART?" was organized by six students from ABACA's Visual Thinking Program at Satellite Academy High School on Forsyth Street, New York City. ABACA (Arts Benefit All Coalition Alternative) is composed of Art in General, Artists Space, The Drawing Center, Franklin Furnace, and the Lower Manhattan Cultural Council.

As first-time curators, the students orchestrated the exhibition from its initial conceptualization, reviewed slides, made studio visits with African-American and Latino/a artists, and selected the works, which culminated in an exhibition at Art in General.

The following statements were written by the students to explain their choices of artists.

Lisa Corinne Davis was one of the artists we chose for our exhibition. The reason I chose her was because I could really understand the point she is trying to portray. Her artwork is made out of newspaper and other materials. When she is finished with the pieces, she buries them in order to let the weather deteriorate them. Due to this process, her work acquires its own unique history.

During our studio visit she talked about how it is very hard for her to fit into her own culture because she doesn't look like an African American. She is light skinned with fine features, and people don't always recognize her as an African American. I felt that Lisa would be a great asset to our show. Her work is unusual and most importantly, it talks about how Latinos and African Americans come in so many different shades and how this enriches our culture and our people.

PAOLA MEDAGLIA

I like Esperanza Cortés' work because she does work mainly about women. She feels very strongly about females and their rights. I'm convinced that this attitude has a very strong impact and reflects a great deal in her work. She has pointed out that she is not totally against men, but for her being a female is something that is of major importance.

Her feminist aesthetic of women with serpent legs shows how in some cultures the serpent is a very powerful reptile. No matter what happens, it is able to shed its skin and start all over again, much like a woman.

Ms. Cortes' work struck me personally because the colors are bright and she sets them up in a delicate manner. As an amateur curator, I was able to talk to her and find out the true definition of her work. I became more interested.

TYEASHA RICHARDSON

The artist I like the most is Michael Bramwell. I like his work because he expresses the way he and other people lived with government food. When Michael Bramwell puts his work in galleries people ask themselves if Government food is art. I think if an artist does a piece of artwork you can call it art. That's why our show is called "What Is Art?" Art could just be anything; that's my opinion.

Michael makes a really big effort to use food and put it in another context. His food boxes and labels look so real that I thought he just stacked up

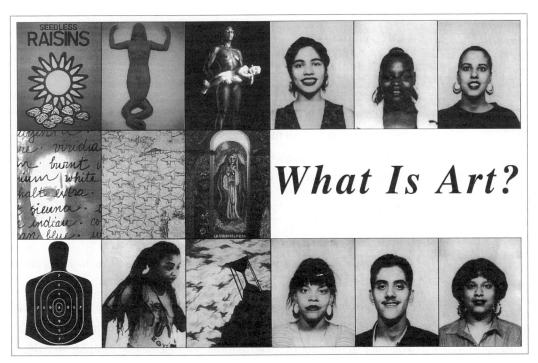

Announcement card. Curators (from left to right): Paola Medaglia, Tyeasha Richardson, Sinnia Cotto, Odemaris Rivera, Ernesto Rivera, and Nubia Vilchez. Left: details from works in the exhibition

cardboard boxes together. However, his boxes are handmade wooden boxes and he silkscreens labels. The artist's hands are in the work.

ODEMARIS RIVERA

Ernesto Pujol's work is based on memories and oral history passed down to him as he was growing up.

His piece *cuba and jamaica* is very interesting because of its repetitious images of sharks surrounding the islands of Cuba and Jamaica. The people living in these islands were afraid of going toward freedom. They had to go out on small boats to escape the island, knowing that they had to go through the sharks surrounding the island. Through these images of sharks, the shape of Cuba, and boats, the artist expresses his connection to his country. By repeating and numbering these personal symbols, Ernesto Pujol attempts to order his memories.

As someone who grew up with a strong oral family history, I can identify with this artist's experience. It is wonderful when an artist is able to express his experiences within his or her images.

ERNESTO RIVERA

One of the artists that is important to me is Elaine Soto. The *Kali Ma* piece interested me because of the way the colors are shown and the way the piece is represented. *Kali Ma* represents an Indian Goddess. The third eye represents knowledge and allows her to transform herself.

This piece of artwork is very interesting and nice to look at.

NUBIA VILCHEZ

Ricardo Zulueta's art is important to me because I like the idea behind the art, and I agree with it and understand it.

His photographs are of nude people, males and females, paired up together of the same sex in public places: trains, bathrooms, dance clubs. The photographs are of performances put together by Ricardo. His idea is

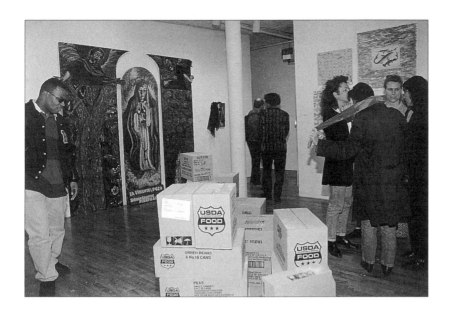

that people generally stereotype others by how they dress or look, but naked people are all equal and you can't pass judgment on a person by how they dress when they are naked.

You can't judge a book by its cover. A person can dressed bummy but be very smart or have a wonderful personality. You may miss out on a great person if you judge them by appearance. That caught me about Ricardo, and I'm glad he's part of our exhibition.

SINNIA COTTO

ERNESTO PUJOL I am interested in "the skin of memory" in a sort of archeology of the mind, particularly around secrets. I use personal and family memory and domestic objects.

ELAINE SOTO The purpose of my work is to honor our divine mother in all her various manifestations. This desire was born out of a cultural reverence for our Lady of Montserrat, a black madonna from Puerto Rico known for miracles.

RICARDO ZULUETA My work is about concepts of interactive behavioral patterns in people that determine identity.

Above: Exhibition opening. "We feel these artists share our common concerns and cultures through a clarity of individual self-expression."
—The curators

NIGHT WATERS

MAY 13–JUNE 25, 1994

Lynne Yamamoto

Fourth floor

LYNNE YAMAMOTO

My work is impelled by the personal history of women in my family who worked on a sugar plantation in Hawaii. It deals with the woman's body in relation to labor and sexuality. I also consider my role as an educator to be an integral part of my art practice.

It was black and spread across one breast like an oval pond. When she was little, she tried to wash it off, scrubbing the skin raw.

"Night Waters" invites the itinerant ethnographic gaze to focus upon Japanese women laborers in Hawaii, only to send it spiraling inward, toward a psychic space of the "self-as-other." [1] Here, the bitter legacy of colonialism is played out, leaving its lasting mark of internalized despair and racial self-loathing on the body and psyche of the colonized. This is the space that the viewer enters.

Black hairs grew in tufts in the middle of it. She snipped them once, but they came back thicker.

Nine unfinished pine boxes are planted in the middle of the room: an ordered forest of trees, a gathering of bodies. Through a glass lens embedded in some of the boxes, the viewer spies archival images, most of them taken by white photographers of Japanese women working on Hawaiian sugarcane plantations. Some date back to the 1890s, when the first wave of immigrants was arriving from Japan as exploitable labor for white plantation owners, and women came as picture brides. Women laboring as field workers and laundresses, or in elite resort hotels as servants during the 1920s, are typically posed as compliant curiosities for the camera, or effaced at the photograph's margins, as the prosperous *haoles* (whites) leisurely occupy the center. Bathing female field workers are photographed as half–naked primitives, objects of the ethnographer's mastery. Still other images are productions of wartime propaganda and tourism.

Why don't you touch it, put your hand on it? she thought. But her mother sat mute, hands folded. She felt the roaring inside.

A sensation of intimacy is felt, peering into the hole. A quiver of fascination, of repulsion at the sight of the alien other. But also a yearning for the

familiar, as the artist might have experienced, recovering the traces of her deceased grandmother, an *issei* (immigrant Japanese) picture bride who lived the harsh life of a laundress on a plantation like these photographed women.

What was this stain on her flesh? Something that marked her birth, marred the canvas before the brush had even been raised. She felt her breast, hot and burning. She moved away from the mirror.

On the wall, lengths of gauze are suspended like ghostly surrogates. One bears a small protrusion filled with clippings of black hair that slip through the fabric's weave. The protrusion possesses an astringent, perverse beauty, and functions metonymically to refer to the raced, gendered, sexual body. Growthlike in formation, it suggests how racism is internalized; how notions of beauty and normalcy can be turned against oneself.

The black seeped deeper and wider. It would stain him if he touched her again.

The same pouch of hair appears in multiple on the wall opposite, severed from the body: uncanny and tenacious, fetish-like, they persist as evidence of self-othering, and the oppression inherent in women's ceaseless, arduous labor. For the artist, the pouch is reminiscent of the netted bun of her grandmother's hair, and the pincushions, similarly stuffed with hair clippings, once typically used by *issei* women for sewing. The crafting of these pouches, one after another, stages the repetition that reenacts yet subsumes desire.

Viewer looking at one of the nineteenth-century photographs of Japanese in Hawaii, enclosed in the box

Below: Photograph of women and children bathing, c. 1890, W. T. Brigham Collection, Bishop Museum, Honolulu, Hawaii

In "Night Waters," as in past work, artist Lynne Yamamoto uses metonymic elements to invoke the body of the Asian-American woman: the history of that body, its experience. The potency of their affects disturbs viewers; impels them beyond images from official history to glimpse the inherited psychic violence of colonialism.

It was raining. She felt weak. Her clothes were soon soaked, yet she felt dry beneath, withered; that she would never be rejuvenated by this wetness. She went home to her room where she slept, and dreamt of hiding in crisp autumn leaves. In the morning, her mother floated into her room, sat by her side whispering, "you look so pretty," lips brushing her forehead.

KERRI SAKAMOTO

1. Stuart Hall, "New Ethnicities," in *Black British Cinema*, ICA Documents #7, London: Institute of Contemporary Arts, 1988, p. 28.

The writer thanks Ruth Libermann for her comments.

WINDOW INSTALLATIONS

RECENT ARCHEOLOGICAL FINDINGS FROM THE LATE 20TH CENTURY

Dina Bursztyn

OCTOBER 9-NOVEMBER 13, 1993

DINA BURSZTYN My urban artifacts are an attempt to integrate the old and the new, while combining lyricism, social issues, and humor.

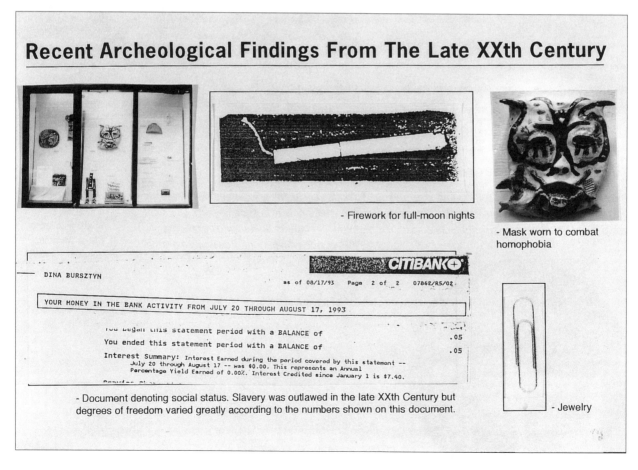

Recent Archeological Findings From The Late XXth Century

- Firework for full-moon nights

- Mask worn to combat homophobia

DINA BURSZTYN

CITIBANK⊕

as of 08/17/93 Page 2 of 2 07862/R5/02

YOUR MONEY IN THE BANK ACTIVITY FROM JULY 20 THROUGH AUGUST 17, 1993

You began this statement period with a BALANCE of .05
You ended this statement period with a BALANCE of .05

Interest Summary: Interest Earned during the period covered by this statement --
 July 20 through August 17 -- was $0.00. This represents an Annual
 Percentage Yield Earned of 0.00%. Interest Credited since January 1 is $7.40.

- Document denoting social status. Slavery was outlawed in the late XXth Century but degrees of freedom varied greatly according to the numbers shown on this document.

- Jewelry

THE SURVIVAL OF THE INNOCENTS Paul Pfeiffer

NOVEMBER 20–DECEMBER 18, 1993 In conjunction with A Day Without Art

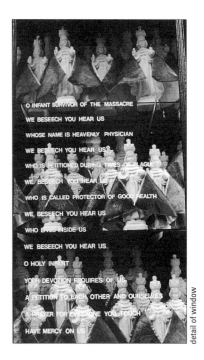

detail of window

The Biblical story of the Massacre of the Innocents recounts the violent slaughter of newborn children decreed by King Herod to preserve his throne from the prophesized coming of an infant king.

Using the image of the Blessed Infant—the sole survivor of the massacre—as a symbol of physical and spiritual survival, *Survival of the Innocents* reinterprets the Christian myth as an allegory about the AIDS crisis. Taking its cue from botanica window displays and Philippine tradition of *virinas,* in which devotional tableaux in a glass case enshrine prayers and vows, this virinas serializes the Infant to challenge narrowly defined notions of innocence and guilt around HIV/AIDS. The Christ Child popularly embodies the asexual innocence of childlike purity. By multiplying the Blessed Infant a hundredfold, *Survival of the Innocents* rejects the archetype of innocence as a singular bodily essence and its moral legacy of purity, versus sexuality or drug use—the catchwords for judging whether "one brings misfortune on oneself," or whether one is an "innocent victim" of AIDS.

Each displayed icon wears a blood-red mantle adorned with gold HIV symbols. Together they form an army of survivors, the symbolic executors of a vow for the transformation of culture in the Age of AIDS. The rows of statues face the street, drawing viewers into a meditation on the genocidal proportions of political and personal indifference in the AIDS crisis.

PAUL PFEIFFER

PAUL PFEIFFER My work explores identity and community issues from a queer Filipino-American perspective. Religious symbols are merely the most potent icons I know of longing for wholeness and belonging.

PERSISTENCE OF RITUAL NO. 2 Michael Bramwell

JANUARY 15–MARCH 5, 1994 In conjunction with the Elevator Audio Project (page 79)

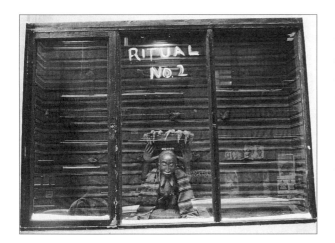

MICHAEL BRAMWELL "This poor man cried, and the Lord heard *him,* and saved him out of all his troubles. The angel of the LORD encampeth round about them that fear him, and delivereth them." (Psalm 34:6–7)

Persistence of Ritual No. 2 explores how consumer culture restructures object-meaning and conditions patterns of commercial behavior. *Gallus domesticus* (chicken), once admired as a ceremonial object in 1500 B.C. Africa, and esteemed as a symbol of fertility, pride, and timekeeping ability, has been reduced to just another commercial object. This tendency to experience objects and people in materialistic (commercial) terms has diminished the spiritual dimension of life, once valued and expressed in ritualistic behavior. What has happened to the chicken since its introduction into American society is a symbolic metaphor for the current state of contemporary life.

MICHAEL BRAMWELL

HEART'S DESIRE—MY LIQUID RICE

Arlan Huang

MARCH 12–APRIL 30, 1993

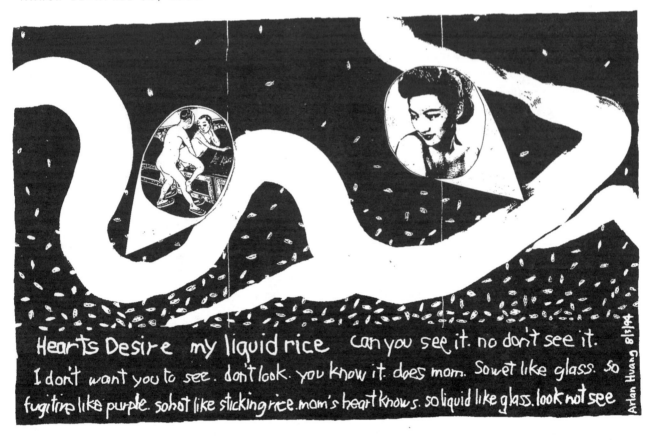

Hearts Desire my liquid rice can you see it. no don't see it.
I don't want you to see. don't look. you know it. does mom. So wet like glass. so
fugitive like purple. so hot like sticking rice. mom's heart knows. so liquid like glass. look not see

Arlan Huang 8|3|94

PINK PROJECT

Portia Munson

MAY 13–JUNE 25, 1994

"Pink" dates from the sixteenth century; its origins are unknown. Its many meanings as a noun include a kind of flower or army officer's trousers. "Pink" is an elite condition of quintessence; a person dressed to the height of fashion; "in the pink" means in the best of health or situation. As an adjective it suggests subjectivity, an emotional or excited disposition ("tickled pink"); "pinkos" lean to the Left politically. To pink is to ornament, or to cut (with pinking shears) a sawtooth border; more insidiously, it's also to pierce or stab, to wound with words (a "woman's weapons"), using irony and ridicule. Pink elephants are alcohol-induced hallucinations; the threat of the pink slip hangs over underpaid pink-collar (secretarial and clerical) workers if they complain.[1]

Portia Munson's mesmerizing "Pink Project" explores the paradoxical condition of femininity as both elevated and debased in contemporary commodity culture. Her found pink objects connote adornment and the cult of beauty, lowly tasks, and sexual aberrations. Some cruel, unconscious cultural joke must lie behind the tinting of dildos, baby pacifiers, tampon applicators, fly swatters, French ticklers, powder puffs and hair curlers, styrofoam meat trays, princess telephones, and vibrators, with the shades of a color associated with both girl-

ishness and female genitalia.

With the *objet trouvé*, artists began to swap individualistic, Romantic vision for quotidian popular culture. Munson's rose-colored glasses reveal a world in which everyday objects are tinged with sexual meaning; we sense that what we see here is a small part of a seemingly infinite collection. It's as if, some eighty years later, Duchamp's urinal had woken from its long sleep, and found itself in the ladies' room. Do we color these objects, or do they color us? When you next reach for a packet of a popular saccharine product, take a moment to consider that its sickeningly pink paper envelops a carcinogen destined specifically to address anxieties surrounding "excessive" feminine corporeality; this little-girl tint will lose its innocence indefinitely.

LESLIE CAMHI

1. All definitions of "pink" are taken from *Merriam Webster's Collegiate Dictionary*, 10th edition.

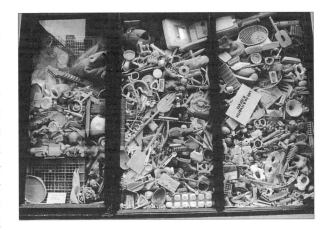

PORTIA MUNSON My pink collection assembles objects connoting at once little–girlness, lowly tasks, and sexual aberrations. Through accumulation and juxtaposition, pink, a sign of femininity, is exposed in its full range of culturally ambivalent meanings, and colors even "innocent" objects with insidious connotations.

KENNEL
Christina Bothwell
JULY 1–SEPTEMBER 10, 1994

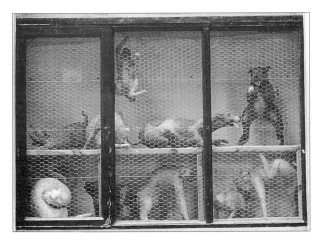

CHRISTINA BOTHWELL I am interested in the juxtaposition of diverse elements, particularly the tension that exists between beauty and decay.

Living full-time in the city and being nature-deprived, I find more and more that the dogs I see have become personal symbols for the common and modern dilemma of man cut off from the natural element and enslaved to manically striving for some happiness outside himself. The dogs in *Kennel* are made in a variety of materials, from sewn, stuffed rubber to encaustic waxes mixed with pigments poured over cast and shrunken handmade paper and plaster. Based on the infamous puppy farms where the cramming of dogs into filthy, crowded enclosures without food and water is the norm and where dogs are forced to stand in their own filth with untended wounds, this project began as a commentary on our society's lack of humanity and respect for life, and then evolved to focus on the spark of creativity inherent in each individual. The intent of the sculptures is not to make a political statement, but to express that quality of energy under restraints that through its own volition always creates a way out, an opening, to greater possibility.

CHRISTINA BOTHWELL

ELEVATOR AUDIO PROJECTS

38 Seconds Average Travel Time

MARKING/MAKING TIME

"Our attention shifts effortlessly from a passing automobile or humming of electronic equipment to the inner voice. Yet, in between the constant switches from inner to outer, there are minuscular pauses. Those are the existential moments."

—"Ear," Mediamatic, vol. 6, no. 4

I hate waiting.
I seldom have the patience to sit through
time based art, particularly in the blank space of the gallery.
Those recorded, guided tours never work for me.

I fidget; my attention wanders at concerts,
is lead to other things: I am bored and/or inspired.

The focus is different, better in a lift.

One is, of course, a captive audience, though that doesn't mean one has to listen. You might not even be expecting anything and are surprised when you realize that it is not just the typical hum and rumble of the machine moving. Physical source is hard to identify but it is clear there is somehow an unseen operator. (*"Made you look!"*)

LOCATION LOCATION LOCATION

The sound relocates you anyway.

Is it any different going up or going down?

"It's not really automatic—you have to press the button"
—and what if you press the button...and nothing happens?

And if there is a pause in the mechanism—if the tape is between cycles and you hear only silence, how long do you wait?
And, if you are not alone,
conversations stop, change, modulate, become different,

become muted—
or are highlighted, willfully continued at the same volume and tempo or even
more so: becoming brasher,
willfully unself-conscious;
or more self-conscious in the confines
of the small space.

You never know who you might meet up with, who you might be stuck with
in sudden, forced intimacy—
do you acknowledge each other?
Unlike strangers on a train
with the luxury of time
in which to sprawl.

Or are you alone but still hearing voices?
A surveillance of other scenes, but as if *you* are being watched.

IS THIS THING WORKING?

(*"I'll take the stairs"*)
And if the cable snaps or the thing jerks to a stop
are these the people with whom you will spend a long moment?
—or your last one? In this small box?

A moment defying gravity.
Wait until the elevator is just about to start, to descend, and...
 —Jump!
You are for a moment suspended and then, before your brain can even process it,
take it in, you are free-falling until you hit the floor of the elevator, being let
down at its more controlled rate...

Not knowing the real source of those sounds you hear, and the pieces them-
selves delivered as if overheard, no visible means of support, of transmission.
The secret shared.
But controlled, massaged, spun.

The lift is a distraction in and of itself:
where you imagine what the unknown will be like,
what will be upstairs or back outside,
how it was when you'd been here before...

And the mechanism: so obvious, so hidden,
the stuff of horror, science fiction —
claustrophobia/paranoia.

THE THINGS YOU HEAR...

The small box in motion, an unusually close public space shared for a short
time—which can stretch out or become the most ephemeral experience of all. The
elevator is a unique place: the utilitarian device on the way to the main event— the
show, maybe a meeting, socializing. The subjective attention span bred by MTV is
one thing, but with such limited objective duration, attention is not so much the
issue as the content that can be provided in such a brief period of randomly
accessed time.

continued on p.80

ELEVATOR MUSIC

Tom Burckhardt

SEPTEMBER 10–OCTOBER 2, 1993

TOM BURCKHARDT My Elevator Music piece could be described as anti-Muzak in the way it calls attention to the weird social space of elevators. Elevators always seem like sad places to me.

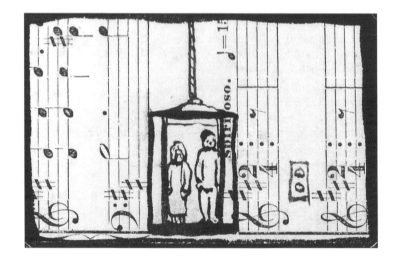

HAVE A NICE DAY

Anne Torke

OCTOBER 9–NOVEMBER 13, 1993

ANNE TORKE My work uses experimental video narrative, audio installations, and performances to dissect, expose, and explore interpersonal relationships in the contemporary urbanscape.

'Tell me to have a nice day.'

'Tell me to have a nice day.'

'Tell me to have a nice day.'

'Tell me to have a nice day, ok?'

THE ELEVATED EXAMINATION OF THE CARTESIAN SPLIT

Conway and Pratt

NOVEMBER 20–DECEMBER 18, 1993

CONWAY AND PRATT As collaborators since 1986, we create densely layered site-specific multimedia installations and performances, which take several years to develop, and which incorporate complex sound tapes, super-8 films, assemblage pieces and art books.

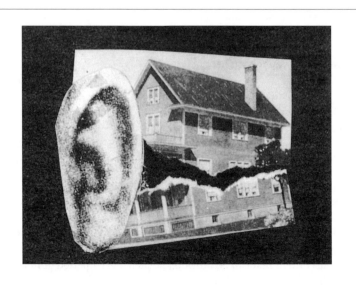

PERSISTENCE OF RITUAL NO. 2

Michael Bramwell

JANUARY 15–MARCH 5, 1994

THE LIL TAPE

Carole Ramer

MARCH 12–APRIL 30, 1994

CAROLE RAMER I wanted to get beyond the pathetic humor of my lifelong subjection to a living cliché of every mother to show how the power of negative thinking and complete self-absorption sabotaged Lil's life.

NO MEANS NO

Ann-Sargent Wooster

MAY 13–JUNE 25, 1994

ANN-SARGENT WOOSTER My multifaceted video and audiotape on dating and rape addresses this problem in three languages and multiple points of view from abstract to real, video art to documentary, subjective personal imagery to real-life stories. In all my multimedia work, listening is as important as looking.

continued from p. 77

Each of the works in this series provides a different address to the space, its function, and the contexts it can provide:

HAVE A NICE DAY

A single female voice telling a tale—a rant, really, the same *paranoia* of strangers on a train but NYC circa 1990 something, one 90-second loop of a single insistent female voice escalating to almost a frenzy, and only *almost* released, most likely the moment before or after one has joined the car, like passing some strange social interaction or personal monologue on the city street and continuing on because you have business somewhere else or don't want to get involved or stay to study it, because you recognize something you haven't heard before, but something human, yet startling...

ELEVATOR MUSIC

Literally: dental office goes gamelan, playing off an elevator's own tones: the synthetic *ping* and *dong* as it moves by each floor.

Really a *nice* loop of a melody—like a ride all the way up and down without stopping to get off—embracing the fragmented presentation allowed by the mechanism by providing constant continuity: you can get on or off at any point—go on about your business—and it makes no difference, you won't find any resolution (or commencement) here, and it's very easy to listen to while you don't.

NO MEANS NO

The elevator as metaphor for the feeling of being trapped, where it's easier to go along for the ride. Overlapping anecdotes by a female who couldn't say "No," or was misunderstood (a male voice interrupts —*"When she said 'No,' she really meant 'Maybe'"*) and almost audible beneath her story other voices (male and female, sometimes in other languages) as if simultaneously contrast, translation, or an undermining subtext.

THE LIL TAPE

Intense self-portrait of a mother's ongoing *kvetch* to her daughter with sound-track of period pop songs accompanied by color Xerox images of gaudy mom and her blown-up text. This, and the direct address, cause one unavoidably to become involved, implicated, and to empathize even while one will cringe.

PERSISTENCE OF RITUAL NO. 2

In conjunction with the window display downstairs (the take-away fried chick-en held up by a West African statuette) one is greeted by a series of samples— less than sound bites— mostly of folks giving their orders at a fast-food joint. These short clips lead nowhere knowingly, save as fragments that accrete to signify a premade form.

This time the disembodied voice recalls the speaker of the inanimate clown (the Colonel, Ronald, and Jack—caught in a different box)—only here it doesn't listen, *won't* take any order, but just demo an already established program. Or, the passenger becomes the jack-in-the-box, experiencing the onslaught of repetitive orders: fried chicken, dark and light meat, wings and thighs...

THE ELEVATED EXAMINATION
OF THE CARTESIAN SPLIT

More obsessive collecting (see Art in General exhibition, spring 1993): a voice enumerating matter-of-factly someone else's compulsive spirit getting out of hand, moving from one random fetish of the mundane to another; each is

more meaningless (and ridiculous) than the last, until some sort of sublime saturation is reached...and the listing of things still goes on and on...*ad nauseam*.

And this reinforces the comforting spartan quality of the elevator box where no great physical clutter can penetrate, much less accumulate. The freight collected here is passengers—and their psyches.

The Elevated Examination... provides the best strategic take on the limited, fragmentary time frame allowed by the ride, since it is impossible to gather it all—all of anything, in any time frame. One thing leads to another, endlessly, until the compartments of the brain threaten to fill up and spill over, unable or unwilling to follow along the list.

The compartment of the lift spills out eventually, thankfully, since this profuse cycle of collecting threatens to never stop.

BRIAN KARL

S P E C I A L I N S T A L L A T I O N

LA ULTIMA TOILETTA

Christa Black and Robert Chi

NOVEMBER 20, 1993–JUNE 25, 1994

CHRISTA BLACK AND ROBERT CHI Art serves no purpose. We, as artists, have no function. We are not artists; we celebrate life.

Created for Art in General's bathroom, this art-installation parody critiques the commercial excesses of the contemporary art world in a sardonic tribute to artists who have achieved great financial success. Left: detail of toilet paper rolls with mannequin piss insignia, which were displayed against purple draperies and multicolored painted walls. Right: excerpt from "La Ultima Toiletta." The song, irreverently set to Bizet's aria "La Habanera" from the opera *Carmen*, includes the names of artists whose works sell for $20,000 and above

PUBLIC PROGRAMS

Artist Talk,
December 4, 1993

OCTOBER 16, 1993
Art in General Fall Benefit
SoHo Artists' Studio Tour, conducted by Eleanor Heartney,
Anne Pasternak, and Eugenie Tsai;
Reception at Dennis Oppenheim's
studio

OCTOBER 20, 1993
Poetry and Prose Reading
Charles Simic and Nadja Tesich

OCTOBER 27, 1993
Video Screening
Marina Abramović, Victoria Vesna
Bulajić and De Stil Marković, and
Maja Zrnić

SEPTEMBER 13, 1993
Slide Talk
"Women in Contemporary Cuban
Art" by Erena Hernandez, of the
Center for Development of Visual
Arts, Ministry of Culture,
Havana, Cuba

OCTOBER 13, 1993
Poetry and Prose Reading
Ira Cohen, Vincent Katz, Vladimir
Pištalo, and Nina Živančević

OCTOBER 30, 1993
Artist Talk
Zoran Belić Weiss, Vesna Golubović,
Vlasta Volcano Mikić, Vladimir
Radojičić, and Maja Zrnić;
Moderated by Andrev Veljković

Art in General's
Resource Room
during the exhibition
of Emma Amos
"Changing the
Subject"

Solidarity Event (performance, video, and slide show)
Miodrag Lazarov Pashu, Dr. Raphael Montanez Ortiz, Ivo Škorić, Miha Vipotnik, and Milan Trenc

Music Concert
Music by Dušan Bogdanović, Vuk Kulenović, Marjan Mozetich, Michael Pepa, and Milos Raickovich; performed by Georgia Kelly, Dorothy Lawson, Djurja Mirković, Gabriela Mangini, Mauricio Molina, Nicola Radan, Maria-Olga Piñeros, Michael Sanita, Jillian Samant, Nell Snaidas, Daniel Swenberg, and Vlanada Zorjan

Video presentation by Veran Matić from B92, the Independent Belgrade Radio Station

Artist Talk
Charles Yuen; Moderated by Holly Block

Artist Talk
Artists from "Good and Plenty"; Robert Chi and Christa Black; Moderated by members of Artists Advisory Board

From left to right,
Karen Porter,
Emma Amos, and
bell hooks at
Art in General,
March 12, 1994

DECEMBER 11, 1993
Artist Talk
Michelle Charles, Gail Goldsmith,
Stacy Greene, and Zhang Hongtu
Paul Pfeiffer; Conway and Pratt;
Moderated by Holly Block

DECEMBER 18, 1993
Art in General Holiday Party

JANUARY 19, 1994
Video Screening
Prudence Brown and Diana Casillas,
Yun-Ah Hong, and Jocelyn Taylor;
Organized by Jocelyn Taylor

FEBRUARY 5, 1994
Artist Talk
Artists from "Gathering Medicine";
Moderated by Carole Byard

FEBRUARY 6, 1994
Artists Cooking for Art in General
Benefit Dinner at Jacob el Hanani's
studio

FEBRUARY 19, 1994
Artist Talk
Ingrid Bachmann; Michael
Bramwell; Moderated by Holly Block

FEBRUARY 23, 1994
Storytelling, Poetry, Performance, and Music
Coatlicue-Las Colorado, Kimoko
Hahn, Sheryl Boyce Taylor, Lydia
Ramirez, and Jin Hi Kim; Organized
by Carole Byard and Donna
Thompson, Coast to Coast: National
Women Artists of Color

MARCH 2, 1994
Dance, Poetry, Reading and Performance
Suzana Cabañas, Laurie Carlos,
Beverly R. Singer, and Marlies
Yearby; Organized by Carole Byard
and Donna Thompson, Coast
to Coast: National Women Artists
of Color

MARCH 11, 1994
Art in General Book Party

MARCH 23, 1994
Slide Talk
"Contemporary Eastern European
Artists" by independent curator
Laura J. Hoptman

MARCH 26, 1994

Artist Talk

Artists from "Little Things";
Moderated by Eleanor Heartney

APRIL 9, 1994

Art in General Spring Benefit

SoHo Artists' Studio Tour, conducted
by Petra Barreras, Saul Ostrow, and
Walter Robinson; Reception at collec-
tor Thea Westreich's office

APRIL 16, 1994

Artist Talk

Emma Amos

MAY 18, 1994

Artist Talk

Artists from "What Is Art?";
Moderated by student Paula Medaglia
from ABACA's Visual Thinking
Program

MAY 25, 1994

Artist Talk

Lynne Yamamoto; Portia Munson;
Moderated by Holly Block

JUNE 1, 1994

Writing Workshop

Conducted by Critic-in-Residence
Linh Dinh with artists from
"Animated". Funded by Mid Atlantic
Arts Foundation

Slide and Gallery Talk

Conducted and moderated by Linh
Dinh with artists from "Animated"

Above: Critic-in-
Residence
Linh Dinh (center
with glasses)
at the opening of
"Animated,"
May 13, 1994

Below: Students
from Visual Thinking
Program at Satellite
Academy with
their teachers and
ABACA (Arts
Benefit All Coalition
Alternative)

members at the
opening of "What is
Art?," May 13, 1994

SPLIT IDENTITY: Martin Weinstein and Holly Bloch look at an Emma Amos painting at the Walker St. Gallery of Art in General.

'LITTLE TINGS': A painted wood sculpture by Emily Feinstein at Art in General.

PHOTOS BY MARSHA LIPTON/NEWS

The Industrial Evolution

How a family tool business developed its own cutting-edge

By ANN HORNADAY

Martin and Gerald Weinstein have always appreciated the esthetics of form and function.

In fact, it's in their blood.

Their great-great-grandfather Harris Rosenberg worked as an apprentice metal worker on the gates of the Vanderbilt mansion, which was built where Bergdorf Goodman now stands. "That could be where it started," Martin speculated recently as he guided a visitor through General Tools Manufacturing Company Inc., the firm his family has owned since the 1880s.

The spare offices at 80 White St. are unprepossessing and unadorned, save for displays of the plumb bobs, burring reamers, and calipers for which the company is renowned. But five floors up, the atmosphere changes and General Tools becomes Art in General.

On the fifth floor, you will probably see more contemporary sculpture than countersinks and drills: more expressionist paintings than edge finders. Art in General, a nonprofit art gallery founded by Martin Weinstein and a group of artists in 1981, presents five to seven group exhibitions a year. At first glance, the contemporary installations in the gallery are at odds with the more utilitarian fare downstairs. But in fact, Art in General is as natural a part of the company's history as doweling jigs.

Artists and businessmen

Since 1922, General Hardware (renamed General Tools last year) has had offices in Manhattan's hand-tool district, a three-block shard of the island near the edge of Chinatown. In 1980, General ran out of room in its White St. offices, and broke through to the building behind it, on Walker St.

"But General Hardware only needed the lower floors, for shipping and packing," says Martin, who, in addition to packing boxes for the company, was pursuing a career as a painter at the time. "There was this empty floor

sitting upstairs, and I got together with some artist friends, and said, 'Let's do an exhibition.' "

"We did one show the first year, two shows the second year, three shows the third year, and built up," says Martin. "We started out sending 400 invitations to our openings; now we send 7,500." Some 20,000 people now visit the gallery each year.

Martin, whose paintings have been exhibited internationally, shouldn't be

BROTHERS OF INVENTION: Gerald and Martin Weinstein on the loading dock of General Tools.

mistaken for the family renegade; dedication to both tools and art has run in the family since great-grandfather Rosenberg first wrought his influence on the Vanderbilt gates. Even Abraham Rosenberg, Martin and Gerald's grandfather, who started General Hardware, had an artist's sensibility.

"He was an idea man," says Gerald, 44, chairman of General Tools, and a photographer. "My Grandmother made the money. But they also collected art." That tradition, Martin adds, "really carried over into the next generation. Our mother ran General Hardware after her father died, and our father was an artist."

The company donates both the sixth and fourth floors as exhibition spaces to Art in General, and pays for the gallery's utilities and renovations. Instead of being a tax write-off, the

gallery comes under the company's operating expenses, according to Gerald Weinstein. "The surprising thing is, it's not that big of a strain on the business," he says. Martin adds that businesses that donate experimental art spaces in New York are rare. "Big companies may open a branch to show the same things that are shown in museums," he says, "But they do nothing to foster the grass-roots development of artists."

Grass-roots success

Art in General is dedicated to providing emerging artists with entry-level exhibition space. Anyone can submit slides, which are reviewed by a revolving panel of artists and art professionals. "Everything gets looked at," says Martin Weinstein. The term "emerging," says executive director Holly Block, "can mean anyone — we've had an 85-year-old painter and a 72-year-old woodcarver showing with 23-year-olds."

Kitty Carlisle Hart, chair of the New York State Council on the Arts, commends Art in General for nurturing the city's cultural life. "The major institutions bring in the big tourist money, but we need these alternative spaces in order to allow the young people to get into the game."

Ronald Feldman, a gallery owner in SoHo, says of his fellow dealers, "We aren't current unless we're catching what Art in General is doing. They give us a lot of leads, and a sense of what directions artists are taking."

Downstairs at 80 White St., General Tool employes load shipments of drill point gages, burring reamers and tubing cutters, oblivious to the finishing touches being put on the 93-work "Gathering Medicine" show upstairs. The only art in General is the portrait of founders Abraham and Lillian Rosenberg in Gerald's office. The parallel lives of General Tools and Art in General are right in keeping with their values, says Martin. "They were both from hardware families, and they both loved art," he says. "I think they would approve."

"**Gathering Medicine,**" a component of "The Women's Health Show" sponsored by the Women's Caucus for Art at Art in General, is equally a body of considered transformational work. My first day out, I move an office chair on wheels forward by inches on my "good" leg, stopping beside each of the 90 objects.

Organizers Carole Byard and Miriam Hernández state outright that medicine is an art that relies heavily on the skill of the healer and the faith and determination of the patient. The slowness of my procedure helps me to stay with the works. They are not to be merely observed but activated by my awareness. Coast to Coast, like Swartz, wishes to bring about the pattern shift required to reverse discord and oppression.

As an act of reclamation, "Gathering Medicine" artists made power objects in forms suggested by the curators: pouch, chest, vial, chant, totem, amulet, formula, chart or card, potion, shrine, rattle, talisman, self-help tape. Small sculptures, constructions, and paintings sported dried vegetation, earth, rocks, skin, hair, body fluids, metals, and plastic.

A collagist sensibility and highly visceral means use plenty of raw parts. Chicken-bone legs, silver-limb amulets, the extremities of portraits and self-portraits are prominently incorporated or noticeably amputated.

The path to setting humanity on its collective legs is strewn with severed members surviving broken promises. Sorrow and rage as tears and blood stand for corporeal and chemical revolutions of the flesh.

Nails protrude from all sides of Ana Ferrer's *St. Lazaro-Babalu-Aye.* Suffering can be dangerous; the cure, fatal.

Clarissa Sligh's *Enough* contains a naked female figure in a frame on which the prescriptive "to heal our scars and wounds, know what we are is enough" is written. The revolution is of perception; the evolution, to the origin.

By Arlene Raven

DAILY NEWS ● Wednesday, March 16, 1994

Lynne Yamamoto has been showing conceptual objects inspired by the journey her relatives have made from Japan to colonialist America. Yamamoto's grandmother was brought to Hawaii as a mail-order bride; she worked as a laundress most of her life until her suicide. Her grandmother's biography has been embedded in a series of works taking on the legacy of colonialism and more contemporary versions of the same racism. Yamamoto is one of the strongest and most original artists negotiating the minefield of ethnicity and identity. The materials of her objects, usually readymades, have an immediate poignancy. Hair, highly valued in Japanese culture, has become Yamamoto's signature image. While this has been the year for hairpieces, Yamamoto owns this material.

This is one of the artist's most ambitious, but least successful, installations. Nine pine boxes, which look a little like blue birdhouses, sit on the floor of a dimly lit gallery. Each box has a small hole about the size of a coin, inviting us to look in; we quickly realize that it's necessary to kneel before these containers to see inside them. The problem is, the viewing conditions make it impossible to see the images inside. We peer into these tiny openings only to be frustrated. Without the handout in the gallery, we would never know that these coffins contain historical (mostly early-20th-century) photographs of Hawaiian laborers—plantation field workers, women serving tea and sewing bandages. It's a shame. This is work we want to see.

Pods of hair, tied up and netted in buns, are clustered on a wall of the gallery. Yamamoto treats these fetishistic mounds with spiritual reverence, paying tribute to her grandmother and to generations of working-class women. The atmosphere in this installation is potent, but particular images can't endure because they can't be deciphered. ∎

OUT OF SCHOOL

To organize **"What Is Art?"** six high-school student curators did what so many professional exhibition organizers do: They began by poring over slides in the files of **Artists Space**, **Art in General**, and the **Drawing Center**. They settled on the show's open-ended theme because of their disagreements about what to include, according to curators **Sinnia Cotto** and **Ernesto Rivera**. "There was plenty of horse trading," Rivera chuckled. Although the nine-person show of African American and Latino artists doesn't quite embody its capacious theme, it does stake out a wide swath of contemporary expression. **Elaine Soto**'s painterly triptych of the Virgin complements **Renée Cox**'s photo self-portrait with child; **Ernesto Pujol**'s quirky images of Cuba adrift in sharky seas contrast sharply with **Michael Bramwell**'s self-effacing and pointed facsimiles of USDA surplus food-distribution boxes.

The curators are students in artist **Kara Lynch**'s "visual thinking" class at **Satellite Academy**, an alternative high school on the Lower East Side. Lynch's class is funded through the **Arts Benefit All Coalition Alternative** (ABACA), a consortium of five nonprofits comprising those with the slide registries mentioned above, as well as **Franklin Furnace** and the **Lower Manhattan Cultural Council**. Predicated on the philosophy of educational theorist **Abigail Housen**, visual thinking encourages criticality—not to mention consideration of big questions like "what is art?" Rivera not only believes that "art makes you more open to the world," but that he'll become a professional curator. "I'll be going to art or art history school," he breezily confided. The show is up at Art in General through June 25; you can meet the curators and artists at 7 p.m. on May 18.

Art

SCENE & HEARD Robert Atkins

Art in America

February 1994

L. Alcopley at Art in General

L. Alcopley's abstract paintings are marked by an odd tension between abandon and control. Huge, isolated brushmarks sweep across monochrome fields of rich color. The strokes may be solitary marks skidding with a ripple across the canvas; or they may come in pairs or triplets that loop, coil or cross each other. Each stroke appears to have been made with an oversized brush only partially loaded with paint, so that bits of the ground show through. One can follow the striations made by individual brush hairs and almost feel the pressure as the brush bears down more or less heavily on the canvas, depositing varying amounts of paint in its wake. As a result, the strokes have an almost sculptural presence. They seem to float in visual detachment from the bands and fields of color beneath them.

A superficial reading might relate these paradoxical brush-strokes to the deconstruction of painterly gesture practiced by artists like Roy Lichtenstein, David Reed and Gerhard Richter. But while those artists' brushstrokes parade their artificial quality, the uneasiness in Alcopley's paintings seems to come from another source. Alcopley, who died in 1992, had two identities. As an artist, he showed and socialized with the New York School, participated in the historic 1951 Ninth Street Show and counted among his close friends such luminaries as Jean Arp, Sonia Delaunay, Jean Dubuffet and Willem de Kooning. As the scientist Alfred L. Copley, he pioneered the sciences of hemorheology (the flow properties of blood) and biorheology (the flow properties of all biological matter).

In his writings, Alcopley mused frequently about the relationship between art and science, both in general and as it manifested itself in his own work. Though he cautioned against literal readings, he suggested that his scientific interest in the theory of flow stimulated his artistic fascination with the thrust and movement of gestures in space.

As a result, it seems possible to relate the incongruity of gesture and ground in his paintings to the different habits of mind required by science and art. In this exhibition of work from the years 1970 to '90, Alcopley's brushstrokes are at once free and fixed. They curl and twist across the canvas like records of a spontaneous movement, yet the ground, which often seems to have been painted around them afterward, binds them to the canvas with a deliberation that seems premeditated. The intriguing mix is further augmented by the inclusion, in many of the works, of a border pattern. Composed of broken dashes or uneven rows of little boxes, this border both standardizes the composition and flaunts its own irregularity.

Thus order and freedom are both given their due in these paintings. It may be Alcopley's willingness to acknowledge the necessity and the irreconcilability of these two principles which gives his paintings such a contemporary feel. While he came to maturity during the heyday of Abstract Expressionism, his late work speaks directly to our own far more equivocal age.

—Eleanor Heartney

L. Alcopley: *Ease*, 1980, oil on canvas, 50 by 94 inches; at Art in General. (Review on p. 108.)

New York PRESS

MAY 18–24, 1994 "NEW YORK'S FREE WEEKLY" VOL. 7, NO. 20

Ingrid Bachmann
Speaking Sites / Dialogue: Ingrid and Plato

January 15 to March 5

Art in General, 4th floor

79 Walker Street

212 219-0473

Using Plato's Socratic Dialogues as a loose model, this installation transforms the gallery space into a giant chalkboard. Bachmann invites viewers to respond to drawings, stories and quotations on the floors and walls throughout the duration of the installation. The artist will give a gallery talk on Saturday, February 19, 3:30pm.

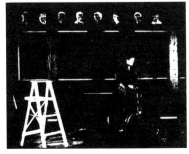

Speaking Sites Dialogue: Ingrid and Plato

GALLERIES

◆ **Art in General**, 79 Walker St. (betw. B'way & Lafayette St.), 219-0473. Every inch of gallery and adjacent space (street window, elevators, bathroom & stairway) crammed with art, not merchandise. Shows culled from selection of over 2000 artists' slides on file. "Animated," group exhibition of paintings, drawings & sculpture that derive inspiration from comics: Diego Guitierrez' band-aid/stick-on drawings, Jane Fine's high key abstract paintings, et al. Laugh-out-loud funny and visually compelling. Reference room w/ books used by artists provides insight into works and process [through 6/25].

JUNE 1–7

Wednesday

ANIMATED

A gallery talk at Art In General in conjunction with *Animated*, a group show full of pure pop for now people, moderated by poet/artist/curator Linh Dinh. Though Koons hovers over some of these works, others display an earnest and funny adaptation of the comic form (Michael Carroll's *Pubina Comics*, Melissa Marks' *Adventures of Volitia—The Abstract Vagina* and Jane Fine's *My Definition of a Bombastic Drip*, to name a few). Weds., June 1, at 7 p.m. 79 Walker St. (betw. B'way & Lafayette St.), 219-0473.

—SERVETAR

Styles
of The Times

Objects and Objets

Art by Emma Amos and from the Musée des Arts Décoratifs, New York, March 11 and 12.

RIGHT March 12, 7:10 P.M.: **EMMA AMOS**, right, with **SAPPHIRE**, left, a performance artist, at the opening of an exhibition of Ms. Amos's work, "Changing the Subject: Paintings and Prints," at Art in General, a gallery in TriBeCa. Ms. Amos was the only woman in the Spiral Group of African-American painters in the 1960's.

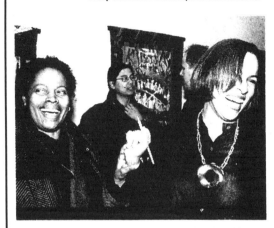

ART

The curated bathroom: The "Bad Girls" show at the New Museum of Contemporary Art includes songs by female singers like Ethel Waters piped into the bathrooms. The Art in General gallery is featuring an art-installation parody in the bathroom itself, called "La Ultima Toiletta."

●

TRIBECA

Art and Music Offered In Tribute to Yugoslavia

As part of an exhibition entitled "Remember Yugoslavia," Art in General, a gallery in TriBeCa, will present on Wednesday a concert of Yugoslav music ranging from modern experimental works to ancient Balkan compositions.

Sunday, April 3, 1994

The exhibition features nine artists from what was once Yugoslavia with a wide range of media and styles. One piece, "Gods Eat Immortality: A Sarajevo Calendar," is fashioned from faux-archival packages of moldy bread. Another piece plays off military recruitment ads. Vlasta Volcano Mikić will show his "Signs Along the Road" (detail pictured above).

"Lack of cultural identity, anxiety, pain and distrust have become a part of our everyday lives," said Andrev Veljkovic, an artist who organized the event. "Therefore, we, the artists from the former country of Yugoslavia, have decided to begin a long-term art project so that we can express our feelings with American people."

Art in General, 79 Walker Street; concert, Wednesday, 7 P.M.; suggested contributions, $10 for adults and $7 for students; (212) 219-0473.

Tour of SoHo Studios

SATURDAY — Art in General, a 13-year-old group of artists that provides exhibition space for as-yet-unrecognized artists, will hold fundraising tours of SoHo studios. There will be three tours, each visiting five artists and all starting at 4 P.M. from the organization's office at 79 Walker Street, south of Canal Street. A cocktail party from 6 to 8 P.M. will be held at the loft of the art collector Thea Westreich. Tickets, $75 or $125 a couple, from (212) 219-0511.

ARTISTS' BIOGRAPHIES

Abramović, Marina b. 1946, Belgrade, Yugoslavia. Education: Academy of Fine Arts, Belgrade, Yugoslavia (Diploma 1970). Selected Exhibitions: "Marina Abramović," Laura Carpenter, Santa Fe, NM (1994); "La Biennale di Venezia," Venice, Italy (1993); "Documenta 9," Kassel, Germany (1992).

Agard, Nadema b. 1948, New York, NY. Education: Teachers College, Columbia University, New York, NY (MA 1973). Selected Exhibitions: "She Is the Four Directions," Tweed Museum of Art, University of Minnesota, Duluth (1994); "Door to Heaven, Door from Heaven," Schaefer Gallery, Gustavus Adolphus College, St. Peter, MI (1993); "Sacred Door," Woodland Pattern, Milwaukee, WI (1992).

Akamine, Karen Lee b. 1949, Honolulu, HI. Education: Chouinard School of Art, California Institute of the Arts, Valencia (BFA 1972). Selected Exhibitions: "Yellow Forest," Somar Gallery, San Francisco, CA (1994); "J.A.P.* with Attitude," [*Japanese American Princess], performance, Irvine Valley College, CA (1994); "4 lbs. a Day," Santa Monica Place, Santa Monica, CA (1993).

Alcopley, L. (Alfred L. Copley). b. 1910, Dresden, Germany: d. 1992, New York, NY. Education: University of Heidelberg, Germany (MD 1935). Selected Exhibitions: Nyhöfn Gallery, Reykjavík, Iceland (1990); Galerie Rudolf Zwirner, Köln, Germany (1978); Stedelijk Museum, Amsterdam, The Netherlands (1962); "Ninth Street Show," New York, NY (1951).

Alptekin, Hüseyin b. 1957, Istanbul, Turkey. Education: Self-taught. Selected Exhibitions: "Metalica," Bergdorf Goodman, New York, NY (1994); "Een Dialoog," Stedelijk Museum,

Schiedam, The Netherlands (1993); "Blind Potent Spot/Magneto-Radiator," Gallery Nev, Istanbul, Turkey (1992).

Amos, Emma b. 1938, Atlanta, GA. Education: Antioch College, Yellow Springs, OH (BA 1958); London Central School of Art, England (Diploma 1960); New York University, NY (MA 1965). Selected Exhibitions: "Emma Amos: Paintings and Prints 1982– 1992," The Studio Museum of Harlem (1994); "The Falling Series," The Bronx Museum of the Arts, NY (1991); "The Wild Blue Yonder Series," The Newark Museum, NJ (1990).

Aponte, Manuela b. 1946, San Juan, Puerto Rico. Education: Moore College of Art, Philadelphia, PA (BFA 1967). Selected Exhibitions: "African Influence in Puertorican Culture," University of Puerto Rico, Río Piedras (1994); "New Faces of Puertorican Art," Peter Madero Gallery, New York, NY (1994); "A Garden of the Gods," Gainesville Regional Airport, FL (1994).

Arai, Tomie b. 1949, New York, NY. Education: Philadelphia College of Art, PA (1967). Selected Exhibitions: "Framing an American Identity," Alternative Museum, New York, NY (1992); "The Decade Show: Frameworks of Identity in the 1980s," Museum of Contemporary Hispanic Art, The New Museum of Contemporary Art, and The Studio Museum in Harlem, New York, NY (1990); "Committed to Print," The Museum of Modern Art, New York, NY (1988).

Arnold, Anthony b. 1941, Vancouver, Canada. Education:Art Students League of New York, NY (1962–64); University of British Columbia, Vancouver, Canada (BA 1974) Ontario College of Art, Canada (1988). Selected Exhibitions: Workscene Gallery, Toronto, Canada (1993); "Toronto/Chicago Exchange," Arc Gallery,

Chicago, IL (1992); "Paintings and Drawings," Newcastle Visual Arts Centre, Bowmanville, Canada (1992).

Bachmann, Ingrid b. 1958, London, Canada. Education: York University, Toronto, Canada (1987–90). Selected Exhibitions: "Nomad Web: Sleeping Beauty Awakes," Walter Phillips Gallery, The Banff Centre, Alberta, Canada (1993–94); "Berlin Stories," OR Gallery, Vancouver, Canada (1993); "The Rose Glasses Suite," Open Studio, Toronto, Canada (1993).

Barnum, Sarah b. 1962, New York, NY. Education: Yale University, New Haven, CT (BA 1984). Selected Exhibitions: "Out of Bounds, Books as Art/Art as Books," Creative Arts Workshop, New Haven, CT (1994); "Twenty-Fourth Juried Show," Allentown Art Museum, PA (1994); "The Return of the Cadavre Exquis," The Drawing Center, New York, NY (1993).

Belić Weiss, Zoran b. 1955, Belgrade, Yugoslavia. Education: Mason School of the Arts, Rutgers University, New Brunswick, NJ (MFA 1991). Selected Exhibitions: "Opus Alchymicum," Mason Gross School of the Arts, Rutgers University, New Brunswick, NJ (1991); "Art of Peace Biennial," Art Space, Hamburg, Germany (1985); "Works and Words," The Apple, Amsterdam, The Netherlands (1979).

Beltré, Mildred b. 1969, New York, NY. Education: Carleton College, Northfield, MN (BA 1991); University of Iowa, Iowa City (MFA due 1995). Selected Exhibitions: "(In a) Whirly," Carleton College, Northfield, MN (1994); "Six at Summit," Summit Street Gallery, Iowa City, IA (1994); Speedboat Gallery, St. Paul, MN (1993).

Berger, Sidney b. 1952, Pittsburgh, PA. Education: Kansas City Art Institute, MO (BFA 1975).

Black, Christa b. 1907, Indian Territory, Dibble. Education: Self-taught. Selected Exhibitions: "Exposition Internationale du Surréalisme," Galerie des Beaux-Arts, Paris, France (1938); "Entartete Kunst (Degenerate Art)," Haus der Kunst, Berlin, Germany (1938); "The Armory Show, an International Exhibition of Modern Art," Sixty-ninth Regiment Armory, New York, NY (1913).

Bothwell, Christina b. 1960, New York City, NY. Education: Pennsylvania Academy of Fine Arts, Philadelphia (Diploma 1983). Selected Exhibitions: "Recent Works: Christina Bothwell," Philadelphia Art Alliance, PA (1993); "Spring and Summer Exhibitions," Allan Stone Gallery, New York, NY (1993); "CAN Exhibition," Stuart Levy Gallery, New York, NY (1993).

Bowens, Kabuya Pamela b. 1957, Miami, FL. Education: Howard University, Washington, DC (BFA 1979); Tyler School of Art, Elkins Park, PA (MFA 1984). Selected Exhibitions: "Where the Water Tastes Like Cherry Wine: African-American Artists in Florida," Polk Museum of Art, Lakeland, FL (1994); "Identity Crisis," Puffin Room, New York, NY (1994).

Bramwell, Michael b. 1953, Bronx, NY. Education: Oakwood College, Huntsville, AL (BS 1976); Columbia University, New York, NY (MA 1983). Selected Exhibitions: "The American Warehouse," Washington Project for the Arts, Washington, DC (1994); "Signs of Poverty/Poverty of Signs," Resnick Gallery, Long Island University, Brooklyn, NY (1994); "Urgent Perspectives," Florida Center for Contemporary Art, Tampa (1994).

Brathwaite, Angela-Nailah E. b. 1951, Panama City, Panama. Education: Bank Street College, New York, NY (MA 1990). Selected Exhibitions: "Black Women Artists of Brooklyn and Environs," Brooklyn Presbyterian Church, NY (1983, 1982); Bedford Stuyvesant Restoration Project, Brooklyn, NY (1976, 1974, 1973); Elizabeth Seton College, Yonkers, NY (1972, 1971).

Buell, Joy Dai b. 1941, Boston, MA. Education: Tufts University, Medford, MA (BSED1963); Yale University, New Haven, CT (MFA 1971). Selected Exhibitions: "Refined/Reborn," Augusta Savage Gallery, University of Massachusetts at Amherst (1992); "Ancestors Known and Unknown: Box Works," Coast to Coast: National Women Artists of Color, traveling exhibition, opened at Art in General, New York, NY (1990); "Four Sacred Mountains," Arizona Commission on the Arts, Phoenix (1988–90).

Burckhardt, Tom b. 1964, New York, NY. Education: State University of New York at Purchase (BA 1986). Selected Exhibitions: "Tom Burchkardt," Frick Gallery, Belfast, ME (1993); "Fever," Exit Art, New York, NY (1992); "Painting, Self-Evident Abstraction 1992," Spoleto Festival USA, Charleston, SC (1992).

Bursztyn, Dina b. 1948, Mendoza, Argentina. Education: Universidad Nacional de Córdoba, Argentina (MA 1971). Selected Exhibitions: "Sculptures and Prints," Ex Gallery, Tokyo, Japan (1993); "Houses of Spirit: Memories of Ancestors," Woodlawn Cemetery, The Bronx Council on the Arts, NY (1992); "Cosmic Turtle," Sculpture Walk in Prospect Park, Prospect Park Visual Arts Program, Brooklyn, NY (1992).

 Butler, Erin b. 1949, Spokane, WA. Education: Grays Harbor College, Aberdeen, WA; University of Washington, Seattle (AA 1969); Art Students League of New York, NY (1974–81). Selected Exhibitions: "Garden of Delights: A Summer Exhibition by Women in the Arts," Steinhardt Conservatory Gallery, Brooklyn Botanical Garden, NY (1994); "Not Mass Media," Haenah-Kent, New York, NY (1990); "Space and Light," Straus Gallery, New York, NY (1990).

 Byard, Carole b. 1941, Atlantic City, NJ. Education: New York Phoenix School of Design, NY; Fliesher Art Memorial, Philadelphia, PA. Selected Exhibitions: "I Mind/Eye Mind/I Mind," John Michael Kohler Art Center, Sheboygan, WI (1994); "Pasando la Mano/Laying the Hand," Soho 20, New York, NY (1994); "Malcolm X: Man, Ideal, Icon," Walker Art Center, Minneapolis, MN.

 Cabañas, Suzana b. 1941, San Juan, Puerto Rico. Education: Hunter College, City University of New York, NY (BA 1989). Selected Readings: "Yo Soy/I Am: A Celebration of Women Latina Poets," Nuyorican Poet's Cafe, New York, NY (1993); "A Tribute to Nuyorican Poetry," Walt Whitman Cultural Art Center, Camden, NJ (1993); "First Books Award Reading," The Writer's Voice Project of the YMCA of the USA, New York, NY (1992).

 Carroll, Micheal b. 1956, Worcester, MA. Education: Self-taught. Selected Exhibitions: "Open Studio 1986," Paladino Gallery, San Francisco, CA (1986).

 Carter, Yvonne Pickering b. 1939, Washington, DC. Education: Howard University, Washington, DC (AB 1962, MFA 1968). Selected Exhibitions: "Book as Art VI," National Museum of Women in the Arts, Washington, DC (1994); "Gathered Visions: Selected Works by African-American Women Artists," Anacostia Museum, Smithsonian Institution, Washington, DC (1990); "Introspectives: Contemporary Art by Americans of African Descent," California Afro-American Museum, Los Angeles (1989).

 Charles, Michelle b. 1959, London, England. Education: Foundation Harrow School of Art, London, England (1978); Brighton Polytechnic, England (BA 1981); Florida State University, Tallahassee (MFA 1984). Selected Exhibitions: "New from New York," Montgomery Glasoe Fine Art, Minneapolis, MN (1994); "Traveling exhibition, of Pennsylvania Council on the Arts Recipients," Museums and Galleries of Pennsylvania (1993); Penine Hart Gallery, New York, NY (1989).

 Charlier, Vladimir-Cybil b. 1967, Queens, NY. Education: School of Visual Arts, New York, NY (MFA 1993); Skowhegan School of Painting and Sculpture, ME (1993). Selected Exhibitions: "The Global Sweatshop," Labor Center, Rutgers University, New Brunswick, NJ (1994); "Grafting Identities," The Paramount Theater Club, Peekskill, NY (1993); "Haitian Paintings: Color and Feelings," Quisquey Art, New York, NY (1991).

 Chavez, Martha b. Santa Cruz, Costa Rica. Education: School of Visual Arts, New York, NY (BFA 1979); Fordham University, New York, NY (MA 1994). Selected Exhibitions: "Imira! The Second Canadian Club Hispanic Art Tour," El Museo del Barrio, New York, NY (1985–89); "Chautakua Art Association Galleries," Chautakua Gallery, NY (1987); "Latina Art: Showcase '87," Mexican Fine Arts Center Museum, Chicago, IL (1987).

 Chi, Robert b. 1876, Havana, Cuba. Education: L'Ecole de Beaux-Arts, Paris, France (1873). Selected Exhibitions: "The American Warehouse," Washington Project for the Arts, Washington, DC (1994); "Signs of Poverty/Poverty of Signs," Resnick Gallery, Long Island University, Brooklyn, NY (1994); "Urgent Perspectives," Florida Center for Contemporary Art, Tampa (1994).

 Chu, Polly b. 1961, Los Angeles, CA. Education: The Claremont Graduate School, CA (MFA 1992). Selected Exhibitions: "Utopian Dialogues," Los Angeles Municipal Art Gallery, CA (1993); "Dangerous Memories: Honoring Her Stories," North Gallery, California State University at Northridge (1992).

 Colorado, Elvira b. Chicago, IL. Education: Self-taught. Selected Exhibitions: "The Submuloc Project," traveling exhibition, opened at the Evergreen State College, Olympia, WA (1992); "Decolonizing the Mind: End of a Five-Hundred-Year Era," Center on Contemporary Art, Seattle, WA (1992); "Ancestors Known and Unknown: Box Works," Coast to Coast: National Women Artists of Color, traveling exhibition, opened at Art in General, New York, NY (1990).

 Colorado, Hortensia b. Chicago, IL. Education: Goodman Memorial Theater School, Chicago, IL. Selected Exhibitions: "The Submuloc Project," traveling exhibition, opened at the Evergreen State College, Olympia, WA (1992); "Decolonizing the Mind: End of a Five-Hundred-Year Era," Center on Contemporary Art, Seattle, WA (1992); "Encuentros: Invasion of the Americas and the Making of the Mestizo," SPARC, Venice, CA.

Conway, Merry b. 1950, Albuquerque, NM. Education: Boston University School of Fine Arts, MA. Selected Multimedia Site Specific Installations and Performances: "Too Close to Home," in association with the University of Massachusetts and the city of New Bedford, MA (1994); "As a Dream That Vanishes," Solomon R. Guggenheim Museum in association with Creative Time, New York, NY (1991); "In the Eye of the Beholder," Conway & Pratt Project at 30 Bond Street, New York, NY (1988).

Corritore, Regina Araujo b. 1958, Bronx, NY. Education: University of New Mexico, Albuquerque (MFA 1984). Selected Exhibitions: "Conversation with the Spirits," Longwood Arts Gallery, The Bronx Council on the Arts, NY (1994); "Regina Araujo Corritore: Sculptures," Soho 20, NY (1993); "Adios Columbus," Hillwood Art Museum, C. W. Post Campus, Long Island University, Brookville, NY (1992).

Cortés, Esperanza b. 1957, Bogota, Colombia. Education: Queens College, City University of New York, NY (1976–80). Selected Exhibitions: "After the Embers," Jamaica Arts Center, Queens, NY (1994); "Entre Sombra El Vacio," Soho 20, New York, NY (1993); "Remerica/America, 1492–1992," The Bertha and Karl Leubsdorf Art Gallery, Hunter College, City University of New York, NY (1992).

Cosby, Erika b. 1965, Los Angeles, CA. Education: Wesleyan University, Middletown, CT (BA 1987); University of California at Berkeley (MFA 1993). Selected Exhibitions: "The Berkeley Connection," Weintraub Hunter Gallery, Sacramento, CA (1994); "Comic Influences, "Susan Cummins Gallery, Mill Valley, CA (1994); "Cherry Bomb," Southern Exposure Gallery, San Francisco, CA (1993).

Cox, Renée b. Colgate, Jamaica. Education: School of Visual Arts, New York, NY (MFA 1992); Whitney Museum of American Art Independent Study Program, New York, NY (1993). Selected Exhibitions: "Black Male: Representations of Masculinity in Contemporary Art," Whitney Museum of American Art, New York, NY (1994–95); "Bad Girls," The New Museum of Contemporary Art, New York, NY (1993); Jack Tilton Gallery, New York, NY (1993).

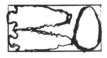

Criswell, Joan b. New Bedford, MA. Education: Hunter College, City University of New York, NY (BA 1981). Selected Exhibitions: "To Be: How Do You See Yourself as an Artist in American Culture Today?" Kentler International Drawing Space, Brooklyn, NY (1993); "45th Anniversary Exhibition," Hudson Guild Art Gallery, New York, NY (1993); "Waves of Peace," The Community Cases at One Court Square, Long Island City, NY (1992).

Cruz, Adriene b. 1953, Harlem, NYC. Education: School of Visual Arts, New York, NY (BFA 1975). Selected Exhibitions: "Spirits of the Past, Voices of the Present," Hammonds House Galleries and Resource Center of African-American Art, Atlanta, GA (1994); "Uncommon Beauty in Common Objects: The Legacy of African-American Craft Art," traveling exhibition, opened at the Afro-American Historical and Cultural Museum, Philadelphia, PA (1993); "A Common Thread: Innovations and Improvisations in Contemporary Textiles," Bomani Gallery, San Francisco, CA (1993).

Cruz, Pura b. 1947, Santurce, Puerto Rico. Education: State University of New York at Stony Brook (BA 1988). Selected Exhibitions: "Twentieth Birthday Show," Islip Art Museum, East Islip, NY (1993); "Original Sin," Hillwood Art Museum, C. W. Post Campus, Long Island University, Brookville, NY (1991); "Dreams and Illusions," Islip Art Museum, East Islip, NY (1990).

Cuadros, Maricela b. 1967, Los Angeles, CA. Education: Woodbury University, Burbank, CA (BA 1990).

Cummings, Linda b. 1954, Valley Forge, PA. Education: Nova Scotia College of Art and Design, Halifax, Canada (BFA 1977). Selected Exhibitions: "Artist in Marketplace XIV," The Bronx Museum of the Arts, NY (1994); "All Out," Salena Gallery, Long Island University, Brooklyn, NY (1994); "26 Slips," Metro Gallery, Empire State College, New York, NY (1993).

Daniels, Valery b. 1955, Princeton, NJ. Education: Yale University, New Haven, CT (MFA 1988). Selected Exhibitions: "Making Evidence," Organization of Independent Artists, Police Building, New York, NY (1994); Sarah Doyle Gallery, Brown University, Providence, RI (1993); "Art in Anchorage, produced by Creative Time, Brooklyn, NY (1992).

Davis, Lisa Corinne b. 1958, Baltimore, MD. Education: Hunter College, City University of New York, NY (MFA 1983). Selected Exhibitions: "Artist in the Marketplace XIII," The Bronx Museum of the Arts, NY (1993); "Emerging Artists," Kenkeleba Gallery, New York, NY (1993); "Mixed Media," Print Club, Philadelphia, PA (1993).

Deering, Gregg b. 1960, Croton-on-Hudson, NY. Education: Bennington College, VT (BFA 1982).

Dent, Susanna b. 1958, Wilmington, DE. Education: Bennington College, VT; Pratt Institute, Brooklyn, NY (MFA 1989). Selected Exhibitions: "Things That Make Your Eyes Happy," Maranushi Lederman, Productions, New York, NY (1993); University of Minnesota, Morris (1993); Auburn University, Montgomery, AL (1993).

Diedrich, Louise b. 1959, San Francisco, CA. Education: California Institute of the Arts, Valencia (MFA 1993). Selected Exhibitions: "Open Studios," Whitney Museum of American Art Independent Study Program, New York, NY (1994); "Home Alone," Bliss Gallery, Pasadena, CA (1993); "Silent Partners," Cyberspace Gallery, Santa Monica, CA (1993).

Dominguez, Maria M. b. 1950, Cataño, Puerto Rico. Education: School of Visual Arts, New York, NY (BFA 1985). Selected Exhibitions: "Women's Month: Women in Art," Boricua College Gallery, Brooklyn, NY (1994); Longwood Arts Gallery, The Bronx Council on the Arts, NY (1992); "Food," Ceres Gallery, New York, NY (1990).

Dorell, Karni b. 1960, Cleveland, OH. Education: Pratt Institute, Brooklyn, NY (MFA 1990). Selected Exhibitions: "The Kentler Project," Kentler International Drawing Space, Brooklyn, NY (1993); "Remote Control," Ridge Street Gallery, New York, NY (1993); "The Return of the Cadavre Exquis," The Drawing Center, New York, NY (1993).

Feinstein, Emily b. 1955, Queens, NY. Education: Bard College, Annandale-on-Hudson, NY (MFA 1994). Selected Exhibitions: "Raw Materials," Organization of Independent Artists, Police Building, New York, NY (1994); "Sculpture Survey," One Main Street, Brooklyn, NY (1993); "Community Spirit—Artistic Vision," Krasdale Corporation, Bronx, NY (1992).

Ferrer, Ana b. 1959, Placetas, Cuba. Education: Pratt Institute, Brooklyn, NY. Selected Exhibitions: "Diagnosis: Breast Cancer," Denise Bibro Fine Art, New York, NY (1994); "Underdevelopment in Progress: 500 Years," Soho 20 Gallery, New York, NY (1993); "AIDS: The Artist's Response," Hoyt L. Sherman Gallery, Ohio State University, Columbus (1989).

Fine, Jane b. 1958, New York, NY. Education: Harvard University, Cambridge, MA (BA 1980). Selected Exhibitions: "Paintings," Petzel/Borgmann Gallery, New York, NY (1994); "Pure Pop for Now People," Jack Tilton Gallery, New York, NY (1993); "White Room Show," White Columns, New York, NY (1992).

Futai, a.k.a. b. 1950, Canton, OH.

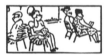

Galindo, Felipe b. 1957, Cuernavaca, Mexico. Education: National School of Arts, National University of Mexico, Mexico City (BFA 1978). Selected Exhibitions: "Behind the Borders: Art by Recent Immigrants," The Bronx Museum of the Arts, NY (1994); "Mexico: 20th-Century Visions," Lehman College Art Gallery, New York, NY (1992); "Icon, Real and Unreal," P.S. 122 Gallery, New York, NY (1989).

> We're in a craggy unplowed field looking for the ruins. We approach a wooden rail fence. Should we climb over or look for an entrance?

Geller, Matthew B. b. 1954, New York, NY. Education: Connecticut College, New London, (BA 1976); University of Delaware, Newark (MFA 1978). Selected Exhibitions: "Annual," American Academy in Rome, Italy (1992); "From Receiver to Remote Control: The TV Set," The New Museum of Contemporary Art, New York, NY (1990); "New Narratives," Whitney Museum of American Art, New York, NY (1990).

Gemperlein, Elizabeth b. 1961, Pittsburgh, PA. Education: State University of New York at Buffalo (MFA 1989). Selected Exhibitions: "Elizabeth Gemperlein: Paintings," Julian Scott Memorial Gallery, Johnson, VT (1993); "Recent Paintings," Indiana University, Bloomington (1993); "Faculty Exhibition," Indiana University, Bloomington (1993).

Giancoli, Maria Teresa b. 1963, Berkeley, CA. Education: Wellesley College, MA (BA 1986). Selected Exhibitions: "One Voice," Insights Gallery, Seattle, WA (1993); "New Works," El Taller Boricua, New York, NY (1990); "Maria Teresa Giancoli and José Antonio Varquez," Black & White in Color Gallery, Bronx, NY (1989).

Golden, Kenneth Sean b. 1954, New Hyde Park, NY. Education: New York University, NY (MA 1990); International Center of Photography, New York, NY. Selected Exhibitions: "AIDS Forum," Artists Space, New York, NY (1994); "Computers in Art: From Drawing to Montage," Parsons School of Design, New York, NY (1994); "A Life of Secrets," A/C Project Room, New York, NY (1994).

Goldsmith, Gail b. 1934, Cincinnati, OH. Education: Cranbrook Academy of Art, Bloomfield Hills, MI (MFA 1958). Selected Exhibitions: "I Myself and Me," The InterArt Center, New York, NY (1994); "That Is a Hat," Organization of Independent Artists, Police Building, New York, NY (1993); "Artists on Their Own," Jane Hartsook Gallery, New York, NY (1992).

Golubović, Vesna b. 1955, Banja Luka, Yugoslavia. Education: Academy of Fine Arts, Belgrade, Yugoslavia (MFA 1986). Selected Exhibitions: "Ritual Places," John Nichols Gallery, New York, NY (1990); Gallery of Museum of Modern Art, Belgrade, Yugoslavia (1986); Fashion Moda, Bronx, NY (1983).

González, Maria Elena b. 1957, Havana, Cuba. Education: San Francisco State University, CA (MA 1983). Selected Exhibitions: "Composite," Neuberger Museum of Art, State College of New York at Purchase (1994); "Cubana," Cuban Museum of Arts and Culture, Miami, FL (1993); "Cadences: Icons and Abstraction in Context," The New Museum of Contemporary Art, New York, NY (1991).

Gonzalez, Wilda b. 1965, Bronx, NY. Education: Fashion Institute of Technology, New York, NY; Parsons School of Design, New York, NY. Selected Exhibitions: " Hi Neighbor: Art Exhibition," Bronx 178th Street Block Association Street Fair, NY (1991); "Emerge," Lincoln Square Gallery, New York, NY (1990).

Goulet, Karen Elise b. 1959, Seattle, WA. Education: The Evergreen State College, Olympia, WA (BA 1994). Selected Exhibitions: "Women of the New World III," Cunningham Gallery, Seattle, WA (1993); "One Voice: Call and Response," Insights, Seattle, WA (1993); "The Definitive Contemporary American Quilt," traveling exhibition, opened at Bernice Steinbaum Gallery, New York, NY (1991).

Greene, Stacy b. 1955, Fairbanks, AK. Education: University of Wisconsin–Stout, Menomonie (BS 1979); Central School of Art and Design, London, England (1980). Selected Exhibitions: "Members Only," Carles Poy Galería, Barcelona, Spain (1993); "Engendered Stories," 494 Gallery, New York, NY (1992); "The Travel and Leisure Show," 4 Walls, Brooklyn, NY (1992).

Griffith, Dennison W. b. 1952, Delaware, OH. Education: Ohio Wesleyan University, Delaware (BFA 1974); Ohio State University, Columbus (MFA 1994). Selected Exhibitions: "Self-Portrait Show I," Art Initiatives at the New York Law School, New York, NY (1994); "Ohio, USA," Butler Institute of American Art, Youngstown, OH (1993); "Site/Insight," Southern Ohio Museum and Cultural Center, Portsmouth (1993).

Gutiérrez, Diego b. 1966, Mexico City, Mexico. Education: Self-taught. Selected Exhibitions: "La Lengua," Temistocles 44, Mexico City, Mexico (1994); "En-tensión," Corpus Callosum Alias El Callo, Guadalajara, Mexico (1994); "Si Colon Supiera......," Museo de Monterrey, Mexico (1992).

Hahn, Kimiko b. 1955, Mt. Kisco, NY. Education: Columbia University, New York, NY (MA 1985).

Han, Baiyou b. 1936, Shanghai, China. Education: Hua-Tung College of Fine Arts, Wu Hsi, China (BA 1956). Selected Exhibitions: "Baiyou Han: Paintings," Pyramid Art Center, Rochester, NY (1994); "Baiyou Han: Paintings," Shanghai Art Museum, Shanghai, China (1988); "Twelve Persons Art Exhibition," Huang Pu Activity Center, Shanghai, China (1979).

el Hanani, Jacob b. 1947, Casablanca, Morocco. Education: Avni Art Institute, Tel Aviv, Israel (1966–69). Selected Exhibitions: "Works on Paper," Barbara Mathes Gallery, New York, NY (1993); "Jacob el Hanani and Moshe Kupferman," Bronfman Centre for the Arts, Montreal, Canada (1993); "Existence, Passage, and the Dream," Rose Art Museum, Waltham, MA (1991).

Harris, Teresa b. 1957, St. Louis, MO. Education: Pratt Institute, Brooklyn, NY (MFA 1990). Selected Exhibitions: "Group Exhibit," Daniel P. Quinn Gallery, Long Island City, NY (1992); "Open Studio Exhibition," Long Island City Artlofts, NY (1991, 1990); "Webster College," The Gallery of Loretto Hilton Center, Webster Groves, MO (1984).

Heist, Eric b. 1962, West Chester, PA. Education: Hunter College, City University of New York, NY (MFA 1990). Selected Exhibitions: "MOB at Speedway," Speedway Gallery, Boston, MA (1993); "Art of Self-Defense and Revenge.... It's Really Hard," Momenta Art, New York, NY (1993); "Little Women/Little Men," White Columns, New York, NY (1992).

Henry, Janet b. 1947, New York, NY. Education: Fashion Institute of Technology, New York, NY (AA 1969). Selected Exhibitions: "Bad Girls," The New Museum of Contemporary Art, New York, NY (1994); "Welcome Edition," A/C Project Room at 303 Gallery, New York, NY (1993); "Urban Masculinity," Longwood Arts Gallery, The Bronx Council on Arts, NY (1993).

Hernández, Miriam b. 1947, Santurce, Puerto Rico. Education: Maryland Institute College of Art, Baltimore (MFA 1978). Selected Exhibitions: "Vistas: Little Sister," Augusta Savage Gallery, University of Massachusetts at Amherst (1993); "Adios Columbus," Hillwood Art Museum, C. W. Post Campus, Long Island University, Brookville, NY (1992); "Impact of Two Worlds," Artspace, New Haven, CT (1992).

Hill, Amy b. 1954, New York, NY. Education: Carnegie-Mellon University, Pittsburgh, PA (BFA 1976). Selected Exhibitions: "Bad Girls," The New Museum of Contemporary Art, New York, NY (1994); Sunen Gallery, New York, NY (1992); The Queens Museum Gallery at the Bulova Corporate Center, NY (1991).

Hiwot, Linda b. 1943, Providence, RI. Education: Pratt Institute, Brooklyn, NY (BFA 1980, MA 1983). Selected Exhibitions: "The Journey," Watermark Cargo Gallery, Kingston, NY (1993); Museum of Science and Industry, Chicago, IL (1992); "Abstract Expression," Kenkeleba Gallery, New York, NY (1991).

Holder, Robin b. 1952, Chicago, IL. Education: Art Students League of New York, NY; Werkgroep Uit Het Amsterdam Grafisch Atelier, The Netherlands. Selected Exhibitions: "Monoprints," Roberta Wood Gallery, Syracuse, NY (1993); Site Specific Public Art Project, commissioned by New York City Department of Cultural Affairs Percent for Art Program, NY (1993); "Robin Holder," The Shoestring Gallery, Rochester, NY (1993).

Holguin, Anita Miranda b. 1942, Los Angeles, CA. Education: California State University, Los Angeles (BA 1979). Selected Exhibitions: "Ink and Clay," Kellogg University Art Gallery, California State Polytechnic University, Pomona (1994); "1993 Los Angeles Juried Exhibition," Watts Towers Art Center, Los Angeles, CA (1993); "Cycles," Brand Library, Glendale, CA (1991).

Holmes, Safiya Henderson b. 1951, New York, NY. Education: New York University, NY (BA 1972); City College, City University of New York, NY (MA 1982). Selected Exhibitions: "Ancestors Known and Unknown: Box Works," Coast to Coast: National Women Artists of Color, traveling exhibition, opened at Art in General (1990).

Hongtu, Zhang b. 1943, Gansu Province, China. Education: Central Institute of Arts and Crafts, Beijing, China (BA 1969). Selected Exhibitions: "The Fifth Biennal of Havana," Wifredo Lam Centre, Cuba (1994); "Beyond the Borders: Art by Recent Immigrants," The Bronx Museum of the Arts, NY (1994); "Material Mao," Chinese American Arts Council, New York, NY (1993).

Huang, Arlan b. 1948, Bangor, ME. Education: Pratt Institute, Brooklyn, NY (BFA 1972). Selected Exhibitions: "New York Biennal of Glass," Robert Lehman Gallery, New York Experimental Glass Workshop, Brooklyn, NY (1994); "Dim Sum/Heart's Desire," Chinatown History Museum, New York, NY (1993–94); "Arlan Huang: Paintings," Exit Art, New York, NY (1987).

Jacquette, Julia b. 1964, New York, NY. Education: Skidmore College, Saratoga Springs, NY (BS 1986); Hunter College, City University of New York, NY (MFA 1992). Selected Exhibitions: "Julia Jacquette," David Klein/O.K. Harris, Birmingham, MI (1994); "New Faces, New Energy," Frick Gallery, Belfast, ME (1994); "Douglas Anderson and Julia Jacquette," P.S. 122 Gallery, New York, NY (1993).

Jaremko, Marta b. 1950, Wakbrzych, Poland. Education: University of Illinois, Chicago (BA 1973); State University of New York at Albany (MFA 1985). Selected Exhibitions: "Maria Jaremko and Gayle Johnson," The Hess Gallery, Elizabethtown College, PA (1994); "Light: AIDS Benefit Exhibition," Russell Sage College Gallery, Troy, NY (1993); "Artists of the Mohawk-Hudson Region Exhibition," Schenectady Museum, NY (1992).

Kim, Jin Hi b. 1958, Inchon, South Korea. Education: Mills College, Oakland, CA (MFA 1985). Selected Concerts: "Free Music Production: Komungo Solo," Academy of Musik, Berlin, Germany (1994); "No World Improvisations," Walker Arts Center, Minneapolis, MN (1994); "TAKTLOS Festival," Rote Fabrik, Zurich, Bern, Switzerland (1994).

King-Comer, Arianne b. 1945, San Diego, CA. Education: Howard University, Washington, DC (BFA 1967). Selected Exhibitions: "The Rain Forest," American Motors Building, Southfields, MI (1993); "Roots of Elegance," Torruella Quander Gallery, Washington, DC (1993); "A Place of Meditation," Fisher Building, Detroit, MI (1991–92).

Korf, Kumi b. 1937, Tokyo, Japan. Education: Tokyo University of Fine Arts, Japan (BA 1959); Cornell University, Ithaca, NY (MFA 1977). Selected Exhibitions: "Masters of the Craft: Works by Instructors of Book Arts," Center for Book Arts, New York, NY (1994); "Area Artists Collection 1993–1994," Albright-Knox Art Gallery, Buffalo, NY (1993); "Book as Art V," National Museum of Women in the Arts, Washington, DC (1992).

Kuo, Anna b. 1951, Milwaukee, WI. Education: State University of New York at Buffalo (MFA 1976). Selected Exhibitions: "China: June 4, 1989," Reinberger Galleries, Cleveland Institute of Art, OH (1992); "Anna Kuo: Paintings and Works on Paper," The Fanette Goldman/Carolyn Greenfield Gallery, Daemen College, Amherst, NY (1992); "Selected Works: Pat Badt, Lucy Gans, Anna Kuo, Judith Ross," Frank Martin Art Gallery, Muhlenberg College, Allentown, PA (1990).

Lee, Lanie b. 1951, Bronx, NY. Education: School of Visual Arts, New York, NY (BFA 1981). Selected Exhibitions: "A New World Order III: The Curio Shop," Artists Space, New York, NY (1993); "Seven Rooms/Seven Shows," P.S. 1 Museum, Long Island City, NY (1992); "Recent Work," New York Experimental Glass Workshop, Brooklyn, NY (1990).

Lee, Taylor b. 1959, Rochester, NY. Education: Alfred University, NY (BFA 1982). Selected Exhibitions: "Film Series," University of California, Davis, (1989); Laight Street Gallery, New York, NY (1986–87).

Lemeh, Dori b. 1959, Springfield, MA. Education: The Pennsylvania State University, University Park (MFA 1989). Selected Exhibitions: "Dis-Covered, Un-Covered, Re-Covered," Manchester's Downtown Gallery, Pittsburgh, PA (1994); "I Mind/Eye Mind/I Mind," John Michael Kohler Art Center, Sheboygan, WI (1994); "Visions: Six Women Artists," Salena Gallery, Long Island University, Brooklyn, NY (1993).

Lewis, Charlotte b. 1934, Prescott, AZ. Education: Portland Art Museum Art School, OR (Certificate 1955). Selected Exhibitions: "We Speak," Travel Mural Project, Portland, OR (1992–); "Kwanzaa: A Celebration of Life," Interstate Firehouse Cultural Center, Portland, OR (1994); "In My Sisters' House There Are Many Rooms," Graystone Gallery, Portland, OR (1992).

Leys, Rejin b. 1966, Brooklyn, NY. Education: Parsons School of Design, New York, NY (BFA 1988). Selected Exhibitions: "Propositions sur Papier," Centre Interculturel Strathearn, Montreal, Canada (1993); "Word!," Jamaica Arts Center, New York, NY (1993); "Reflections for Peace," Mexic-Arte Museum, Austin, TX (1993).

Littlechild, George b. 1958, Edmonton, Canada. Education: Nova Scotia College of Art and Design, Halifax, Canada (BFA 1988). Selected Exhibitions: "Spirit of the Plains Cree," Abboke Gallery, Kasama, Japan (1993); "Night Sky Visions," Gallery of Tribal Art, Vancouver, Canada (1993); "Endangered Species," Galerie Otto Van de Loo, Munich, Germany (1992).

Lum, Mary b. 1951, St. Cloud, MI. Education: Rochester Institute of Technology, NY (MFA 1981). Selected Exhibitions: "Reader," window installation, Printed Matter, New York, NY (1994); "The Reading Room," Southern Exposure, San Francisco, CA (1993); "Open Book," Washington Project for the Arts, Washington, DC (1992).

McCann, Margaret b. 1957, Cleveland, OH. Education: Yale University, New Haven, CT (MFA 1985). Selected Exhibitions: "Giants at Large," Artemisia Gallery, Chicago, IL (1994); "Anthropolities," Arc Gallery, Chicago, IL (1992); "Margaret McCann and Paul Lucchosi: Saints, Sinners, and Icons," Bridgewater/Lustberg Gallery, New York, NY (1991).

Mac Donald, Ellen b. 1955, Royal Oak, MI. Education: The Corcoran School of Art, Washington, DC. Selected Exhibitions: "Stubborn Hope," Washington Project for the Arts, Washington, DC (1985); "Political/Figurative," W.P.A. in Andover, England (1985); "10+10+10," Corcoran Gallery of Art, Washington, DC (1982).

Mantello, Larry b. 1964, Rockford, IL. Education: Kansas City Art Institute, MO; The School of the Art Institute of Chicago, IL (BFA 1986). Selected Exhibitions: "Front Runners," Pittsburgh Center for the Arts, PA (1994); "Lax," Santa Monica Museum of Art, CA (1994); Jose Freire Fine Art, New York, NY (1993).

Marcano, Soraya b. 1965, Cidra, Puerto Rico. Education: University of Puerto Rico, Rio Piedras (BFA 1988); Pratt Institute, Brooklyn, NY. Selected Exhibitions: "IV Encuentro de Arte Popular," Casa del Lago, Universidad Nacional Autonoma de México, Mexico City (1992); "Soraya Marcano," Colegio de Abogados, San Juan, Puerto Rico (1991); "Digo Presente," La galería El Bohio, Charas, Inc., New York, NY (1991).

Mark-Chan, Malpina b. 1944, Lodi, CA. Education: Earlham College, Richmond, IN (BA 1969). Selected Exhibitions: "Ancestors Known and Unknown: Box Works," Coast to Coast: National Women Artists of Color, traveling exhibition, opened at Art in General, New York, NY (1990); "Photography '83," Tacoma Art Museum, WA (1983); "Photography: Faculty and Staff Work," The Evergreen State College, Olympia, WA.

Markley, Norma b. 1950, Youngstown, OH. Education: Cleveland Institute of Art, OH (BFA 1983); Columbia University, New York, NY (MFA 1985). Selected Exhibitions: "Edward F. Albee Foundation Visual Arts Fellowship," The Barn, Montauk, NY (1992); "The Salon of the Mating Spiders," Herron Test-Site Gallery, Brooklyn, NY (1992); "Selections 30," The Drawing Center, New York, NY (1985).

Marks, Melissa b. 1965, New York, NY. Education: Wesleyan University, Middletown, CT (BA 1987); Yale University, New Haven, CT (MFA 1992). Selected Exhibitions: "The Return of the Cadavre Exquis," The Drawing Center, New York, NY (1993); "MFA Exhibition," Yale University, New Haven, CT (1992).

Maya, Gloria b. Hurley, NM. Education: California College of Arts and Crafts, Oakland (MFA 1972). Selected Exhibitions: "Fiesta Artistica and the Gathering of Native American Arts," Albuquerque Convention Center, NM (1994); "V Bienal de Grabado Latino Americano," Instituto de Cultura Puertorriqueña, San Juan, Puerto Rico (1982); "Un Elefante Y Viente Grabados," Ex-Convento del Carmen, Bellas Artes, Guadalajara, Mexico (1975).

Maynard, Iris b. Brooklyn, NY. Education: Hunter College, City University of New York, NY (BA 1972) Selected Exhibitions: "Silkscreens," private exhibition, Brooklyn, NY (1992).

Maynard, Valerie b. 1937, New York, NY. Education: Goddard College, Plainfield, VT (MA 1977). Selected Exhibition: "Roots Through the Heart," Hartnett Gallery, University of Rochester, NY (1994); "No Apartheid Anywhere," Compton Gallery, Massachusetts Institute of Technology, Cambridge (1992); "Looking In and Out of Windows," Town Art Gallery, Wheelock College, Boston, MA (1991).

Mejia, Liliana b. 1966, Pereira, Colombia. Education: Self-taught. Selected Exhibitions: "Women's Art Month Celebration," Shubert Theater, New Haven, CT (1993); "Women's Caucus for Art National Conference," Insights Gallery, Seattle, WA (1993); "North American Artists Summit," Webb Gallery, North Haven, CT (1992).

Mendieta, Raquelín b. 1946, Havana, Cuba. Education: The University of Iowa, Iowa City (MA 1977). Selected Exhibitions: "Raquelín Mendieta: From the Personal to the Universal," Vincent Visceglia Arts Center, Caldwell College, NJ (1993); "Barro de America: I Biennial," Museo de Arte Contemporáneo de Caracas Sofia Imber, Venezuela (1992); "Cuba/USA: The First Generation," Fondo del Sol Visual Arts Center, Washington, DC (1991).

Mesquita, Rosalyn b. 1945, Belen, NM. Education: University of California at Irvine (MFA 1976). Selected Exhibitions: "Unification," Santa Monica City College Art Gallery, CA (1994); "One in Eight," F.H.P. Gallery, Long Beach, CA (1994); "Ree Vision," Beacon Gallery, Chicago, IL (1994).

Mikić, Vlasta Volcano b. 1958, Peć, Yugoslavia. Education: University of Fines Art, Belgrade, Yugoslavia (BFA 1983). Selected Exhibitions: "P.F.G. in Progress," Studio 515, New York, NY (1987); "Art in Eighties," Museum of Modern Art, Belgrade, Yugoslavia (1983); "Space of Sculpture," Salon of Museum of Modern Art, Belgrade, Yugoslavia (1982).

Miksić, Vesna Todorović b. 1956, Novi Sad, Yugoslavia. Education: Fine Arts Academy, Novi Sad, Yugoslavia (BFA 1980); Syracuse University, NY (MFA 1983). Selected Exhibitions: "Artists of Conscience: Sixteen Years of Social and Political Commentary," Alternative Museum, New York, NY (1991–92); "Aging: The Process, the Perception," The Forum Gallery, Jamestown, NY (1990); "Ž, or the Soul That Travels While the Body Is Asleep," The Museum of Contemporary Art Gallery, Belgrade, Yugoslavia (1990).

Miller, Damali b. 1949, Atlanta, GA. Education: Cooper Union School of Art, New York, NY (BFA 1973). Selected Exhibitions: "Social History: Show II," Bronx River Art Center and Gallery, NY (1994); "Texture," Bronx River Art Center and Gallery, NY (1992).

Min, Yong Soon b. 1953, Bugok, South Korea. Education: University of California at Berkeley (BA 1975, MA 1977, MFA 1979). Selected Exhibitions: "Asia/America: Identities in Contemporary Asian American Art," The Asia Society, New York, NY (1994); "The Decade Show: Frameworks of Identity in the 1980s," Museum of Contemporary Hispanic Art, The New Museum of Contemporary Art, and The Studio Museum in Harlem, New York, NY (1990); "Committed to Print," The Museum of Modern Art, New York, NY (1988).

Mori, Maryln b. 1939, Alameda, CA. Education: San Jose State University, CA (BA 1961); West Valley College, Saratoga, CA. Selected Exhibitions: "Yellow Forest," Somar Gallery, San Francisco, CA (1994); "40th Annual Exhibition of the National Society of Painters in Casein and Acrylic," National Arts Club, New York, NY (1993); "Works by Marlyn Mori," Creative Arts Center Gallery, Sunnyvale, CA (1991).

Morris, Michael b. 1950, Eugene, OR. Education: Self-taught. Selected Exhibitions: "Metalica," Bergdorf Goodman, New York, NY (1994); "Een Dialoog," Stedelijk Museum, Schiedam, The Netherlands (1993); "Blind Potent Spot/Magneto-Radiator," Gallery Nev, Istanbul, Turkey (1992).

Mumm, Denise b. 1956, Munich, Germany. Education: University of Iowa, Iowa City (BFA 1979, MA 1981). Selected Exhibitions: "The American Family Inside Out," Creative Arts Workshop, New Haven, CT (1993); "Beneath the Skirts of the Virgin Mary," Artist Access Gallery, Snug Harbor Cultural Center, Staten Island, NY (1993); "1990 Snug Harbor Sculpture Festival," Snug Harbor Cultural Center, Staten Island, NY (1990).

Munson, Portia b. 1961, Beverly, MA. Education: Cooper Union School of Art, New York, NY (BFA 1983); Mason Gross School of the Arts, Rutgers University, New Brunswick, NJ (MFA 1990). Selected Exhibitions: "Portia Munson," Yoshii Gallery, New York, NY (1994); "Bad Girls," The New Museum of Contemporary Art, New York, NY (1994); "White Room Show," White Columns, New York, NY (1992).

Namenwirth, Aron b. 1963, Ipswich, MA. Education: Yale University, New Haven, CT (MFA 1987). Selected Exhibitions: "Artist in the Marketplace XIV," The Bronx Museum of the Arts, NY (1994); "Those Silly Republicans," Flamingo East, New York, NY (1992); "$45 a Month," Cooper Union School of Art, New York, NY (1991).

Nash, Annie b. 1960, Fontana, CA. Education: Teachers College, Columbia University, New York, NY (EdD 1987). Selected Exhibitions: "New Directions in the '90s," Hello Artichoke, Los Angeles, CA (1994); "CAJE '94: America's Cultural Diversity," Center of Contemporary Arts, Saint Louis, MO (1994); "Route 66 Revisited Exhibition," traveling exhibition, opened at Red Mesa Arts Center, Gallup, NM (1993).

Newman, Nurit b. 1960, New York, NY. Education: Mason Gross School of the Arts, Rutgers University, New Brunswick, NJ (MFA 1993). Selected Exhibitions: "Artist in the Marketplace XIV," The Bronx Museum of the Arts, NY (1994); "Ten by Ten: 10 Dealers Choose 10 Artists," Art Initiatives Gallery, New York, NY (1994); "Small Works," East West Cultural Studies, New York, NY (1994).

Nicol, Heather b. 1960, Ottawa, Canada. Education: School of Visual Arts, New York, NY (BFA 1983); New York University, NY (MA 1990). Selected Exhibitions: "Charadezade," Château de Courances, France (1994); "Outside Possibilities," Rushmore Festival, Woodbury, NY (1992); "Trinity," Ledisflam Gallery, New York, NY (1991).

Noh, Sang-Kyoon b. 1958, Seoul, Korea. Education: Pratt Institute, Brooklyn, NY (MFA 1994). Selected Exhibitions: "We Count! The State of Asian Pacific America," Tweed Gallery, New York, NY (1993); "Rainbow Fish," Higgins Hall Gallery, Brooklyn, NY (1992); "Sang-Kyoon Noh," Kwan-Hoon Gallery, Seoul, Korea (1988).

Okuyan, Selime b. 1963, Adana, Turkey. Education: School of Visual Arts, New York, NY (BFA 1987). Selected Exhibitions: "Artist in the Marketplace XIV," The Bronx Museum of the Arts, NY (1994); "Pasando la Mano/Laying the Hand," Soho 20, New York, NY (1994); "A New World Order," Artists Space, New York, NY (1993).

Patton, Gloria b. 1945, New York, NY. Education: Pratt Institute, Brooklyn, NY (BFA 1969, MS 1978). Selected Exhibitions: "Pier Show II," Bewac, Brooklyn, NY (1994); "Choices," A.I.R. Gallery, New York, NY (1991); "Artist Makes Mask," The New Muse Community Museum, Brooklyn, NY (1985).

Pérsico, Selena Whitefeather b. 1951, Chester, PA. Education: Cooper Union School of Art, New York, NY (BFA 1974). Selected Exhibitions: "Nexus Grants," Nexus Contemporary Art Center, Atlanta, GA (1989); "Artwords and Bookwords," Institute of Modern Art, Brisbane, Australia (1982); "IX International Encounter on Video," Museo Alvar y Carmen Carillo Gil, Mexico City, Mexico (1977).

Pfeiffer, Paul b. 1966, Honolulu, HI. Education: San Francisco Art Institute, CA (BFA 1987); Hunter College, City University of New York, NY (MFA 1994). Selected Exhibitions: "Santo Niño Incarnate," Colonial House Inn, Lesbian and Gay Community Services Center, New York, NY (1994); "Extreme Unction," Market Garage Old Spitalfields Market/Panchayat, London, England (1994); "Kayumanggi Presence," Academy of Art, Honolulu, HI (1993).

Piñeiro, Emma b. 1932, Buenos Aires, Argentina. Education: Hunter College, City University of New York, NY (MA 1974). Selected Exhibitions: "The Quincentennial: A Native View," Arch Gallery, New York, NY (1992); "Mirror's Dream," Ibera Gallery, Buenos Aires, Argentina (1991); "Inner Landscapes," Candido Mendes Foundation, Rio de Janeiro, Brazil (1989).

Pitt, Lillian b. 1943, Warm Springs, OR. Education: Mount Hood Community College, Gresham, OR (AA 1981). Selected Exhibitions: "Crosscut," Portland Art Museum, OR (1993); "Contemporary Artwork," Te Taumata, Auckland, New Zealand (1993); "Lillian Pitt," Spirit Square Art Center, Charlotte, NC (1991).

Porter, Liliana b. 1941, Buenos Aires, Argentina. Education: Escuela Nacional de Bellas Artes, Buenos Aires, Argentina; La Universidad Iberoamericana, Mexico City (BE 1963). Selected Exhibitions: "Latin American Artists of the Twentieth Century," Kunsthalle Köln, Germany (1992); "Fragments of the Journey," The Bronx Museum of the Arts, NY (1992); "Projects," The Museum of Modern Art, New York, NY (1973).

Pratt, Noni b. 1958, Salem, MA. Education: Smith College, Northampton, MA. Selected Multimedia Site-Specific Installations and Performances: "Too Close to Home," University of Massachusetts, Dartmouth Art Gallery, MA (1994); "As a Dream That Vanishes," Solomon R. Guggenheim Museum in association with Creative Time, New York, NY (1991); "In the Eye of the Beholder," Conway & Pratt Project at 30 Bond Street, New York, NY (1988).

Pujol, Ernesto b. 1961, Havana, Cuba. Education: Universidad de Puerto Rico, Río Piedras (BFA 1979); Pratt Institute, Brooklyn, NY; Hunter College, City University of New York, NY. Selected Exhibitions: "Taxonomies," Galería Ramis Barquet, Monterrey, Mexico (1994); "Elements," INTAR Latin American Gallery, New York, NY (1994); "New York," Cavin-Morris Gallery, New York, NY (1993).

Radojičić, Vladimir b. 1958, Split, Yugoslavia. Education: University of Belgrade, Yugoslavia (BA 1982); Fug International, Hamburg, Germany (BA 1985). Selected Exhibitions: "The Aliens," Sebastian Gallery, Belgrade, Yugoslavia (1994); "1993 National Showcase Exhibition," Alternative Museum, New York, NY (1993); "Contemporary Yugoslav Photography," The Museum of Modern Art, Belgrade, Yugoslavia (1991).

Ramer, Carole b. 1948, New York, NY. Education: Brooklyn College, NY.

Ramirez, Lidia b. 1965, Santo Domingo, Dominican Republic. Education: City College, City University of New York, NY (BFA 1990). Selected Performances: "69," Joseph Papp Public Theater, New York, NY (1994); "La Casa Verde," Under One Roof, New York, NY (1994).

Ramsaran, Helen Evans b. Bryan, TX. Education: Ohio State University, Columbus (BS 1965, MFA 1968). Selected Exhibitions: "Helen Evans Ramsaran," The Studio Museum in Harlem, New York, NY (1994); "Helen Evans Ramsaran," The Chrysler Museum, Norfolk, VA (1994); Porter Randall Gallery, La Jolla, CA (1993).

Rinden, Thor b. 1937, Marshalltown, IA. Education: Hunter College, City University of New York, NY (MA 1968). Selected Exhibitions: "New Abstraction," Weatherspoon Art Gallery, The University of North Carolina at Greensboro (1989); "New Abstract Paintings," Cork Gallery, New York, NY (1986); "Selections from the Artists' File," Artists Space, New York, NY (1985).

Rivera, Sophie b. New York, NY. Education: New School for Social Research, New York, NY. Selected Exhibitions: "Artists Talk Back: Visual Conversations with El Museo," El Museo del Barrio, New York, NY (1994); "El Puerto Rican Embassy," Kenkeleba House, New York, NY (1994); "Una Vision del Mas Alla En El Nuevo Mundo," National Museum of Modern Art, Santo Domingo, Dominican Republic (1993).

Sakai, Janice b. Sanger, CA. Education: The Evergreen State College, Olympia, WA (BA 1991). Selected Exhibitions: "The Landscape, the Reliquary, and the Nude," Penelope Loucas Gallery, Tacoma, WA (1994); "December Art," Village Art Gallery, Gig Harbor, WA (1993); "T.C.C. Semi-Annual Arts and Crafts Show," Tacoma Community College, WA (1993).

Sandler, Barbara b. 1943, New York, NY. Education: Self-taught. Selected Exhibitions: "Nijinsky," Trabia/MacAfee Gallery, New York, NY (1989); "The Center Show," The Gay and Lesbian Center, New York, NY (1989); "Rites of Passage," Segal Gallery, New York, NY (1984).

Schafer, David b. 1955, Kansas City, MO. Education: University of Missouri, Kansas City (BA 1979); University of Texas, Austin (MFA 1983). Selected Exhibitions: "Pastoral Mirage," Project Park for Prospect Park Alliance, Brooklyn, NY (1993–94); "Living Room," Betty Rymer Gallery Chicago, IL (1993); "Corporealities," Sue Spaid Fine Art, Los Angeles, CA (1990).

Shackelton-Hawkins, Cheryl Ann b. 1958, Bronx, NY. Education: Sarah Lawrence College, Bronxville, NY (BA 1979); Columbia University, New York, NY (MLS 1987). Selected Exhibitions: "Prints and Books from the Lower East Side Print Shop," Pyramid Atlantic, Riverdale, MD (1991); "War and Peace," Center for Book Arts, New York, NY (1991); "Grieving," Hera Gallery, Providence, RI (1991).

Sharpe, Yolanda R. b. 1957, Detroit, MI. Education: Wayne State University, Detroit, MI (MFA 1982). Selected Exhibitions: "Hale Woodruff Memorial Exhibition," The Studio Museum in Harlem, New York, NY (1994); "Angels: Wings of Fire," George R. N'Namdi Gallery, Birmingham, MI

(1993); "Spiritual Natures: The Art of Yolanda Sharpe and Phil Young," Munson-Williams-Proctor Institute, Utica, NY (1992).

Singer, Beverly R. b. 1954, Brigham, UT. Education: University of Chicago, IL (MA 1977); Anthropology Film Center, Santa Fe, NM. Selected Exhibitions: "Imagining Indians," Scottsdale Center for the Arts, AZ (1994); "Wind and Glacier Voices: Film and Media Celebration," Walter Reade Theater, New York, NY (1994); "Pasando la Mano/Laying the Hand," Soho 20, New York, NY (1994).

Singletary, Deborah b. 1952, Brooklyn, NY. Education: Self-taught. Selected Exhibitions: "Women Artists Now and Forever," New Harlem Gallery, New York, NY (1993); "Raising My Voice," Generations Gallery, Brooklyn, NY (1993).

Sligh, Clarissa b. 1939, Washington, DC. Education: Howard University, Washington, DC (BFA 1972); University of Pennsylvania, Philadelphia (MFA 1973). Selected Exhibitions: "Clarissa Sligh," Toronto Photographers Workshop," Canada (1994); "History 101: The Re-Search for Family," The Forum for Contemporary Art, St. Louis, MO (1994); "The Subject of Rape," Film and Video Gallery, Whitney Museum of American Art, New York, NY (1993).

Smaka, Stashu b. 1944, Detroit, MI. Education: Wayne State University, Detroit, MI (BA 1977). Selected Exhibitions: Anita Shapolsky Gallery, New York, NY (1992); Stephen Haller Fine Art, New York, NY (1991); "Corners," The Rotunda Gallery, Brooklyn, NY (1985).

Smith, Yumiko Ito b. 1965, Nagoya, Japan. Education: City College, City University of New York, NY (MA 1994); Aichi University of Education, Japan. Selected Exhibitions: "Sakkarin," Nova Gallery, Nagoya, Japan (1992); "Koromo," Nova Gallery, Nagoya, Japan (1990); "88 Sculpture Show," Nagoya City Museum, Japan (1989).

Snowden, Gilda b. 1954, Detroit, MI. Education: Wayne State University, Detroit, MI (MFA 1979). Selected Exhibitions: "Abstract Realities," Sherry Washington Gallery, Detroit, MI (1994); "Signature Images: Gilda Snowden and Michael Luchs," Detroit Institute of Arts, MI (1990); "Gilda Snowden and Yolanda Sharpe," Mark Masuoka Gallery, Las Vegas, NV (1990).

Soto, Elaine b. 1947, New York, NY. Education: New York University, NY (PhD. 1979); School of Visual Arts, New York, NY. Selected Exhibitions: "Women and Their Work," Aaron Davis Hall, City College, City University of New York, NY (1993); "Vistas Latinas," Porter Butts Art Gallery,

University of Wisconsin, Madison (1993); "Meditations," Broadway Gallery, Passaic County Community College, Paterson, NJ (1990).

de Souza, Allan b. 1958, Nairobi, Kenya. Education: Whitney Museum of American Art Independent Study Program, New York, NY (1994). Selected Exhibitions: "Beyond the Borders: Art by Recent Immigrants," The Bronx Museum of the Arts, NY (1994); ""Na(rra)tive," Camerawork, London, England (1994); "Fourth Baguio Arts Festival," National Convention Center, Baguio, The Philippines (1993).

Fans, regardless of ethnic background, applauded loudly as a confused announcer introduced Mr. Park as "Ho Chan Park" and gave him a standing ovation as he trudged in from the bullpen. They cheered his first strike, groaned as several pitches went above...and around home

Spear, Jeremy b. 1960, New York, NY. Education: Yale University, New Haven, CT (BA 1982). Selected Exhibitions: "A Life of Secrets," A/C Project Room, New York, NY (1994); "The New World Order III: The Curio Shop," Artists Space, New York, NY (1993); "Jeremy Spear," Butlers Gallery, Portland, OR (1993).

Spino, HollyAnna b. 1968, Pasco, WA. Education: Self-taught. Selected Exhibitions: "Speely Arts and Crafts Show," Yakima Indian Nation Cultural Center, Toppenish, WA (1994); "Spirits Keep Whistling Us Home," Daybreak Star Art Gallery, Seattle, WA (1993); "Sahapquin," Nez Perce National Historic Park, Spalding, ID (1992).

Steck, Norman b. 1953, Pittsburgh, PA. Education: Washington University, St. Louis, MO (BA 1976); Hunter College, City University of New York, NY (MFA 1992). Selected Exhibitions: "Donna Moylan and Norman Steck," Postmasters, New York, NY (1993); "Some Artists I've Been Thinking of Who Fall Under the Tittle of: Wouldn't It Be More Pluralistic to Embrace Turmoil and/or Violence?," Andrea Rosen, New York, NY (1993); "Selections/Fall 1992," The Drawing Center, New York, NY (1992).

Sternbach, Joni b. 1953, Bronx, NY. Education: New York University, NY (MA 1987); International Center of Photography, New York, NY. Selected Exhibitions: "A Second Look: Women Photographers at Harry Ransom Humanities Research Center," University of Texas, Austin (1993); "Joni Sternbach," Lieberman and Saul Gallery, New York, NY (1992); "Pleasures and Terrors of Domestic Comfort," The Museum of Modern Art, New York, NY (1991).

Suzuki, Diane Education: The Claremont Graduate School, Claremont, CA (MFA 1993). Selected Exhibitions: "Utopian Dialogues," Los Angeles Municipal Art Gallery, CA (1993); "Dangerous Memories: Honoring Her Stories," North Gallery, California State University at Northridge (1992).

Takahashi, Masako b. 1944, Topaz Relocation Center, UT. Education: University of California at Berkeley (BA 1974). Selected Exhibitions: "Still Life," Sharon Truax Fine Arts, Venice, CA (1993); "The Ladders and Beyond," Tokoro Gallery, Los Angeles, CA (1990); "Memory," Tokoro Gallery, Los Angeles, CA (1990).

Takenaga, Barbara b. 1949, North Platte, NE. Education: University of Colorado, Boulder (MFA 1978). Selected Exhibitions: "Visible Meaning," Ise Art Foundation, New York, NY (1993); "Barbara Takenaga," College of Wooster Art Museum, OH (1993); "Art to Art: Expressions by Asian American Women," Asian Art Museum, San Francisco, CA (1993).

Thompson, Donna b. 1965, New York, NY. Education: City College, City Univeristy of New York, NY (MA 1994). Selected Exhibitions: "Who's on First: Colonialism as Subversion," 843 Studio Gallery, Brooklyn, NY (1993); "Interiors and Exteriors: Photographs in Black and White," International House, Columbia University, New York, NY (1990).

Ting, Mary b. 1961, Glen Cove, NY. Education: Parsons School of Design, New York, NY (BFA 1983). Selected Exhibitions: "Memories and Wounds," Augusta Savage Gallery, University of Massachusetts at Amherst (1993); "The Political Landscape," The Hillwood Art Museum, C. W. Post Campus, Long Island University, Brookville, NY (1990); "Leila Daw and Mary Ting," A.I.R. Gallery, New York, NY (1988).

Ting, Mimi Chen b. 1946, Shanghai, China. Education: San Jose State University, CA (MA 1976). Selected Exhibitions: "Of Fact and Fiction," University of Arizona, Tucson (1992); "Completing the Circle," Triton Museum of Art," Santa Clara, CA (1992); "Just Pictures," Rosicrucian Museum, San Jose, CA (1990).

Tiscornia, Ana b. 1951, Montevideo, Uruguay. Education: Facultad de Arquitectura, Universidad de la República, Montevideo, Uruguay (1971–77). Selected Exhibitions: "Beyond the Borders: Art by Recent Immigrants," The Bronx Museum of the Arts, NY (1994); "Working on Paper," INTAR Latin American Gallery, New York, NY (1994); I"ll Bienal de la Habana," Cuba (1986).

Todosijević, Raša b. 1945, Belgrade, Yugoslavia. Education: Akademija Likovnih Umetnosti, Belgrade, Yugoslavia (BFA 1969). Selected Exhibitions: "Europäer," Grazer Kunstverien im Stadtmuseum, Graz, Austria (1993); "The 5th Biennale of Sydney," Art Gallery of New South Wales, Australia (1984); "Dixième Biennale des jeunes artistes," Musée d'Art Moderne de la Ville de Paris, France (1977).

Torke, Ann b. 1965, Milwaukee, WI. Education: University of California, La Jolla, CA (MFA 1991). Selected Exhibitions: "Out of Bounds," CSPS Gallery, Cedar Rapids, IA (1994); "Downsizing the Image Factory," Unité d'Habitation de Le Corbusier, Firminy, France (1993); "Interlink Festival of New American Music," Present Music, Tokyo, Japan (1992).

Torrence, Charzette b. 1964, Detroit, MI. Education: Center for Creative Studies, Detroit, MI (BFA 1993). Selected Exhibitions: "Vision of Eight," Dell Prayor, Detroit, MI (1994); "Visionary Views, Society in Conflict," Detroit Repertory Theatre, MI (1993); "Image and Text," Detroit Artist Market, MI (1992).

Tremblay, Gail b. 1945, Buffalo, NY. Education: University of Oregon, Eugene (MFA 1969). Selected Exhibitions: "The 5th Biennal Native American Fine Art Invitational," Heard Museum, Phoenix, AZ (1991–92); "The Submuloc Project," traveling exhibition, opened at The Evergreen State College, Olympia, WA (1992); "The Definitive Contemporary American Quilt," traveling exhibition, opened at Bernice Steinbaum Gallery, New York, NY (1991).

Triana, Gladys b. 1937, Camaguey, Cuba. Education: Long Island University, Dobbs Ferry Campus, NY (ME 1977). Selected Exhibitions: "Path to the Memory," The Bronx Museum of the Arts, NY (scheduled for 1995); "Revealing the Self: Portrait by Twelve Contemporary Artists," Paine Webber Art Gallery, New York, NY (1992); "Lines of Vision: Drawing by Contemporary Women," Museo de Arte Contemporáneo de Caracas Sofia Imber, Venezuela (1990).

Vallejo, Linda b. 1951, Los Angeles, CA. Education: California State University, Long Beach (MFA 1978). Selected Exhibitions: "Cara," traveling exhibition, opened at the Wight Art Gallery, University of California, Los Angeles (1990); "Símbolo y Fuerza," Galería Las Americas, Los Angeles, CA (1992); "Vallejo," Galería Las Americas, Los Angeles, CA (1991).

Veca, Mark Dean b. 1963, Shreveport, LA. Education: Otis Art Institute of Parsons School of Design, Los Angeles, CA (BFA 1985). Selected Exhibitions: "Waterworks," Edward Thorp Gallery, New York, NY (1994); "Le Temps d'un Dessin," Galerie de l'Ecole de Beaux-Arts, Lorient, France (1994); "Splat Figures," White Columns, New York, NY (1994).

Veljković, Andrev b. 1946, Belgrade, Yugoslavia. Education: Self-taught. Selected Exhibitions: "First National Showcase Exhibition," Alternative Museum, New York, NY (1992); "Ecofest '89," Riverside Park, New York City Department of Parks and Recreation, NY (1989); "Collaborations," Alternative Museum, New York, NY (1985).

Verna, Gelsy b. 1961, Port-au-Prince, Haiti. Education: The School of the Art Institute of Chicago (MFA 1990). Selected Exhibitions: "Strokes and Stitches," Hyde Park Art Center, Chicago, IL (1994); "Black Creativity 1993," Museum of Science and Industry, Chicago, IL (1993); "From America's Studio: Drawing New Conclusions," Betty Rymer Gallery, Chicago, IL (1992).

Vesna, Victoria b. 1959, Washington, DC. Education: University of Fine Arts, Belgrade, Yugoslavia (Diploma 1984). Selected Exhibitions: "Machine Culture: The Virtual Frontier," Siggraph, Anaheim, CA (1993); "Virgin Territories," Long Beach Museum of Art, CA (1992); "La Biennale di Venezia," Art and Science, Venice, Italy (1986).

Vine, Marlene b. New York, NY. Education: Carnegie Institute of Technology, Pittsburgh, PA. Selected Exhibitions: "The Grammercy International Contemporary Art Exhibition," Graig Cornelius, New York, NY (1994); "Isn't It Romantic?" Crosby Street Gallery, New York, NY (1994); "Contemporary Art on Canvas," Maryland Federation of Art Gallery, Annapolis (1993).

Volonakis, Michael b. 1952, New York, NY. Education: Pratt Institute, New York, NY (BFA 1974). Selected Exhibitions: "Life Is Elsewhere," Richard Anderson Fine Art, New York, NY (1994); "Drawings and Photographs," The Gallery State Theatre Center for the Arts, Easton, PA (1994); "New Paintings and Monoprints," Stephen Rosenberg Gallery, New York, NY (1987).

Wan, Betty Phoenix b. 1959, Los Angeles, CA. Education: Otis Art Institute of Parsons School of Design, Los Angeles, CA (BFA 1982). Selected Exhibitions: "The Autobiography of Difference and the Asian-American Experience," Side Street Gallery, Santa Monica, CA (1993); "In Visible Past," John Wayne Airport, Irvine, CA (1993); "Chinese Heritage: Five Contemporary Perspectives," California State University Art Gallery, Northridge (1993).

Warfield, Carolyn b. 1944, Indianapolis, IN. Education: University of Detroit, MI (BA 1974); Center for Creative Studies, Detroit, MI. Selected Exhibitions: "Synthetic Linen," Lafayette Museum of Art, IN (1994); "Questions of Identity," Turman Gallery, Indiana State University, Terre Haute (1993); "Visual Perspectives, Americanism: Breaking the Mold," Porter Butts Gallery, University of Wisconsin, Madison (1993).

Washington, Bisa b. 1951, Albany, NY. Education: Jersey City State College, NJ (BA 1975). Selected Exhibitions: "Sanctuary," Edward Williams Gallery, Fairleigh Dickinson University, Rutherford, NJ (1992); "The Artist as Shaman: The Spiritual and the Commonplace," Robeson Gallery, Rutgers University, Newark, NJ (1992); "Tar Babies, Rag Dolls, and Corrugated," The Newark Museum, NJ (1992).

Washington, Gina T. A. b. 1967, Cleveland, OH. Education: University of Rochester, NY (BA 1989). Selected Exhibitions: "The J.C.C. Annual Photography Show," Jewish Community Center, Cleveland Heights, OH (1989); Hartnett Art Gallery, Rochester, NY (1989).

Weaver, Thomas b. 1950, San Francisco, CA. Education: Hunter College, City University of New York, NY (MFA 1982). Selected Exhibitions: "Thomas Weaver," Condeso/Lawler Gallery, New York, NY (scheduled for 1995); "Thomas Weaver," TAI Gallery, New York, NY (1994); "Landscapes," Condeso/Lawler Gallery, New York, NY (1993).

Williamson, Suzanne b. 1950, Bronxville, NY. Education: State University College at Purchase, NY (BA 1977); International Center of Photography, New York, NY (1978–80). Selected Exhibitions: "Tradition and the Unpredictable: The Allan Chasanoff Collection," Museum of Fine Arts, Houston, TX (1994); "Ellis Island: Echoes from a Nation's Past," Ferrara Cultural Institute, Italy (1993); "Suzanne Williamson—Animals," Moore College of Art, Philadelphia, PA (1992).

Woodson, Shirley b. 1936, Pulaski, TN. Education: Wayne State University, Detroit, MI (BFA 1958, MA 1965); The School of the Art Institute of Chicago, IL (1960). Selected Exhibitions: "I Remember...Images of the Civil Rights Movement, 1963–1993," Corcoran Gallery of Art, Washington, DC (1993); "Shirley Woodson: Figurations, New Paintings, and Drawings," Sherry Washington Gallery, Detroit, MI (1992); "A Point of View," Hughley Gallery and Objects, Atlanta, GA (1992).

Wooster, Ann-Sargent b. Chicago, IL. Education: Bard College, Annandale-on-Hudson, NY (AB); Hunter College, City University of New York, NY (MA 1972). Selected Exhibitions: "Lesson Boards," New Arts Program, Kutztown, PA (1994); "No Means No," videotape, The Contemporary Arts Center, Cincinnati, OH (1993); "Carmen" videotape, broadcast by New Television (1990).

Yagjian, Tina b. 1954, Worcester, MA. Education: Wheaton College, Norton, MA (BFA 1976). Selected Exhibitions: "On the Way Home," Artists and Homeless Collaborative, New York, NY (1993); "Travel and Leisure," 4 Walls, Brooklyn, NY (1992); "Over the Bridge," Artists Open Studios, Brooklyn, NY (1989).

Yamamoto, Lynne b. 1961, Honolulu, HI. Education: New York University, NY (MA 1991). Selected Exhibitions: "Four-Story Building," Lehman College Art Gallery, Bronx, NY (1994); "Construction in Process," The Artists' Museum, Lodz, Poland (1993); "Wash Closet," Information Gallery, New York, NY (1993).

Yearby, Marlies b. 1960. Munich, Germany. Education: San Jose State University, CA. Selected Performances: "American Exit," Dance Festival, La Maison de la Culture, Créteil, France (1994); American Center, Paris, France (1994), "Movin' Spirits Dance Theater Company," Lincoln Center Out-of-Doors, New York, NY (1993).

Yoguel, Mónica b. 1953, Buenos Aires, Argentina. Education: National Sculptor Professor, Buenos Aires, Argentina (MFA 1982). Selected Exhibitions: "Propositions sur papier," Centre Interculturel Strathearn, Montreal, Canada (1993); "Hispanidad '93," Les Galeries des Sources, Montreal, Canada (1993); "La Mirada (The Sight)," Cinter Gallery, Santa Fé, Argentina (1992).

Yuen, Charles b. 1952, Honolulu, HI. Education: Mason Gross School of the Arts, Rutgers University, New Brunswick, NJ (MFA 1981). Selected Exhibitions: "The New World Order III:

The Curio Shop," Artists Space, New York, NY (1993); "Tiananmen Square Show," Blum Helman Warehouse, New York, NY (1989); "Double Vision," Hallwalls Contemporary Arts Center, Buffalo, NY (1988).

Zemel, Julie b. 1968, Brooklyn, NY. Education: Cooper Union School of Art, New York, NY (BFA 1989). Selected Exhibitions: "Artist in the Marketplace XIV," The Bronx Museum of the Arts, NY (1994); "Small Works," 80 Washington Square East Galleries, New York University, NY (1994); "The Joke Show," 4 Walls, Brooklyn, NY (1993).

Zrnić, Maja b. 1961, Sisak, Yugoslavia. Education: Law University, Zagreb, Yugoslavia (Juris Doctor 1986); New York University Film School, NY, (1986–88). Selected Screenings: "Rhythm of Life," Leipzig Film Festival, Germany (1992); "Jazz Night," Film Video Arts Angel's Award, Donnell Public Library, New York, NY (1990); "Larry Weight," broadcast on PBS (1990).

Zulueta, Ricardo b. 1962, Havana, Cuba. Education: Florida International University, Miami (BFA 1985); New York University, NY (1985–87). Selected Exhibitions: "Imagining Families: Images and Voices," Smithsonian Institution, Washington, DC (1994–95); "American Voices," Rockefeller Foundation, Houston Foto Festival, TX (1994–95); "Information Stands II," San Francisco Art Commission Public Art Project, CA (1994–95).

WORKS IN THE EXHIBITIONS

Art in General wishes to thank the artists who have contributed to our 1993–1994 exhibitions. Unless otherwise noted, the works listed below are from the artist's collections; height precedes width precedes depth.

L. ALCOPLEY: THE LATE WORKS 1970–1990

Untitled. 1970.
Oil on canvas, 35 x 40"

Nina Tryggvadottir in Memoriam: A Spring. 1971.
Oil on canvas, 84 x 108"

Release. 1973.
Oil on canvas, 50 x 208 1/2"

Coil—Uncoil: Celebration. 1973.
Oil on canvas, 106 x 100"

Proceedings. 1973.
Oil on canvas, 50 1/2 x 102"

Untitled. 1974.
Oil on canvas, 54 x 210"

Inside the Window Pane. 1977.
Oil on canvas, 94 x 68"

Reaching Out. 1978.
Oil on canvas, 52 x 69"

Untitled. 1978.
Acrylic on canvas, 68 x 200"

In the Playground. 1980.
Oil on canvas, 82 x 100"

A Wind. 1982.
Oil on canvas, 25 x 41"

Rencontre. 1982.
Oil on canvas, 41 x 26"

What Is Life. 1984.
Oil on canvas, 105 x 81"

Ascent. 1986.
Acrylic on canvas, 56 x 50"

Memories. 1986.
Acrylic on canvas, 50 x 96"

Passage. 1987.
Acrylic on canvas, 58 x 132"

Untitled. 1990.
Oil on linen, 42 x 12"

REMEMBER YUGOSLAVIA

Marina Abramović
Anthology of Performances. 1976–80.
4 black-and-white and color volume sets compiled by Time Based Arts, 4 hours 30 minutes.
Courtesy Electronic Arts Intermix

City of Angels. 1983.
Videotape, color, 21.37 minutes.
Courtesy Electronic Arts Intermix

Terra degli dea Madre. 1984.
Videotape, color, 15.40 minutes.
Courtesy Electronic Arts Intermix

Terminal Garden. 1986.
Videotape, color, 20.14 minutes.
Courtesy Electronic Arts Intermix

The Shifting Paradigm (Arts Meets Science and Spirituality). 1993.
Videotape, color, 52 minutes.
Courtesy Mystic Fire, Inc.

Zoran Belić Weiss
The Banner of History. 1993.
Acrylic on gallery wall, gold cloth panels, spear, gilded ram's horns, vessels of intravenous blood supply, and bowl with red liquid and gold leaf, 14 x 20 x 3'

Vesna Golubović
Prayer. 1993.
Acrylic and chalk on gallery wall, 11 x 63'

Vlasta Volcano Mikić
Signs Along the Road. 1991–93.
Installation with cut and burned rubber tires, steel wire, charcoal and chalk, 14' x 16' x 12'

Vesna Todorović Miksić
(collaboration with Vera Miksić)

Gods Eat Immortality: 140 Days. 1993.
140 plastic zip-lock sandwich bags with bread rolls, 124 x 72 x 2"

Vladimir Radojičić
The Aliens (from *The Alien* series, installation No. 3). 1992–93.
72 black-and-white Polaroids with gold identification plates, 24 x 171"

Raša Todosijević
Stories About the Art. 1989.
Typewritten texts on leaflet, 126 1/2 x 70"

Andrev Veljković
Thirty-Seven Days of Mourning. 1993.
Installation with mirror, wooden frame, earth, water, candles, live fish, burning incense from Mount Athos, sand, and fresh flowers, 96 x 60 x 30"

Victoria Vesna
In Order to Shine, You've Got to Burn. 1993.
Wooden cross with glass cover, 11 mounted Cibachrome prints from computer generated images, and TV monitor inlaid in a child's coffin, 10 x 10 x 4'

Maja Zrnić
Resident Alien. 1989.
Videotape, black-and-white and color, 14 minutes

Kristina. 1990.
Videotape, color, 30 seconds

Self-Commercial. 1990.
Videotape, black-and-white and color, 30 seconds

Untitled by Anonymous. 1991.
Videotape, black-and-white and color, 6 minutes

Zoran Belić Weiss, **Vladimir Radojičić**, and **Andrev Veljković**.
Remember Brothers and Sisters in Arms/Remember Yugoslavia (from the collaborative *Artworks* series, Installation RY 02). 1993.
Installation and performance with transparent plastic banner, book of condolences on metal table, two stocks of gauze mounted on 12" high metal spikes, two metal bowls with red paint, drawing paper, and two metal receptacles with cotton cushions, 96 x 120 x 72"

Collaborative work by all "Remember Yugoslavia" participants
Remember Yugoslavia/ Dedication Piece (from the collaborative *Artworks* series, Painting RY 01). 1993.
Black and gold acrylic, china markers, charcoal, and chalk on gallery wall, 96 x 96"

CASBAH PAINTINGS

Charles Yuen
Ali Baba. 1991.
Oil on canvas, 70 x 54"

You Were Saying. 1992.
Oil on canvas, 2 panels,
overall 42 x 108 1/2"

Golden Slippers. 1992.
Oil on canvas, 78 x 66"

*The Little Theatre of Hope
and Desire*. 1992.
Oil on canvas, 78 x 66"

The Purloined Handkerchief.
1992.
Oil on paper, 6 panels,
overall 44 x 91"

Pedo de Christo. 1993.
Oil on canvas, 66 x 78"

*The Way the Compass
Points*. 1993.
Oil on canvas, 72 x 54"

After Dusk. 1993.
Oil on canvas, 72 x 53"

GOOD AND PLENTY

Anthony Arnold
Mars. 1992.
Acrylic on canvas, 64 x 32"

Sarah Barnum
Cage. 1992.
Oil on linen, 20 x 21 1/2"

Look Out. 1992.
Oil on linen, 17 1/2 x 17 1/2".
Private Collection

Pearls. 1992.
Oil on linen, 17 1/2 x 17 1/2"

Sidney Berger
Red Rover. 1993.
Oil on wood, 80 x 36"

Valery Daniels
Untitled (*Composite Figure*
series) 1990-93.
Aluminum, height 40",
diameter 9"

Two Part Urn (*Composite
Figure* series). 1990–93.
Bronze and iron, height 24",
diameter 15"

Figure in Waiting
(*Composite Figure* series).
1990–93.
Wood and aluminum foil,
height 41", diameter 15"

Column (*Composite Figure*
series). 1990–93.
Wood, height 96",
diameter 16"

Susanna Dent
Cassiopeia. 1993.
Wax and oil on board,
16 x 14 1/2"

Tender Hope. 1993.
Wax and oil on board,
16 x 14 1/2"

Napkinhead. 1993.
Wax and ink on board,
13 x 13"

Boat Girl. 1993.
Wax and oil on board,
13 x 14 x 3 1/4"

Night Nurse. 1993.
Wax and oil on board,
13 x 14 x 3 1/4"

Snake Rhythm. 1993.
Wax and oil on board,
19 x 24"

Motorcycle Boy. 1993.
Wax and oil on board,
13 x 14 x 3 1/4"

Karni Dorell
Untitled. 1993.
Mixed media on wood,
14 x 15 1/2 x 5"

Untitled. 1993.
Mixed media on wood,
37 x 24 x 9"

Untitled. 1993.
Mixed media on wood,
14 x 15 1/2"

Untitled. 1993.
Mixed media on wood,
11 x 17"

Elizabeth Ernst
Industrial Inversion. 1993.
Oil on canvas, 36 x 48"

Steel I. 1993.
Oil on steel, 105 1/2 x 14"

a.k.a. Futai
*The Water Flows Through
the Fish (Muskellunge)*.
1993.
Acrylic on paper, 28 x 30"

*Where the April Shower
Go #3*. 1993.
Acrylic on paper, 38 x 32"

Matthew B. Geller
*I'd Talk But I Don't Have
Time #3*. 1991
Plastic, steel, gesso, and
paint, edition of 5, 4 x 5 x 1"

Yo! Boss No. 2. 1992.
Cast brass, steel, and gran-
ite, edition of 3, 3 x 8 x 8"

*He Thought He'd Meet His
Best Friend*. 1992.
Marble, glass, and plastic,
12 x 15 x 17 1/2"

*Yea, It's by Force of
Personality #3*. 1992.
Plastic, steel, gesso, and
paint, edition of 5,
7 x 4 x 3/4"

No, I Said No. 1993.
Plastic, steel, gesso, and
paint, 6 x 8 x 8"

Leak (Featuring...). 1993.
Water, cement, plastic, and
latex, 88 x 45 x 1"

Elizabeth Gemperlein
Touch Her if You Dare. 1993.
Oil and wax on canvas,
58 x 76"

Kenneth Sean Golden
Latex Dialogue. 1993.
Latex, silkscreened digital
photograph, wood, and
string, 53 x 72 x 78"

Dennison W. Griffith
Untitled. 1993.
Oil and wax on mixed
materials, 14 pieces, overall
66 x 88"

Baiyou Han
*The Punishment for
Difference*. 1993.
Oil on linen, 68 x 68"

Eric Heist
Newspaper Message. 1993.
Silkscreen on rice paper,
31 x 44"

Newspaper Message. 1993.
Silkscreen on rice paper,
31 x 44"

Amy Hill
Local Stores. 1992.
Color photograph, 16 x 20"

On First Avenue. 1992.
Color photograph, 16 x 20"

On Second Avenue. 1993.
Color photograph, 16 x 20"

Neighborhood Scene. 1993.
Color photograph, 16 x 20"

On Fifth Avenue. 1993.
Color photograph, 16 x 20"

Vanity Street. 1993.
Color photograph, 16 x 20"

Crazy-Mixed Up Street.
1993.
Color photograph, 16 x 20"

Famous Street. 1993.
Color photograph, 16 x 20"

On Fourth Avenue. 1993.
Color photograph, 16 x 20"

Neighborhood Stores. 1993.
Color photograph, 16 x 20"

Marta Jaremko
Baby. 1993.
Gouache on paper, 16 pan-
els, each 9 3/4 x 9 3/4"

Leslie Kippen
Untitled. 1993.
Pastel, charcoal, and marker
on paper, 16 x 12 1/2"

Untitled. 1993.
Pastel, charcoal, and marker
on paper, 16 x 12 1/2"

Untitled. 1993.
Pastel, charcoal, and marker
on paper, 16 x 12 1/2"

Taylor Lee
Factories. 1993.
Acrylic on paper, 20 x 16"

Dog in the Street. 1993.
Acrylic on paper, 20 x 16"

Night. 1993.
Acrylic on paper, 16 x 12"

Barbeque. 1993.
Acrylic on wood, 13 x 9 1/2"

George Littlechild
This Land Is My Land. 1993.
Mixed media, 36 x 24"
Courtesy Derek Simpkins
Gallery of Tribal Art,
Vancouver, Canada

Margaret McCann
Roadblock. 1992.
Oil on canvas, 40 x 40"

Ellen Mac Donald
Breathing. 1991.
Collage, 12 3/4 x 15 3/4"

Containment. 1991.
Collage, 15 3/4 x 12 3/4"

Crossing. 1991.
Collage, 12 3/4 x 15 3/4"

Raw. 1991.
Collage, 12 3/4 x 15 3/4"

It Has Become Quiet. 1991.
Collage, 12 3/4 x 15 3/4"

Untitled. 1991.
Collage, 12 3/4 x 15 3/4"

Listening to a Conch Shell.
1991.
Collage, 12 3/4 x 15 3/4"

Phoenix. 1992.
Collage, 12 3/4 x 15 3/4"

Evan. 1992.
Collage, 15 3/4 x 12 3/4"

Norma Markley
It Feels Firm. 1993.
Oil, thread, and rubber on
canvas, 8 x 8"

Try It. Try It First. 1993.
Oil, thread, rubber, and
needle on canvas, 8 x 10"

How Does It Feel. 1993.
Oil, thread, and metal on
canvas, 8 x 10"

I do. I do. 1993.
Oil and clothespins on
canvas, 8 x 10"

Denise Mumm
Dormition. 1993.
Fiberglas, 58 x 55 x 2"

Heather Nicol
Untitled. 1993.
Dresses, steel, and plastic,
96 x 40 x 40"

Fallen. 1993.
Dress and steel,
25 x 60 x 30"

Sang-Kyoon Noh
Fishy Eye. 1992.
Sequins on canvas, 42 x 42"

Thor Rinden
Making a Point. 1989.
Charcoal and conté crayon
on paper on Sheetrock,
17 x 17"

Vertical Hold. 1989.
Charcoal and conté crayon
on paper on Sheetrock,
13 1/2 x 13 1/2"

Square Lift. 1990.
Charcoal and conté crayon
on paper on Sheetrock,
13 1/2 x 13 1/2"

You Are Here. 1991.
Charcoal and conté crayon
on paper on Sheetrock,
20 1/2 x 20 1/2"

Barbara Sandler
Vanité Sauvage. 1993.
Oil on paper, 50 x 42"

Stashu Smaka
Gandharva. 1992.
Steel, 48 x 12 x 12"

Flood. 1993.
Steel, cloth, and encaustic,
39 x 16 x 65"

Allan de Souza
*Family Albums/Allied
Trophies.* 1991–92.
Laser prints and wood stain
on wood, 80 x 50"

Jeremy Spear
Harem (Ochre I). 1993.
Acrylic on canvas with
fabric, cardboard, plastic,
and tape, 38 x 33 x 5"

Harem (Ochre II). 1993.
Acrylic on canvas with
fabric, plastic, and tape,
38 x 33 x 5"

Masako Takahashi
Cuatro (Four). 1993.
Watercolor on Mexican bark
paper, 4 panels, each
29 x 22"

Mary Ting
Vestiges. 1993.
Nylon, bias tape, and nails,
dimensions variable

Suzanne Williamson
Mother's Milk. 1993.
Heat transfer on cloth,
34 x 32"

Opening. 1993.
Heat transfer on cloth,
38 x 32"

Tina Yagjian
Untitled. 1993.
Collaged laser copies and
wax on Masonite, 2 panels,
each 22 x 17"

POTATOES, LIPSTICKS, TEDDY BEARS, AND MAO

Michelle Charles
Potato Books. 1992–93.
Charcoal with glaze on fold-
out books, 22 books, each
83 x 6"

Gail Goldsmith
Little Sister Bear. 1990.
Clay, 10 x 25 x 15 1/2"

Little Sister Bear. 1990.
Clay, 16 x 16 1/2 x 14"

Sadie's Baby. 1990.
Clay, 8 x 14 1/2 x 23"

Big Sister Bear. 1991.
Clay, 15 x 15 1/2 x 12"

Baby Bear. 1991.
Clay, 9 1/2 x 24 x 11 1/2"

Stacy Greene
Simona (from Lipstick
series). 1993.
Color photograph, 20 x 24"

Wendy (from *Lipstick*
series). 1993.
Color photograph, 20 x 24"

Ellen (from *Lipstick* series).
1993.
Color photograph, 20 x 24"

Roberta (from *Lipstick*
series). 1993.
Color photograph, 20 x 24"

Victoria (from *Lipstick*
series). 1993.
Color photograph, 20 x 24"

Maradee (from *Lipstick*
series). 1993.
Color photograph, 20 x 24"

India (from *Lipstick* series).
1993.
Color photograph, 20 x 24"

Lisa (from *Lipstick* series).
1993.
Color photograph, 20 x 24"

Gwen (from *Lipstick* series).
1993.
Color photograph, 20 x 24"

Nancy (from *Lipstick* series).
1993.
Color photograph, 20 x 24"

Zhang Hongtu
Long Live Chairman Mao.
1987–93.
Acrylic on Quaker Oats
boxes, 30 boxes, each
height 9 1/2", diameter
4 1/2"

Burlap Mao (from *Material
Mao* series). 1992.
Burlap, 77 x 44"

Stone Mao (from *Material
Mao* series). 1992.
Stone, 25 1/2 x 26"

Iron Mao (from *Material
Mao* series). 1992.
Iron, diameter 24 1/2"

Mesh Mao (from *Material
Mao* series). 1992.
Mesh, 36 x 27 1/2 x 8 3/4"

Corn Mao (from *Material
Mao* series). 1992.
Corn, diameter 39"

Leather Mao (from
Material Mao series). 1992.
Leather, 26 x 19"

Fur Mao (from *Material
Mao* series). 1993.
Fur, 29 x 16"

*Material Mao: The
Drawings No. 1–6.* 1993.
Soy sauce on rice paper
sealed with epoxy resin,
each 22 x 33"

BATHROOM INSTALLATION

Robert Chi and **Christa
Black**
La Ultima Toiletta. 1993.
Site-specific installation of
toilet-paper rolls with
mannequin piss insignia,
purple draperies, multi-
colored painted walls, and
audiotape

GATHERING MEDICINE

Nadema Agard
Healing of the Mother.
1993.
Acrylic and mixed media on
canvas, diameter 12"

Karen Lee Akamine
*Say, Speak, Listen—
Gaman.* 1993.
Mixed media on wood,
12 x 8 1/4 x 5 1/8"

Manuela Aponte
Obatala. 1991.
Color photograph, 12 x 12"

Tomie Arai
Drinking Tea. 1994.
Papier-mâché, twine, green
tea, and wood on 12" tray

Mildred Beltré
Untitled. 1993.
Woodcut, 5 1/4 x 4 1/2"

Kabuya Pamela Bowens
Haven of Rest. 1993.
Bottle and mixed media,
under 12"

Brenda Branch
*Ancient Egyptian Goddess
Selket.* 1993.
Collage and mixed media on
canvas, 8 x 11"

**Angela-Nailah E.
Brathwaite**
El Quita Todo (The Heal-All).
1993.
Brass, silver, shells, and
semi-precious stones,
5 x 23"

Joy Dai Buell
Healing Circle. 1993.
Beads, flour, salt, water,
seeds, stones, and
Plexiglas, diameter 12"

Dina Bursztyn
A Witch Poem. 1992.
Handpainted screenprint,
11 x 13"

Carole Byard
American History 101. 1994.
Wood, clay, cotton, and
earth, 15 x 4 x 8"

Yvonne Pickering Carter
*Take Two: Rescue and
Refrain #2.* 1993.
Acrylic on canvas and
assemblage, 12 x 12 x 12"

Vladimir-Cybil Charlier
*(All the Ancestors' Bottles)
and a River of
Forgetfulness.* 1993.
Acrylic on paper, nylon
thread, and plexiglas,
9 x 11"

Martha Chavez
Kelly the Doctor. 1994.
Acrylic and oil on canvas,
12 x 18"

Polly Chu and **Diane
Suzuki**
Tangible. 1992.
Mixed media book,
10 x 8 x 2 1/2"

Regina Araujo Corritore
Jíbaro Traveling Medicine.
1994.
Steel, glass, and paper,
15 X 11 X 8"

Esperanza Cortés
*Memories of My
Grandmother I.* 1993.
Wood, plaster, clay, and
beads, 4 1/2 X 6 1/2"

*Memories of My
Grandmother II.* 1993.
Wood, plaster, clay, and
beads, 5 X 7"

*Memories of My
Grandmother III.* 1993.
Wood, plaster, clay, and
beads, 5 1/2 X 7 1/2"

Erika Cosby
Lost Parts in Pink. 1993.
Acrylic and shellac, 12 x 9"

Joan Criswell
Medicine Wheel #3. 1993.
Mixed media, 11 1/2 x 11
1/2 x 11 1/2"

Adriene Cruz
*Love With Respect (Let
Beauty Shine Through).*
1993.
African and East Indian
pieced fabric, cowrie shells,
and beads, 11 1/2 x 7 1/2"

Pura Cruz
*Democracy Is Coming to
America.* 1993.
Mixed media, 12 x 5"

Maricela Cuadros
*Crumbs of Color Will Take
Flight: Green, Red, Gold.*
1993.
Oil on canvas, 11 x 18"

Maria M. Dominguez
Ex-Votos. 1993.
Mixed media, 6 3/4 x
9 1/2 x 8"

Sheila Eliazer
Untitled. 1993.
Oil on canvas, 10 x 14"

Teresita Fernández
Untitled. 1993.
Graphite, wood, and brass,
5 1/2 x 5 1/2 x 5 3/4"

Ana Ferrer
*Un Remedio (Babalu-
Aye/San Lazaro).* 1993.
Wood, nails, acrylic, and
Xerox, 12 x 12 x 5"

Maria Teresa Giancoli
Coastal Remnants. 1993.
Palladium prints, sorrel,
eucalyptus, shells, sand,
metal, and wood,
6 1/2 x 8 1/2 x 3/4"

Maria Elena González
Untitled. 1992.
Wood, rawhide, joint com-
pound, graphite, lacquer,
and velvet, 9 1/2 x 12 x
16 1/2"

Wilda Gonzalez
*In Ve Tonatiah—The Great
Sun.* 1993.
Acrylic on canvas,
8 1/2 x 11"

Karen Elise Goulet
Heart Matters First No. 1.
1993.
Copper, wood, cardboard,
and paint, 12 x 10 x 2"

Teresa Harris
Untitled. 1990–93.
Watercolor, hair on stencil
sheets, paper, and wood,
12 x 13"

Miriam Hernández
Medicine Chest. 1993.
Acrylic, collage, and metal
leaf on canvas,
12 x 10 1/2 x 9"

Linda Hiwot
Medicine Chest. 1993.
Oil on canvas, 12 x 12 x 3"

Robin Holder
And the Rain Came. 1993.
Paper, wood, and string,
under 12"

Anita Miranda Holguin
Loyal to Mom. 1993.
Mixed media, 14 x 8 1/2 x 7"

**Safiya Henderson
Holmes**
*I'm Dreaming of a Safe,
Happy, Healthy Baby in a
Safe, Happy, Healthy World.*
1993.
Clay, beads, semiprecious
stones, toy babies, Spanish
moss, grapesvines, sage,
cedar, and Plexiglas,
10 x 10 x 10"

Arianne King-Comer
To the Forest. 1993.
Batiked fabric, photo, and
wood bark, 12 x 12, 4 1/2"

Kumi Korf
Breaking Down Cancer.
1993.
Pine board, Foamcore, X-ray
photograph, color Xerox, silk
fabric, dried pomegranate,
and disposable acupuncture
needles, 9 x 12 x 4 1/2"

Anna Kuo
Night Work No. 1. 1993.
Acrylic, gold leaf, herbs,
cork stoppers, and glass
tubes, 12 x 11 1/8"

Lanie Lee
Prime Meridians. 1993.
Mixed media, 12 x 12 x 12"

Dori Lemeh
Vessel No. 2. 1993.
Found objects, charcoal, and
acrylic on paper, under 12"

Charlotte Lewis
*Ba-ra-ka: Soul, Creation,
Spirit.* 1993.
Painted wood sculpture,
12 x 6 1/2 x 3 1/2"

Rejin Leys
Guantánamo Survival Kit
(artist's book). 1993.
Collage, silkscreen, and
mixed media, 11 x 4 1/4"

Soraya Marcano
Poema de Liberación. 1993.
Acrylic, ink, metal, and
handmade paper, 9 x 12"

Malpina Mark-Chan
Ma's Medicine. 1993.
Plexiglas, acetate, metal,
photographs, paper, and
Chinese herbs, 11 x 7 x 7"

Gloria Maya
*Arbol de la Vida (Tree of
Life).* 1993.
Handmade paper, colla-
graph, cotton fiber, wood,
and cleansing sagebrush
stick, 12 x 10"

Iris Maynard
Medicine Man. 1993.
Oil on canvas, 12 x 12"

Liliana Mejia
Breaking the Silence. 1993.
Mixed media, 9 x 12"

Raquelín Mendiéta
Coco-Guerrero-Fetish. 1993.
Mixed media on coconut,
12 x 12 x 12"

Rosalyn Mesquita
Sobadores, Yerbas y la Fe.
1993.
Wire, paper, plastic, and
mixed media, 6 x 11 1/2 x 3"

Damali Miller
Healing Meditation #4.
1993.
Collage and acrylic on wood
and canvas, 12 x 12 x 12"

Maryln Mori
My Heart's in It. 1992.
Acrylic on canvas, 8 x 8"

Annie Nash
Her Visions. 1993.
Acrylic, ink, and ephemera
on paper, 12 x 11"

Selime Okuyan
Tragic Experiment. 1993.
Ink, oil pastel, printing, and
glass, 6 pieces, each 9 x 12"

Gloria Patton
Deux-Dieu. 1993.
Paper, paint, wood, and
found objects, 12 x 11"

**Selena Whitefeather
Pérsico**
Turtle Island. 1993.
Plaster, encaustic, beeswax,
and graphite, 3 x 5 x 8"

Emma Piñeiro
no NO. 1993.
Mixed media, under 12"
Courtesy Daniela Montana

Lilian Pitt
*She-Who-Watches—
Tsagagllallall.* 1993.
Anagama fired stoneware,
6 x 9 x 3"

Liliana Porter
The Way. 1993.
Acrylic and assemblage
with gold frame, 9 x 7"

Helen Evans Ramsaran
*House of the Healing
Spirits.* 1993.
Bronze, 15 x 12 x 4"

Sophie Rivera
Pill. 1993.
Ceramic and plastic,
1 3/4 x 4 3/4"

An Ounce of Prevention.
1993.
Ceramic and plastic,
1 3/4 x 4 3/4"

Janice Sakai
Healing Beads. 1993.
Clay, leather, and copper on
velvet vase with acrylic
cover, 12 x 12 x 6"

**Cheryl Ann Shackelton-
Hawkins**
JuJu Box. 1993.
Plexiglas, binders, fabric,
and objects, 8 x 8 x 8"

Yolanda R. Sharpe
Untitled. 1993.
Oil on canvas, 12 x 12"

Beverly R. Singer
Recovery in Native America.
1993.
Videotape, color,
54 minutes

Deborah Singletary
The Empress (Key 3). 1993.
Acrylic on cutting board,
diameter 12"

Clarissa Sligh
Enough. 1994.
Mixed media, under 12"

Yumiko Ito Smith
*Good Luck Charm/Archaic
Sea.* 1993.
Silver, nonprecious stone,
leather, and paper, 8 x 10"

Gilda Snowden
Album: Fetish for Nadine.
1993.
Assemblage with gold leaf,
copper, fabric, and encaus-
tic, 11 x 10 x 4"

Elaine Soto
La Monserrate. 1992.
Encaustic on wood panel,
11 x 8 1/2"

HollyAnna Spino
Look Back. 1994.
Glass, mirror, beads, feath-
ers, paper, enamel, and
glass, approx. 12 x 12 x 4"

Masako Takahashi
Influence. 1993.
23 Karat gold leaf and
mixed media on velvet cush-
ion, approx. 9 x 9 x 9"

Barbara Takenaga
Blue Bronco and Queue.
1993.
Plastic horse, hair, acrylic,
and plaster, under 12"

Donna Thompson
Waking Trance. 1993.
Toned silver gelatin print

Mary Ting
She Carried Her Wounds in a Bag. 1993.
Tarlatan, wax, paint, rope, and glue, 9 x 4 x 1"

Mimi Chen Ting
A Healing Place. 1993.
Monotype with chine collé on paper, 12 x 10"

Ana Tiscornia
Wall Paper. 1993.
Acrylic on canvas, 8 x 9"

Charzette Torrence
Essence of a Woman. 1993.
2 supergloss Cibachrome prints, 16 x 20"

Gail Tremblay
Real Indian Medicine. 1993.
Wood, acrylic, cedar bark, grass, and medicinal plants

Gladys Triana
The Healing Book. 1993.
Mixed media on cardboard, 8 1/4 x 10 1/2"

Linda Vallejo
La Indigena. 1993.
Gouache on paper, 12 x 12"

Gelsy Verna
This Holds Everything...(Juju Box). 1993.
Metal box and mixed media, 8 1/2 x 8 1/2"

Betty Phoenix Wan
Healing Nature. 1993.
Mixed media on plastic, 8 x 10"

Carolyn Warfield
Janus Heart Mast. 1993.
Mixed media, under 12"

Bisa Washington
Shrine No. 7: Ewe Òsanyin. 1993.
Fiber, tin, wood, found objects, and omiero, 14 x 12 x 10"

Gina T. A. Washington
Grasp the Birds' Tail (Dedicated to Alice Walker). 1993.
Photograph, 12 1/2 x 17"

Shirley Woodson
The Healer. 1993.
Canvas, wood, fiber, and metal, 15 x 9 x 3 1/2"

Mónica Yoguel
Protect Your Smile (Smile Box). 1993.
Wood, paper, charcoal, and tacks, 12 x 8 x 3"

SPEAKING SITES

Ingrid Bachmann
Speaking Sites—Dialogue: Ingrid and Plato. 1993.
Chalkboard paint, ladders, bicycle, roller blinds, slikscreened pigments, Masonite, and chalk

CHANGING THE SUBJECT: PAINTINGS AND PRINTS 1992–1994

Emma Amos
Equals. 1992.
Acrylic on linen, laser-transfer photograph, and African fabric, 76 x 82"

A.R. Pink Discovers Black. 1992.
Acrylic on linen, laser-transfer photograph, and African fabric, 81 x 55"

The Overseer (triptych). 1992.
Acrylic on linen, laser-transfer photographs, Confederate flag, and African fabric, each panel 84 x 56"

Way To Go, Carl, Baby. 1992.
Acrylic on linen, laser-transfer photographs, and African fabric, 87 x 60"

X Flag. 1993.
Acrylic on linen, laser-transfer photograph, and Confederate flag, 58 x 40"
Collection Alice Zimmerman

Malcolm X Morley, Matisse and Me. 1993.
Acrylic on linen, laser-transfer photograph, and African fabric, 74 x 61"

Baggage (diptych). 1993.
Acrylic on linen, silkscreen, and African fabric, each panel 79 1/2 x 56 1/2"

Blindfolds (diptych). 1993.
Acrylic on linen, laser-transfer photograph, silkscreen, and African fabric, each panel 79 1/2 x 55 1/2"

Tee: for Gilbert & George. 1993.
Acrylic on linen, laser transfer photograph, and African fabric, 29 x 36"

Never: for Vivian (Browne). 1993.
Acrylic on linen and African fabric, 45 x 34"

Fragments: For Mel. 1993.
Acrylic on linen and African fabric, 42 1/2 x 33"

X Ray Showing Norman Lewis and Women At the Club. 1993.
Acrylic on linen, laser transfer photograph, and African fabric, 46 x 34"

Captured. 1993.
Laser-transfer photograph, edition of 2, no. 1, 22 3/8 x 30"

Yellow X. 1993.
Laser transfer photograph, monoprint, 22 1/4 x 15"

Work Suit. 1994.
Acrylic on linen and African fabric, 74 1/2 x 54 1/2"

Black, White & Gray. 1994.
Monoprint and litho transfer, 20 x 12"

Reminders GA & FL. 1994.
Laser-transfer photograph and watercolor transfer, edition of 3, no. 1, 22 x 19"

Sold. 1994.
Silk collagraph and laser-transfer photograph, edition of 12, no. 1, 22 x 30"

Ghosts. 1994.
Pencil and laser-transfer photograph, edition of 2, no. 2, 24 1/2 x 41 1/2"

Lucas's Dream. 1994.
Silk collagraph and laser-transfer photograph, edition of 8, no. 1, 22 1/4 x 19 1/4"

Tic Tac Toe. 1994.
Silk collagraph and laser-transfer photograph, edition of 10, no. 1, 12 x 18 1/2"

Standing Out. 1994.
Silk collagraph and laser-transfer photograph, edition of 9, no. 1, 12 x 20"

Confederates. 1994.
Silk collagraph and laser-transfer photograph, edition of 7, no. 1, 18 1/2 x 20 1/16"

Black & White. 1994.
Silk collagraph and laser-transfer photograph, artist's proof, 18 1/2 x 16"

Mrs. Gaugin's Shirt. 1994.
Silk collagraph and laser-transfer photograph, edition of 5, no. 1, 12 x 9"

Work Suit Try-On. 1994.
Laser-transfer photograph and litho roll, edition of 8, no. 1, 17 x 10 1/4"

White Male Suit Try-On. 1994.
Silk collagraph and laser-transfer photograph, artist's proof, 13 7/8 x 22 1/4"

LITTLE THINGS

Zoltán Adám
Sculpture. 1992.
Foam rubber, 7 x 4 3/4"

Hüseyin Alptekin and **Michael Morris**
Blind Potent Spot/Magneto-Radiator. 1992.
Coal, nails, and mixed media, dimensions variable

Beöthy Balázs
Untitled. 1993.
Glass, 5 x 7"

Tamás Banovich
Untitled. 1990–93.
Painted wood, dimensions variable

Laurie Bartholomew
Make a Wish. 1991.
Mixed media

Monica Bock
On Longing. 1990.
Lead, glass, oak, wax, hair, blood, and semen, 3 x 6 1/2 x 3 1/2"

András Böröcz
Pregnant Woman. 1993.
Pencil, 7 x 1"

Elvis. 1993.
Pencil, 7 x 1"

Imre Bukta
Draft Animal. 1992.
Wood and iron, 8 x 12 x 3"

Erin Butler
Fern Meditation. 1993.
Oil on canvas on chipboard, diameter 5"

Gary Cannone
Library Card Proposal. 1993.
Color laser print, 2 1/2 x 4"

Jno Cook
Rollodog. 1992.
16mm filmstrip on a loop, 9 x 12 x 5"

Linda Cummings
Domestic Icon (from *The Fall* series). 1994.
Oil on wooden breadboard, 11 1/2 x 8"

Verne Dawson
Untitled. 1993.
Oil on canvas, 9 x 10"

Carol Deforest
Husband. 1992.
Porcelain, 20 x 4 x 5"

Tom Denlinger
Blond Wax Bacon. 1993.
Wax and metal, 4 x 14 x 11"

Luke Dohner
Olive-Palmolive. 1992.
Mixed media, 8 x 12"

Gail Duggan
Twin. 1993.
Beeswax, 4 1/2 x 6"

Martha Ehrlich
Untitled Painting. 1992.
Acrylic on masonite, 3 panels, each 3 x 3"

Jay Etkin
Manual Dexterity. 1990–91.
Mixed media, 7 x 9 x 5"

Emily Feinstein
Meeting. 1993.
Painted wood,
8 1/2 x 12 x 12"

Rick Franklin
Price Tags. 1992.
Price tags and pushpins,
approx. 12 x 1/2"

Jessica Gandolf
Unidentified Portrait I. 1990.
Oil on panel, 10 x 6"

Elizabeth Giordano
December 9–10, 1993. 1993.
Black-and-white prints, 5 x 7"

Sara Good
Trowel. 1993
Steel, wood, and brick,
12 x 4"

Jacob el Hanani
Untitled. 1993.
Pen and ink on paper, 5 x 7"

Chris Hanson and
Hendrika Sonnenberg
1000 Sculptures (excerpt).
1989–94.
Metal box, index cards, text,
and photographs, 8 x 6 x 6"

Skowmon Hastanan
*An Eye Is Just a Little Ball
in a Socket with a Bubble in
the Middle, Tears,
Secretions.* 1993.
Mixed media, diameter 5"

Janet Henry
Anthropology 101. 1982–94.
Mixed media and dolls,
7 x 12"

Joel Holub
*Jaffa, The Golden Orange of
Israel. 1988.*
Mixed media, 4 x 4"

Michael Hopkins
Untitled. 1993.
Acrylic on postcard,
12 1/2 x 8 x 1 1/2"

Jo Hormuth
Monster. 1992.
Pressed flowers on paper,
11 x 9"

Julia Jacquette
Excerpt: Rings. 1992.
Oil on panel, six panels,
each 3 x 2 1/2"

Terri Jones
How To Slingshot. 1993.
Ink on paper, 2 x 2"

Gyula Juliús
*Present for Lou Reed
(Experiments of Professor
Oveles, #354: The Big New
York Blackout).* 1993.
Mixed media, 5 x 7 x 12"

Sermin Kardestuncer
Split Book. 1993.
Linen, thread, and pigment
on board, 9 x 11"

Byron Kim
*Study for Emmett at Twelve
Months.* 1994.
Egg tempera on paper,
11 x 15"
Courtesy Max Protetch
Gallery, New York

Diana Kingsley
Margaret Bridge. 1993.
Mixed media, 2 x 4"

Mary Lum
The Periodic Table. 1994.
Painted wood, 6 pieces,
overall 12 x 12 x 12"

Bill Lynch
A Walk on the Water. 1993.
Oil on wood, 11 1/2 x 11 1/2"

Adelheid Mers
NESW. 1993.
Red interknit unit and book-
binder's cloth, 14 x 14 x 1"

Liz Meyer
Self-Imposed Limits. 1993.
Mixed media

Greely Myatt
Leak. 1993.
Cedar wood, metal, and
wire, 11 x 9 x 4"

Aron Namenwirth
Warped. 1992–94.
Oil on canvas, 12 x 12"

Victor Ochoa
Recoil. 1993.
Steel, 6 x 6 x 1"

Gabriel Orozco
Maria, Maria, Maria. 1992.
Paper, 9 x 12"

Rolland Pereszlényi
*Veronese Green, Berlin
Edition.* 1993.
Mixed media, 7 x 4"

Elizabeth Peyton
Untitled (Rirkrit as a Boy).
1992.
India ink on paper,
8 1/2 x 11"

Untitled (Rirkrit as a Boy).
1992.
Pencil on paper, 4 x 9 1/2"

András Ravasz
Untitled. 1993.
Xerox, 8 x 10"

Lászlo Lászlo Révész
Untitled. 1991.
Ink on paper, 5 x 7"

Gábor Roskó
Family Heirloom. 1993.
Mixed media, 5 x 4"

Bill Rowe
Velveeta U-Haul. 1993.
Plastic and Velveeta Box,
4 x 8 x 4"

John Salvest
Memoir. 1991.
Cloth, paper, glass, cork,
fingernails, and rubber
stamps, 7 1/2 x 11 x 5 1/2"

Tairah Shah
The Haircut. no date.
Black-and-white photograph

Robert Shatzer
Morsel. 1993.
Pencil on paper, 12 x 12"

Greg Shelnutt
*Soul Houses: Sum of Its
Parts.* 1992.
Wood and mixed media, 3
pieces, each 12 x 10 x 8"

Lisa Sigal
Element. 1992.
Oil on glass, 3 x 5"

Element. 1992.
Oil on glass, 3 x 4"

Element. 1992.
Oil on glass, 5 x 3"

Allison Smith
Through the Orange Door.
1992.
Mixed media

Joni Sternbach
Untitled Silhouette #26.
1991–92.
Platinum and palladium
print, 12 x 12"

János Sugár
*Counterfeit Proposal for the
Future.* 1992.
Mixed media, 3 x 4 x 2"

Péter Szarka
Literal Interpretation. 1993.
Xerox on cardboard, 1 x 12"

István Szili
*Unopened Letters
(Continuous).* 1993.
Paper, dimensions variable.

Tony Tasset
Cup. 1990.
Painted bronze, diameter 3"

James "Son" Thomas
Head. 1990.
Clay, synthetic hair, and
paint, 6 x 10 x 8"
Collection Coleman Coker

Rirkrit Tiravanija
Untitled. 1993.
Mixed media, dimensions
variable

Daniel Tisdale
*Dr. Palmer's Skin Whitener
and Bleach and Tone,
1963–1993: From the Last
of the African Americans,
2020.*
Mixed media,
10 1/2 x 7 x 12"

Péter Ujházi
The Landing. 1990.
Mixed media, 4 x 4"

Gyula Várnai
Eike. 1993.
Pen on paper, 8 x 10"

Marlene Vine
Homage to E.H. 1992.
Mixed media on paper on
Baltic plywood, 11 x 11 x 1"

Michael Volonakis
The Falconer. 1994.
Silver gelatin print, 10 x 12"

Thomas Weaver
Asylum. 1993.
Acrylic and oil on wood,
6 x 5"

Barbara Wiesen
Blood Soap. 1992.
Blood, soap, and porcelain,
3 x 4 1/2 x 4"

Stephen Williams
Untitled (Baptism). 1990.
Oil on canvas, 11 x 9"

THE X-GIRLFRIENDS
He/She. 1991–93.
Color transfer on wood,
7 1/2 x 3 1/2 x 3 1/2"

Charles Yates
Sky Watching. 1993.
Mixed media, 12 x 11"

Julie Zemel
Happy. 1993.
Plastic figure, pine tree,
glass globe, artificial snow,
and mixed media,
4 1/2 x 3 1/2 x 3 1/2"

ANIMATED

Micheal Carroll
Hank #1. 1993.
Watercolor, 6 x 4"

Hank #2. 1993.
Watercolor, 6 x 4"

Sheldrake from Personnel.
1994.
Watercolor, 9 3/8 x 2 1/4"

Pubina Comics. 1994.
Watercolor, 14 3/8 x 11 3/8"

Popeye the Psycho Man.
1994.
Watercolor, 9 3/8 x 12 1/4"

Gregg Deering
Dixie Dugan. 1993.
Oil on Plexiglas, lobby card,
and toy, 14 x 17 x 4"

The Man Upstairs. 1993.
Oil on Plexiglas, lobby card,
tin advertising can, and
decal, 14 x 17 x 3"

Rise and Shine. 1993.
Oil on Plexiglas and lobby
card, 14 x 17 x 2"

Slightly Tempted. 1993.
Oil on Plexiglas, and lobby
card on canvas, 14 x 17 x 2"

Louise Diedrich
Born of Normal Parents, panel #10. 1993.
Graphite and Bic pen on paper, 43 x 63"

Jane Fine
Warrior of Plasm. 1993.
Oil on canvas, 64 x 48"

My Definition of a Boombastic Drip Painting. 1993.
Oil on canvas, 73 x 64"

Felipe Galindo
Shopping. 1988.
Ink, pastel, and watercolor on paper bag, 16 x 9"

Lunch Time. 1993.
Ink, pastel, and watercolor on paper plate, with tray and plasticware, 10 x 13"

Passengers. 1994.
Ink, pastel, and watercolor on subway map, 33 x 11"

Coffee Shop III. 1994.
Ink, pastel, and watercolor on paper with coffee cup, 10 x 12"

Diego Gutiérrez
"Curitas" (Band-Aids). 1993.
Band-Aids, stickers, and pencil on paper, 5 drawings, each 14 x 19 1/2"

Larry Mantello
Lucky Dog Jamboree. 1991.
Greeting cards and collage, 18 x 18".
Courtesy Jose Freire Fine Arts, New York

Jam Buoy. 1992.
Xerox transparencies, greeting cards, beads, bells, and metal pins, 34 1/2 x 4 x 4".
Courtesy Jose Freire Fine Arts, New York

Gate Weight. 1992.
Greeting cards, veneer, and Xerox-transparencies transfer, 9 1/4 x 9 x 5 1/4".
Courtesy Jose Freire Fine Arts, New York

Mint Condition. 1992.
Xerox-transparencies-transfer, and metal pins, 18 3/4 x 16".
Courtesy Jose Freire Fine Arts, New York

Melissa Marks
The Adventures of Volitia— The Abstract Vagina. 1993.
Graphite and colored pencil on paper, 18 1/4 x 15 1/4"

Volitia Meets the Flame (One, Two, Three, Four). 1993.
Graphite and colored pencil on paper, 4 drawings, each 11 x 8 1/2"

Volitia Plays with the Diamond Spiral (One, Two, Three, Four). 1994.
Graphite and colored pencil on paper, 4 drawings, each 11 x 8 1/2"

Nurit Newman
Nose Job. 1994.
Video, vibrating motors, matzo balls, rubber, and china, dimensions variable

Nose Job II. 1994.
Stuffed animals, vibrating motors, and matzo balls, dimensions variable

David Schafer
Twin Smile Face. 1994.
Painted steel, aluminum, rivets, and vinyl signage, 15 1/2 x 45 x 15 1/2"

Norman Steck
Muse. 1992.
Pencil on paper, 11 x 15"

Pussies & Pansies. 1993.
Pencil on paper, 11 x 15"

Kiddie City. 1993.
Pencil on paper, 11 x 15"

Mark Dean Veca
Untitled. 1992.
Oil, acrylic, and ink on canvas, 32 x 42"

Celestial Body I. 1992.
Ink and gesso on canvas, 15 x 15"

Celestial Body II. 1992.
Oil and acrylic on canvas, 15 x 15"

Celestial Body III. 1992.
Oil and acrylic on canvas, 15 x 15"

Celestial Body IV. 1992.
Oil and acrylic on canvas, 15 x 15"

WHAT IS ART?

Michael Bramwell
FINEFOODFOR [ALL CHAPS]. 1994.
Vinyl, latex, silkscreen ink on Masonite, dimensions variable

Esperanza Cortés
A Flor de Piel (After the Embers). 1992–94.
Clay, salt and pigment on marble, 7' x 7' x 5'

Renée Cox
Yo Mama Goes to the Hamptons. 1993.
Silver gelatin print, 60 x 48"

Lisa Corinne Davis
(Brown) Heritage Search #1. 1993.
Oil pastel, colored pencil, and encaustic on copper, 12 x 13"

(Brown) Heritage Search #2. 1993.
Oil pastels and encaustic on type, 11 3/4 x 12 3/4"

(Brown) Heritage Search #3. 1993.
Acrylic, encaustic, earth on corrugated cardboard and twine, 12 x 11"

(Brown) Heritage Search #4. 1993.
Linoleum cut print, ink and colored pencil on corrugated cardboard, 11 1/2 x 11"

(Brown) Heritage Search #20. 1993.
Ink, acrylic paint, earth, plaster, gauze, colored pencil, and oil pastel on chicken bones, 10 3/4 x 12 1/2 x 2 1/2"

Ernesto Pujol
brown sharks (from cuba and the shark series). 1994.
Fabric dye and pigment on paper, 41 x 25 1/2"

cuba and the shark (from cuba and the shark series). 1994.
Collage, fabric dye and ink on paper, 35 1/2" x 34"

school of sharks (from cuba and the shark series). 1994
Fabric dye and ink on paper, 33 x 26 1/2"

cuba and jamaica (from cuba and the shark series). 1994.
Ink on paper, 23 1/2" x 21"

Elaine Soto
La Virgen Del Pozo. 1993.
Encaustic, acrylic, and sand from Puerto Rico, 104 x 107"

Behind the Veil. 1994.
Encaustic on wood, 21 x 16"

Ricardo Zulueta
Untitled (Shooting Targets). 1994.
Silkscreen, glass mirror, and steel, 12 x 12 x 12"

NIGHT WATERS

Lynne Yamamoto
Night Waters. 1994.
Installation: 9 wooden boxes with enclosed photographs, each box 12" square, artificial hair, moss fabric, and audiotape

WINDOW INSTALLATIONS

8 glass panels, overall, 47 x 72 1/2", depth on left side 17", on right side 14 1/2"

Christina Bothwell
Kennel. 1993–94.
Plaster, wax, rubber, cast paper, wood, and papier-mâché

Michael Bramwell
Persistence of Ritual No. 2. 1993.
African sculptured wood stool and African cloth

Dina Bursztyn
Recent Archeological Findings from the Late 20th Century. 1993.
Ceramic sculptures, found objects, and mixed media

Arlan Huang
Hearts Desire—My Liquid Rice. 1994.
Chinoiserie motifs etched and sandblasted on glass panels, mixed curios and glass vessel

Portia Munson
Pink Project. 1994.
Found pink objects

Paul Pfeiffer
The Survival of the Innocents. 1993.
Plaster statues of niños, satin, silkprinted imagen, and text

ELEVATOR AUDIO PROJECTS

Michael Bramwell
The Poultry Corner from *Persistence of Ritual No. 2.* 1993.
Audiotape, 45 minutes

Tom Burckhardt
Elevator Music. 1993.
Audiotape, loop

Conway and **Pratt**
The Elevated Examination of the Cartesian Split. 1993.
Audiotape, 1 hour 40 minutes; voice, Gregor Paslawsky

Carole Ramer
The Lil Tape. 1994.
Audiotape, 37 minutes; voices, Richard Minadeo and Dana Higgins

Anne Torke
Have a Nice Day.
Audiotape, 2.5 minutes

Ann-Sargent Wooster
No Means No. 1993.
Audiotape, 12 minutes

CONTRIBUTORS

LESLIE CAMHI writes frequently on art and cultural politics for the *Village Voice* and other publications.

VEENA CABRERO-SUD is a Philippina-Indian writer, poet, and artist living in New York City.

LAWRENCE CHUA is the managing editor of *BOMB* magazine and a founding member of the black radio collective, Radio Bandung.

LINH DINH is a Philadelphia-based artist and writer who was recently awarded a PEW Fellowship for poetry.

KAREN HIGA is a curator at the Japanese American National Museum, Los Angeles, California.

bell hooks is a feminist, theorist, cultural critic, and professor. Her books include *Ain't I a Woman: Black Women and Feminism; Feminist Theory: From Margin to Center; Talking Back: Thinking Feminist, Thinking Black; Yearning: Race, Gender, and Cultural Politics; Black Looks: Race and Representation;* and, most recently *Sisters of the Yam: Black Women and Self-Recovery.*

LAURA J. HOPTMAN is an independent curator living in New York City. She is a former curator of The Bronx Museum of the Arts.

GALE JACKSON is a writer, poet, storyteller, and cultural historian living in Brooklyn, NY.

BRIAN KARL is a cultural worker living quietly in Brooklyn. He is currently the director of Harvestworks Digital Media Arts and an editor of the Tellus Audio Series.

SOWON KWON is an artist living in New York City.

SONIA L. LOPEZ is the curator of the Agnes Gund Collection and the director of the Visual Arts Project at the Nuyorican Poets Cafe, New York City.

ANDREW PERCHUCK is a former curator and deputy director of the Alternative Museum, New York City, and a regular contributor to *Artforum.*

KERRI SAKAMOTO is a Toronto-born fiction writer and screenwriter.

HAMZA WALKER is living in Chicago and writes occasionally.

PHOTOGRAPH CREDITS

Myles Aronowitz: pp. 13, 61, 62, 15 above, 81 left, 83

© D. James Dee: pp. 32, 34

Einar Falur Ingolfsson: p. 14

Aresh Javadi: pp. 22, 26, 31, 40, 48 below, 73, 82

Becket Logan: pp. 51, 52

Meghan McCarthy: p. 75 below

Vladimir Radojicić: pp. 21, 23

Adam Reich: p. 33

Robert D. Rubic: p. 15 above

© Teri Slotkin: pp. 1, 8, 12, 15 below, 17, 18, 28, 36, 48 above, 53, 64, 69, 71, 84, 85,